MASTER DRAWINGS REDISCOVERED

# MASTER DRAWINGS REDISCOVERED

## TREASURES FROM PREWAR GERMAN COLLECTIONS

TATIANA ILATOVSKAYA

THE MINISTRY OF CULTURE OF THE
RUSSIAN FEDERATION

THE STATE HERMITAGE MUSEUM, ST. PETERSBURG

IN ASSOCIATION WITH

HARRY N. ABRAMS, INC., PUBLISHERS

Editor: JAMES LEGGIO
Designer: MIKO McGINTY
Documentary Photo Research: CATHERINE RUELLO

Color Photography: LEONID KHEIFETS
Translated from the Russian by LYNN VISSON

Library of Congress Cataloging-in-Publication Data

Ilatovskaia͡, Tat ͡iana Afanas ́evna.
   Master drawings rediscovered : treasures from prewar
German collections / Tatiana Ilatovskaya.
      p.   cm.
   Includes bibliographical references.
   ISBN 0–8109–3788–3 (hardcover)
   1. Drawing, European—Catalogs.   2. Drawing—19th century—
Europe—Catalogs.   3. Drawing—20th century—Europe—Cata-
logs.   4. Drawing—Collectors and collecting—Germany—
Catalogs.   I. Title.
NC225.I4  1996
741.94'074'43—dc20                                    96–3545

# CONTENTS

The exhibition "Master Drawings Rediscovered" and this accompanying catalogue are part of the process of bringing a group of art works, the so-called "spoils of war," back to the worldwide community of art lovers – both the professionals in the field and the public at large.

Due to the political situation in postwar Europe, the cultural objects removed to the territory of the USSR as a result of World War II had been kept prisoner, so to speak, in Special Storage, becoming "unknown" masterpieces in the full sense of the term. It was only the democratic changes in Russia that made it possible to return these last prisoners of war to a cultural context.

This exhibition of drawings and watercolors by major European figures presents masterworks by artists such as Francisco de Goya, J.-A.-D. Ingres, Honoré Daumier, Adolph von Menzel, and Vincent van Gogh, among others, from important private collections in prewar Germany. It is a splendid sequel to the exhibition "Hidden Treasures Revealed," presented by the State Hermitage Museum in 1995–96, an event that marked a milestone in the cultural life of Europe.

I am convinced that, despite the complexity of the process of the restitution of art works, the problems at issue will eventually be resolved satisfactorily, in a civilized manner, on the basis of law and common sense.

Dr. Yevgeny Sidorov
*Minister of Culture*
*Russian Federation*

With this exhibition, the State Hermitage Museum continues its effort to bring before an international audience works of art removed from Germany in the wake of World War II – works which, at the request of the state, it had long preserved under conditions of strictly limited access. Our museum believes that the display and scholarly publication of all such works in its care is its highest priority task. A firm basis in factual documentation is thereby provided for discussions among legal experts and journalists and for decisions by politicians and diplomats. The art becomes accessible, and it can then be studied – and admired.

Our first exhibition of this kind was devoted to drawings from the Kunsthalle, Bremen. The second, "Hidden Treasures Revealed," presented great French paintings which before the war had been in private collections in Germany, and which therefore had rarely if ever been shown in public, even in prewar times. That exhibition was extremely well received – not only because of the world masterpieces returned to public view, but also because of the tone that the Hermitage set for the discussion of some rather thorny issues.

Today, we are exhibiting a group of drawings from those same prewar private collections. Once again the viewer can appreciate the outstanding connoisseurship of such remarkable collectors as Otto Gerstenberg, Bernhard Koehler, and Otto Krebs.

The major bodies of work in the exhibition are, of course, the impressive groups of drawings by Francisco de Goya and Honoré Daumier. These works were known in the past, but their reappearance today provides new enjoyment of these two masters and fresh incentive for pondering the social issues often bound up in their art. We are led to consider whether our century has truly been a finer one than theirs.

Other highlights include a series of joyous marine watercolors by Paul Signac, which make fitting companions for Vincent van Gogh's masterpiece *Boats at Saintes-Maries*. At the same time, the intentionally raw images by Emil Nolde offer an interesting contrast to the elegant, refined figures by Alexander Archipenko. This latter series of works may well be one of the most notable revelations of the exhibition.

I have the privilege of welcoming all those who will travel to St. Petersburg to see "Master Drawings Rediscovered." It is for the sake of all such concerned people – the greater public at large – that the museum is seeking solutions to difficult issues. We keenly hope that, like its predecessors, this exhibition will promote our common goal of peace and mutual understanding, and will not become a subject of contention.

Dr. Mikhail Piotrovsky
*Director*
*The State Hermitage Museum*

This catalogue, which documents the exhibition "Master Drawings Rediscovered" at the State Hermitage Museum, continues the publication of works of art that have been in Russia since World War II. The history of the works on paper reproduced here is similar to that of the paintings published in Albert Kostenevich's book *Hidden Treasures Revealed* and exhibited at the Hermitage in 1995–96. For fifty years, the drawings now reproduced here led a hidden life. They were not exhibited, and during all that time, those which in the past had been included in the literature of art were thought lost. The majority of them are now being shown publicly for the first time, as they all return to the world of art history. The works are by outstanding European masters and are of extraordinary quality. Their dates extend from the very end of the eighteenth century through the first decades of the twentieth.

Some of these drawings had been known to scholars and connoisseurs through early catalogues raisonnés or through scattered illustrations published elsewhere; others, however, have never been studied or reproduced, and only their owners or a very small group of art lovers ever knew of their existence, even before the war. The first category encompasses all thirty-five drawings by Francisco de Goya included here, as well as the pencil portrait by Jean-Auguste-Dominique Ingres, the watercolor by Eugène Delacroix, the eight sheets by Honoré Daumier, one of the studies by Adolph von Menzel, the drawing by Paul Cézanne, and the watercolor by Vincent van Gogh. Even here, the extent to which the works in this category are known in the history of art varies: While the van Gogh has been reproduced in virtually every major study of that artist's work, and the drawings by Goya, Ingres, Daumier, and Cézanne are in the relevant catalogues raisonnés, the sheets by Menzel and Delacroix were much less well known, having been published only rarely and a long time ago. The second category, the previously unknown works, includes six of the seven drawings by Thomas Rowlandson, the landscape by Jean-François Millet, the four remaining drawings by Menzel, the fifteen watercolors by Paul Signac, the watercolors by Henri de Toulouse-Lautrec and Emil Nolde, and the group of works by Alexander Archipenko.

The life of drawings differs from that of paintings. Paintings generally are intended for public exhibition, while drawings require a more intimate atmosphere, and close – indeed almost physical – contact. A drawing does not create a space around itself the way a painting can. Rather, it must depend on the sympathetic understanding of the person looking at it. This remains true even when the work is shown at an exhibition. These qualities of drawings are reflected in the special attitude of the collectors. As a rule, private collections of drawings are less accessible than those of paintings. In part this is because a drawing is fragile and cannot tolerate lengthy exposure to light. It is also because drawings have nearly always been a very personal form of art, both for the artists who create them and for the connoisseurs who collect them. A drawing is usually not intended by the artist for the eyes of strangers. It is often an intimate record of the creative process itself, of unexpected discoveries and insights. These study drawings are to be distinguished from the "finished," or presentation, drawings intended for exhibition or done on commission. Although in the twentieth century drawings have become a more independent form of artistic activity, most of the works in this book are studies and sketches. Only a few of them – such as the Ingres portrait, a few of the sheets by Daumier and Rowlandson, and Nolde's watercolors – can be considered truly independent works. Even the highly developed watercolor by van Gogh was preliminary to a painting.

Drawings are thus a more private kind of artwork than are paintings. The German private collections from which the present drawings came were largely formed in the period between the two world wars. For much of this time in Germany, the artistic tastes of connoisseurs ran counter to the official ideology of the state. As a result, it was often necessary to hide important works from view in order to preserve them for posterity. Russia experienced

episodes of this kind from the mid-1930s to the beginning of perestroika. Totalitarian regimes generally forced private collectors who owned avant-garde works of art to avoid publicity and above all any publication of them. Many masterpieces thus dropped out of sight for long periods of time. Such, for example, was the lot of paintings and drawings from the collections of Otto Krebs and Bernhard Koehler.

Among the works in this book, pride of place goes to the drawings from the collection of Otto Gerstenberg (1848–1935). Gerstenberg devoted more than fifty years of his life to the world of finance, and the Victoria insurance company, of which he became director in the 1880s, was well known abroad. But to a great extent, what Gerstenberg is remembered for today is his collecting, which for him became a genuine passion. He first collected drawings and prints by the Old Masters, including Albrecht Dürer, Martin Schongauer, Lucas van Leyden, Rembrandt van Rijn, and Anthony van Dyck. He was attracted as well by Japanese prints. Another passion of Gerstenberg's was the drawings of the French Romantics and the Impressionist painters. Among contemporaneous German artists, he admired Menzel, Max Klinger, Wilhelm Leibl, and Max Liebermann. But perhaps his favorite artists were Daumier, Lautrec, and, most of all, Goya. Daumier was the most comprehensively represented, with paintings, lithographs, drawings, and sculpture – a collection within the collection. Gerstenberg first acquired work by Daumier in 1903, at an auction in Paris of the famous collection of Arsène Alexandre, and the drawings published in the present book came to him from the well-known Bureau and Rouart collections, from that of Charles de Bériot, and from the galleries Durand-Ruel and Bernheim-Jeune. Lautrec lithographs also claimed a large part of Gerstenberg's attention, but the holdings of works by Goya were particularly outstanding. It was on the sheets of Goya's so-called Bordeaux albums and on the pages of *The Disasters of War* that Gerstenberg imprinted his famous collector's seal with the image of Nike. Even in the financially difficult years of 1922–23, when Gerstenberg was forced to sell part of his collection, he kept the Goya drawings and prints, along with his Rembrandt drawings. It was assumed that none of these works would ever

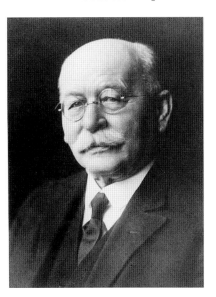

1. Otto Gerstenberg

leave his collection. Nevertheless, after Gerstenberg's death, when the collection passed to his daughter Margarete Scharf, part of it was sold. In 1943, during the war, the Lautrec works that had been taken to Denmark were sold there, and at the same time three Goya drawings also left the collection.

The collection of Bernhard Koehler (1849–1927) is no less famous than that of Gerstenberg, but the nature of the collecting activities and the artistic tastes of these two collectors differed. Though only a single work in this book comes from the Koehler collection, it is of great importance: van Gogh's watercolor *Boats at Saintes-Maries*. (There were also two van Gogh canvases in the Koehler collection.) The character of Koehler's collection was to a great extent determined by his links with painters of the Blaue Reiter group and by his direct contacts with the French dealers Ambroise Vollard, Bernheim-Jeune, and Durand-Ruel. And although Koehler's collection included one El Greco canvas, of which he was particularly proud, his major interests remained the paintings of the Impressionists, the Post-Impressionists, and contemporary German and French artists. Thanks to his close relationship with August Macke, who was married to his niece, Koehler acquired works by Franz Marc, Vasily Kandinsky, Paul Klee, Heinrich Campendonk, Robert Delaunay, and Alexei von Jawlensky. Parts of Koehler's outstanding collection of Expressionist paintings and his rich archive of documents are now in the Lenbachhaus, Munich.

The collection of the well-known Berlin industrialist Friedrich-Karl Siemens included drawings here by Lautrec, Signac, and Menzel. These works came to the Hermitage together with the paintings in *Hidden Treasures Revealed*.

The bulk of the Signac watercolors shown here come from the collection of Otto Krebs (1873–1941), which was also well represented in *Hidden Treasures Revealed*. Virtually all of Krebs's drawings are marked on the verso with a number and the pencil inscription *K*. Therefore, the three watercolors by Nolde and the eleven sheets by Archipenko in this book cannot with certainty be assigned to the Krebs collection, for although they came to the Hermitage together with the other items from Krebs, they do not show such markings; moreover, they were not included in the checklist of the Krebs collection

2. August Macke. *Portrait of Bernhard Koehler*. 1910. Städtische Galerie im Lenbachhaus, Munich

3. Otto Krebs

drawn up by the medical institute in Mannheim that received all of Krebs's archives after the collector's death. Perhaps a more persuasive reason for doubting that these works come from the Krebs collection is their aesthetic character. The works of Nolde and Archipenko do not fit in with Krebs's known artistic preferences. He focused on the Impressionists and Post-Impressionists. Later art apparently did not interest him. The question of whether the Nolde and Archipenko works ever belonged to any one collection remains open. Perhaps further research will reveal their past history.

Doubts also persist regarding the Helene Bechstein collection from Berlin, for which six Rowlandsons and four Menzel studies are listed in the Hermitage's documents. All of these works were found in frames from exhibitions and had the initials H.B. inscribed on the back of the matting and sometimes also on the passe-partout. So far, we have no information regarding this collection, and it is hoped that this publication may lead experts on pre-war German collecting to discover more about it.

The last German repository has not yet been established for the Cézanne drawing, either. It is only known that in March 1935, the work was in a sale of the Paul Graupe collection in Berlin.

◇

The exhibition at the Hermitage and the publication of this catalogue provide a new opportunity to see the works of a wide range of major European artists. There is, most notably, Goya, with his mixture of harsh reality and the otherworldly, but also Rowlandson, with his lightly humorous satire. We see Ingres, whose refined naturalism was combined with the ideal, and the contrasting figure of Delacroix, whose passionate Romanticism was filled with color. And we encounter as well Daumier, depicting the comedy of society; Millet, newly revealing the world of nature; and Menzel, recording details of domestic life. The exhibition gives us a new look at the analytical Cézanne, the visionary van Gogh, the radiant Signac, and the ironic Lautrec. It offers fresh insight into Nolde, who remained a Romantic in his creative work though a realist in life; and finally Archipenko, who carried the Russian artistic dream of fourth-dimensional space to the open spaces of America.

# CATALOGUE

All works are on white or near-white paper unless otherwise indicated; watermarks are noted. Dimensions are given first in inches, then in centimeters, height preceding width. The signature and/or inscription by the artist, if any, is transcribed following the indication of medium. Also transcribed are gallery and museum identification labels and the stamped seals imprinted by former collections. To the extent possible, indications of provenance, exhibition history, and literature are provided for each work. Abbreviations used in the literature citations refer to the Bibliography. The provisional inventory numbers of the works are also given. Each drawing is accompanied by a commentary. For the three artists who are represented by extensive groups of works – Francisco de Goya, Paul Signac, and Alexander Archipenko – the individual drawings are preceded by a brief overall introduction.

After World War II, the State Hermitage Museum received the present group of thirty-five drawings by Goya formerly in the Gerstenberg-Scharf collection. Of these, thirty are from Goya's so-called "Bordeaux albums" (1824–28), identified in the literature on Goya as albums G and H. Another drawing came from the "sepia album" (album F, 1812–23). The four remaining drawings are individual sheets, also done in Bordeaux. After Goya's death, in 1828, all of these drawings had passed to his son, Javier, and were later dispersed to different collections. Their subsequent history was examined in detail in the two catalogues of Goya's drawings compiled by Pierre Gassier in the 1970s (Gassier I and Gassier II; cited in full in the Bibliography).

All thirty-five Goya drawings are mounted on gray-brown passe-partout, which was done before the drawings were acquired by Gerstenberg. The drawings were stored in a leather-bound wooden case, with metal fasteners, imprinted GOYA in gold lettering.

All the Goya drawings acquired by Gerstenberg are stamped on the recto. Prior to his acquisition of them, the sheets bore no stamp at all; when Pierre Lafond published the drawings (Lafond 1907), at

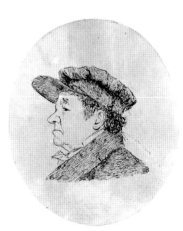

1. Francisco de Goya. *Self-Portrait*. 1824. Museo del Prado, Madrid (483)

which time they were in the collection of Aureliano de Beruete, they still bore no visible stamp. All subsequent reproductions of the drawings, including Russian publications, were made either from the original set of photographs or, more often, from the Lafond book itself (the negatives, as Gassier indicates, are in the Moreno archive in Madrid; see Gassier I, p. 488). This accounts for the absence of the stamp in reproductions of these drawings and also leads one to believe that Gerstenberg never had these works photographed after they came into his possession.

The Gerstenberg stamp depicts the Greek goddess Nike standing atop an oval that encloses the letters O.G. This image of the goddess of victory (*victoria* in Latin) alludes to the Victoria insurance company, to which Gerstenberg devoted decades of his professional life. On several of the Gerstenberg drawings, the stamp extends beyond the edge of the sheet and onto the gray-brown mounting. In the reference on collectors' stamps (Lugt 1921, 1956; commonly abbreviated as "L."), this stamp is identified as "L.2785" and is thus cited in the present book. Lugt points out that this stamp was imprinted on the verso of graphic works, in black. On the Gerstenberg drawings, however, this stamp is imprinted on the recto, and in brown. It can be noted that according to the catalogue raisonné of Henri de Toulouse-Lautrec's graphic works from the Gerstenberg collection (Adriani 1986), Gerstenberg did frequently imprint this stamp in brown rather than black.

The drawings within the Bordeaux albums were numbered by Goya. The artist's numbering indicates only the order in which the drawings were executed. The drawings were only sketches and were not preparatory to any particular future project. When Lafond first published these drawings, however, he decided to title them *Nouveaux Caprices*. But Goya himself referred to them only in passing, in a letter

to Ferrer of December 20, 1825, dealing primarily with the compositions he had executed as miniatures on ivory, and it was rather in that connection that the artist referred to a new edition of graphic works.

In the Goya catalogue raisonné (Gassier/Wilson) and in the catalogue of Goya's drawing albums (Gassier I), the drawings are arranged in order of execution, according to the artist's numbering. In the present volume, however, the arrangement conforms to that of the Gerstenberg collection itself, for the following reasons. In addition to the artist's numbering, there is another numbering of the Gerstenberg drawings, one that was marked in pencil on the passe-partout at the same time the mounting was done – that is, before the drawings were in fact acquired by Gerstenberg. (During the war, three sheets were sold from the collection, among them the sheet *Monk Floating in the Air* [H.32; private collection, Berlin], which had the number 15.) Within this numbering sequence, followed in the Gerstenberg collection, sheets from two different Goya albums were mixed together, while other sheets were also added which Goya had created separately. As this is also the numbering used in Lafond's 1907 publication, it can be concluded that not only the mounting but also this arrangement of the sheets goes back to a time before these parts of albums G and H were acquired by Gerstenberg. Because this numbering on the passe-partout is historically significant, it was decided to follow it in the present exhibition.

All of the drawings from albums G and H were executed in lithographic crayon, which Goya started to use at the beginning of the 1820s, not very long after the invention of the technique of lithography. There is ample evidence that Goya made frequent use of lithographic crayon not only in working on lithographic stones, but also in drawing on paper. Following tradition, however, Gassier identifies the medium of these drawings – the Gerstenberg drawings as well as all the other sheets from albums G and H – as black chalk. Visually, it is extremely difficult to distinguish black chalk from lithographic crayon, but in the preparation of lithographic crayon a greasy binding agent is used, which is detectable on the versos of these sheets. Goya used the medium of lithographic crayon on paper with great sensitivity, creating a richly nuanced surface. This medium evidently provided him with something that black chalk or charcoal could not: a velvety texture filled with light. Analysis in the conservation laboratory at the State Hermitage Museum has determined that lithographic crayon alone was used in these drawings from albums G and H (i.e., the Bordeaux albums). In addition, the presence of a ferrous gallate ink was detected in the drawing *Jacob and His Sons with the Bloody Tunic,* whereas earlier it had been thought to be in India ink.

The thirty drawings from the Bordeaux albums were executed on laid paper. Most of the sheets have watermarks, which Gassier describes in detail (Gassier I, p. 501). In the present volume, the following abbreviations are used to identify the watermarks: GH.I; GH.II; and GH.III. Of the five remaining sheets, which include other kinds of paper as well as laid paper, two have other watermarks: In the drawing *Jacob and His Sons with the Bloody Tunic,* it is the one identified as F.II (Gassier I, p. 387); in *The Skaters,* it is a cartouche with a vine and the word CAPELLADE. The latter is not indicated in Gassier and has not been found in the standard references on watermarks.

Bibliographical abbreviations in the commentaries that follow refer to the sources listed in the Bibliography. Goya's albums of drawings are cited using the following abbreviations:

A = album A (known as the Sanlúcar album)

B = album B (known as the Madrid album)

C = album C

D = album D (known as the unfinished album)

E = album E (known as the black-border album)

F = album F (known as the sepia album)

G = album G (with album H, known as the Bordeaux albums)

H = album H

PROVENANCE: Javier Goya; Federico de Madrazo; B. Montañes, Saragossa; Aureliano de Beruete, Madrid; Otto Gerstenberg, Berlin (acquired through Ricardo de Madraz in June 1911 for 40,000 francs); Margarete Scharf, Berlin (inherited from her father, Otto Gerstenberg, in 1935).

# FRANCISCO DE GOYA

**PRISONER**

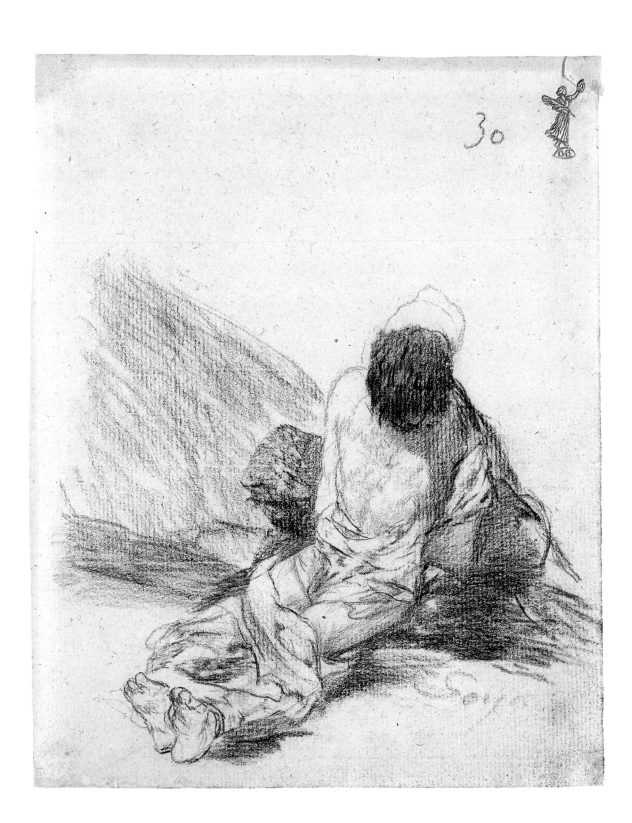

As Pierre Gassier indicates, there is a copy of this drawing, executed in ink wash (private collection, Paris), that bears an inscription in pencil: *Miseria* ("Misery"). Gassier considers the copy a forgery, done on a kind of paper intended to match that of Goya's so-called "unfinished album" (album D) of 1801–3, although the inscription, which Gassier called "fanciful," would seem to suggest a work of a much later date.

Beyond the realistic depiction of the bound prisoner in the present drawing, there is something about the treatment of this subject that is quite characteristic of Goya. Throughout Goya's work, the subject of humility is always coupled with, and yet partially contradicted by, the theme of struggle and resistance. This sheet shows a forced capitulation. Bound and nearly naked, the man is left exposed to the sun. The isolation and impotence of the individual in such conditions are the psychological factors that prompted Goya to return to this subject time and again. Action and resistance – whether in a face-to-face clash or in a more insidious conflict – were

motifs in Goya's work conditioned by the religious and political history of Spain. Torture and repression had played a part in Spanish life since the beginning of the Inquisition. To some extent, the theme of torture in Goya's art was a reflection of the debate in the Spanish parliament in the spring of 1811 on the question of abolishing torture, and also of the anti-clericalism that had long characterized the part of society which formed the opposition (see Pérez Sánchez/Sayre 1989, p. 212).

Prisoners appear in Goya's work over a period of more than three decades. One of the first drawings intended for the graphic series *The Caprices (Los Caprichos)* is dated 1797–98 (Gassier II, no. 130); the next ones appear in the so-called "black-border album" (album E) of 1806–7 (E.[j]) and in the "sepia album" (album F) of 1812–23 (F.80). During the period 1810–24, the artist produced four more drawings and three etchings portraying prisoners in the stocks or in chains (see fig. 1; Gassier II, nos. 163, 164, 165, 166, and Gassier/Wilson, nos. 986, 988, 990). The etchings were not published, being dangerously

1.

Francisco de Goya (Fuendetodos, near Saragossa, 1746–Bordeaux, 1828). *Prisoner* (H.30). Lithographic crayon on laid paper, 7½ x 5⅞" (19.2 x 15 cm). Signed lower right: *Goya*. Inscribed upper right: *30*. Stamp at upper right: L.2785. Inscribed on passe-partout: *1*. Watermark at center of left edge: GH.I. Inv. no. 131-17966

PROVENANCE: On plates 1 through 35, see the headnote, "Drawings by Francisco de Goya from the Gerstenberg-Scharf Collection."

LITERATURE: Loga 1903, no. 611. Lafond 1907, no. 1, p. 7, ill. 1. Calvert 1908, pl. 530. Levina 1958, p. 318, ill. p. 324. Gassier/Wilson, no. 1792. Gassier I, no. 446, p. 640, ill. p. 602.

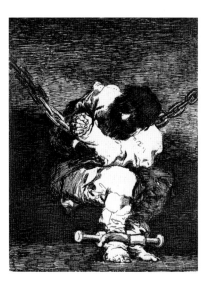

1. Francisco de Goya. *The Imprisonment Is as Barbarous as the Crime*. c. 1810–20. Graphische Sammlung, Eidgenössische Technische Hochschule, Zurich

relevant to contemporary life, but they were included in the set of proofs of *The Disasters of War (Los Desastres de la guerra)* that was sent to Goya's friend Ceán Bermúdez, who edited the captions. In the following decade, Goya returned to such images in the album of sepia and ink drawings known as album C (C.51, C.93–C.114; see figs. 2, 3). It is typical that these portray not only anonymous individuals but historical personages such as Galileo Galilei; the Italian sculptor Pietro Torrigiano, a contemporary of Michelangelo's who died of starvation in a Seville prison; and Diego Martin Zapata, a doctor who was well known at the end of the eighteenth century and was condemned by the Inquisition for professing Judaism.

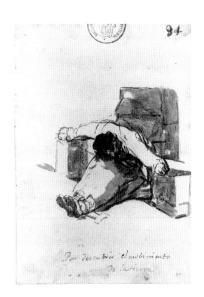

2. Francisco de Goya. *For Discovering the Motion of the Earth* (C.94). 1814–24. Museo del Prado, Madrid (333)

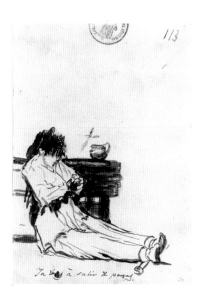

3. Francisco de Goya. *You Are Going to Escape from Your Sufferings* (C.113). 1814–24. Museo del Prado, Madrid (354)

# FRANCISCO DE GOYA

**PENITENT MONK**

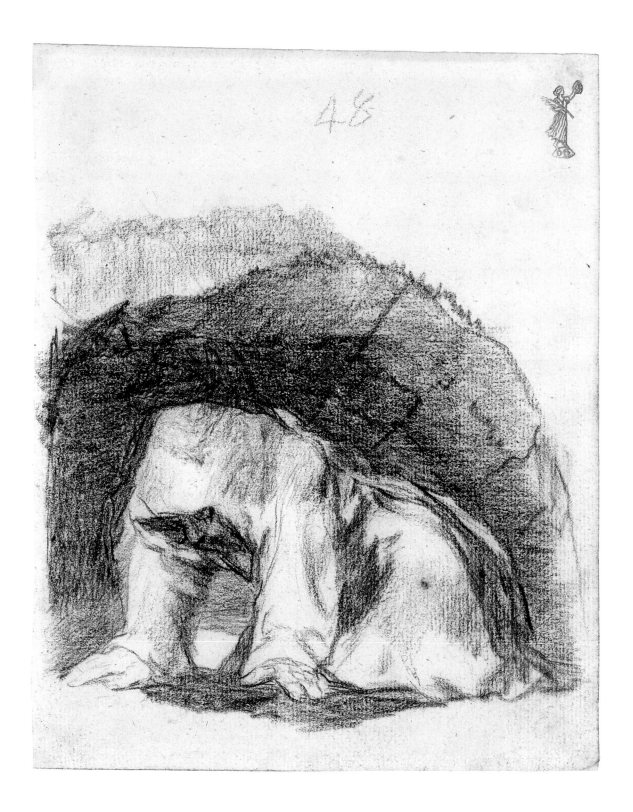

2.

Francisco de Goya. *Penitent Monk* (H.48). Lithographic crayon on
laid paper, 7½ x 5⅞" (19.1 x 15 cm). Inscribed top center: *48*. Stamp
at upper right: L.2785. Inscribed on passe-partout: *2*. Watermark at
center of left edge: GH.I. Inv. no. 131-17967

LITERATURE: Loga 1903, no. 611. Lafond 1907, no. 2, p. 7 (ill.).
Calvert 1908, pl. 569. Gassier/Wilson, no. 1808. Gassier I, no. 462,
p. 644, ill. p. 618. Messerer 1983, p. 149.

The sense of submission so explicitly expressed in
the previous drawing is here associated by Goya
with religious feeling. True, this submission is of a
different kind, for here it is surrender to God, the
humility of repentance. Gassier quite rightly sees in
this a change in Goya's attitude toward religion
during the last years of his life. Suffice it to recall the
monks in *The Caprices,* who had been treated with
sarcasm and biting satire. In the present drawing,
the figure of the monk bent to the ground, his face
barely visible under his hood, seems all meekness
and obedience. Yet even here there is some struggle.
Goya makes powerful use of light and shade, as
though snatching the figure out from under the
weight of the darkness that looms over and sur-
rounds it. A conflict between submission and resis-
tance is suggested simply and clearly through the
contrast between black and white. The anatomically
strange torsion of the body produces an unexpected
but doubtless deliberate feeling of breaking away
from oppression and emerging into the light. The
dark area directly over the bowed head has an almost
palpable solidity and weight, pressing the monk
down toward the earth. The entire figure comprises
a single, compact form whose strength is concentrat-
ed in the pillar-like arms.

The language of Goya's miniature masterpieces
is astonishingly economical and precise. Even a
slight pressure of the soft crayon can provide strik-
ing psychological accents, as with the nearly hidden
face of the monk and its subtly individualized fea-
tures. The face and the hands even in their meekness
also express a certain hidden resistance, a muted
expression of Goya's essential dualism and of the
sense of skepticism that he retained all his life.

# FRANCISCO DE GOYA

## MID-LENT (CUTTING AN OLD WOMAN IN HALF)

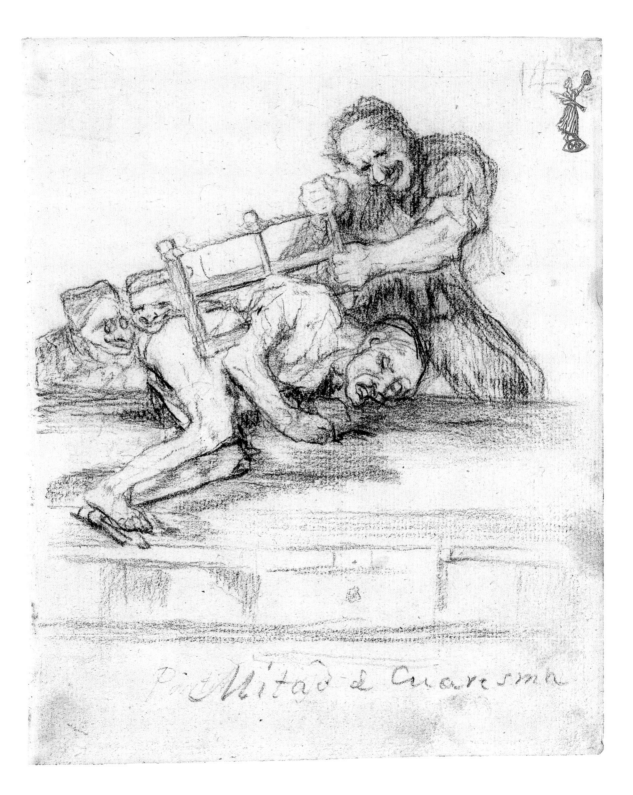

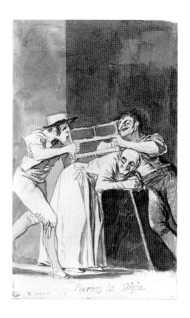

1. Francisco de Goya. *They Are Cutting the Old Woman in Two* (B.60[?]). 1796–97. Musée du Louvre, Paris (RF.6914)

3.

Francisco de Goya. *Mid-Lent (Cutting an Old Woman in Half)* (G.14). Lithographic crayon on laid paper, 7½ x 6" (19.2 x 15.4 cm). Inscribed across bottom: *Mitad de Cuaresma / Partir* [partially legible] *la vieja.* Upper right: *14.* Stamp at upper right: L.2785. Inscribed on passe-partout: *3.* Inv. no. 131-17968

LITERATURE: Loga 1903, no. 611. Bertels 1907, ill. 47. Lafond 1907, no. 3, p. 7 (ill., with the figure identified as a man). Calvert 1908, pl. 548. Mayer 1923, ill. 413. López-Rey 1953, pp. 42–43. Levina 1958, p. 317, ill. p. 322. Gassier/Wilson, no. 1722. Gassier I, no. 375, pp. 502, 556, ill. p. 515. Malraux 1978, ill. 97. Messerer 1983, p. 155.

In comparing this sheet with the related image from the Madrid album (album B) drawn by Goya in 1796–97 (fig. 1; B.60[?]), Gassier pointed to the realism of the subject, since Spain had had a tradition of Lenten performances such as the one shown here. According to José López-Rey, Goya has depicted a kind of presentation that was popular in Andalusia. Gassier adds that Goya had been to the Andalusian city of Cádiz during Carnaval. In the present drawing, however, the heavily detailed naturalism characteristic of late Goya gives this popular scene an ominous conviction.

Though the underlying meanings of his images remain consistent, in different periods of his work Goya did use different artistic forms to express them. An Aesopian language, with submerged levels of significance, or a subtext, was basic to the method and manner of his art. In *The Caprices,* for example, clearly he resorted to providing a "moral," almost as if explaining a code. In his later works, however – and the Bordeaux albums are characteristic examples – the artist does not seek to attach meanings in that way, and instead tries to depict everything precisely the way it appears in life.

The paradox of Goya's genius lies in his ability to allow the moral significance of a thing to infiltrate its actual visual appearance. He thus brings together different levels of perception normally kept separate in daily life. He unites visible appearance with what is invisible – that is, with meaning. This is not a game played by the creative imagination, freely altering appearances. Goya's aesthetic arises not so much from the play of the unfettered imagination as from the quest for a fully integrated vision of the world.

The mimed cutting up of a human body, a symbol of Lenten sacrifices, is "real" for the artist in the sense of representing something genuine about human conduct. An important role is played here, as in many other instances, by Goya's attitude toward Spanish Catholicism and toward its somber, oppressive traditions, which were little lightened even by the popular festivals punctuating the liturgical year. Indeed, the make-believe quality of a holiday spectacle like this one had undoubtedly been undermined by the very real practices of the Inquisition.

# FRANCISCO DE GOYA

**IDIOT**

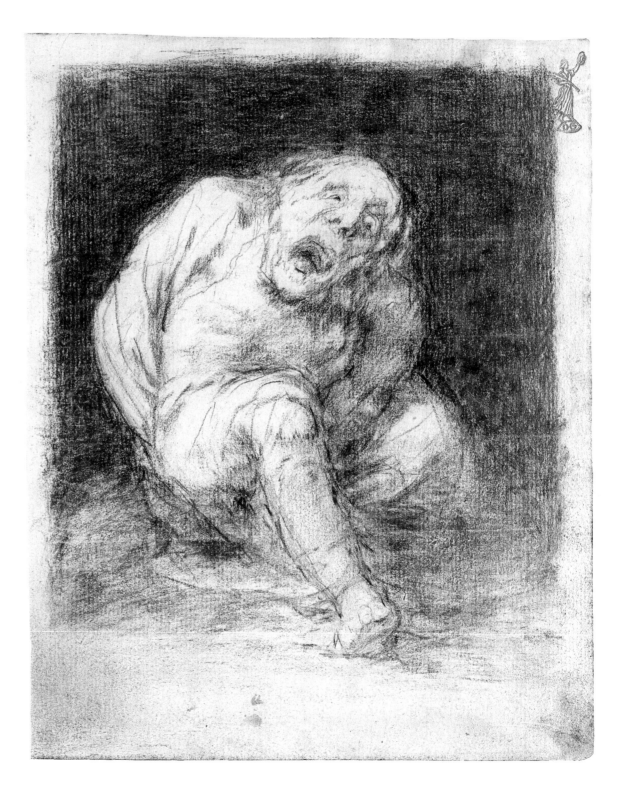

1. Francisco de Goya. *The Mad-house*. c. 1816. Royal Academy of San Fernando, Madrid (672)

4.

Francisco de Goya. *Idiot* (H.60). Lithographic crayon on laid paper, 7½ x 5⅞" (19.1 x 15 cm). Stamp at upper right: L.2785. Inscribed on passe-partout: *4*. Watermark at center of left edge: GH.II. Inv. no. 131-17969

LITERATURE: Loga 1903, no. 611. Lafond 1907, no. 4, p. 7 (ill.). Calvert 1908, pl. 572. Rau 1953, ill. 82. Levina 1958, p. 317. Gassier/ Wilson, no. 1822 (H.b.). Gassier I, no. 472, pp. 503, 504, 646, ill. p. 628 (H.60). Broglie 1973, ill. p. 81. Malraux 1978, p. 17, ill. 102. Bozal 1983, ill. 127. Hölscher 1988, pp. 48, 61, ill. 8.

The subject of the insane first appeared in Goya's work in 1793, in *Yard with Lunatics* (Meadows Museum, Dallas), a year after his first serious crisis. Later, he painted a variation on that composition in a larger format (fig. 1; *The Madhouse,* c. 1816, Royal Academy of San Fernando, Madrid).

At the very beginning of the 1820s, in the Quinta del Sordo, the country house that he had acquired as a refuge from the world, Goya created a series of somber "black paintings" on the walls. Most of these murals convey a sense of horror, and they have been described as constituting a Descent into Hell. Psychologically, their making may seem an act of despair, and yet at the same time it was an act of healing and of liberation from the images that tormented the artist.

The Quinta del Sordo murals (now in the Prado) are a distillation of the worldview that defined Goya's artistic thinking. To a significant extent, the mentality evident in *The Caprices* and *The Disasters of War* was inordinately sensitive to the nightmare quality within reality, the psychosis within common sense. It would be no exaggeration to say that even Goya's most realistic works display a certain degree of this duality – a schizoid vision that sought out the inner contradictions invisible to the normal gaze.

In Bordeaux, Goya made a point of going to visit insane asylums. The resulting drawings, done from life, show the different types of behavior of the

inmates and capture specific psychological states. One of the most dramatic is the present drawing, which in Gassier I is listed as number 60 in album H, making it the last in that album. In the earlier Goya catalogue raisonné (Gassier/Wilson), this work did not have an album sheet number, and was labeled "H.[b]." Gassier assumed that numerals had been inscribed in the dark area in the upper right corner, and were simply not clear enough to be visible in reproductions of the drawing made from an old photographic negative. But in fact, this album sheet was not numbered, and there are no traces of numerals on the actual drawing. Moreover, the drawing is thematically linked with album G, where such subjects are depicted in fifteen sheets (G.17, G.32–G.45), five of them in the Gerstenberg collection (G.33 [erroneously listed by Gassier as G.34], G.36–G.38, G.45). With the exception of the present drawing, there are no portrayals of insane persons in album H. In light of its subject, it would be logical to assume that the present drawing is actually from album G.

With its frontal portrayal of the figure and its discomforting intensity, the drawing is one of the most dramatic of all those depicting the insane. Anguish is forcefully expressed in the mouth, opened to scream, in the unnatural, contorted pose, and in the struggle of the bound arms. Yet were it not for the distracted, unfocused look of the eyes, it might be possible to imagine that this is a fully rational being, undergoing some unbearable pain. The

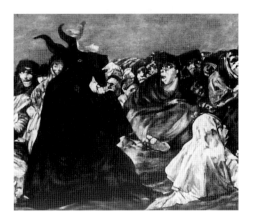

3. Francisco de Goya. *The Witches' Sabbath* (detail). 1820–23. Museo del Prado, Madrid (761)

expressionistic character of the composition – both in the charged dynamics of its forms and in the stark contrast between deep darkness and bright light – seems to anticipate a later era.

One of Goya's ways of suggesting the monstrous is to overemphasize a figure's head, sometimes making it unnaturally large. Such hyperbole occurs frequently in the Bordeaux albums. In this respect, the present drawing also bears a relation to some depictions in the Quinta del Sordo murals, particularly the figure playing the guitar and singing in *The Pilgrimage of San Isidro* of 1820–23 (fig. 2; Museo del Prado, Madrid), and the figures with exaggerated heads, gaping mouths, and bulging eyes in *The Witches' Sabbath* of 1820–23 (fig. 3; Museo del Prado, Madrid). The pilgrim in religious ecstasy, the man frightened to death by the personification of the devil, and the inmate in the present drawing, though they are different in context and intent, do share one important thing – they all cry out, in a state bordering on the irrational. In Bordeaux, Goya also executed some miniatures on ivory that are thematically and stylistically related to the Bordeaux drawings. One of them (see Salas 1979, ill. p. 79) shows the head of a screaming man, a variation of the subject of the present drawing.

2. Francisco de Goya. *The Pilgrimage of San Isidro* (detail). 1820–23. Museo del Prado, Madrid (760)

# FRANCISCO DE GOYA

**PROMENADE**

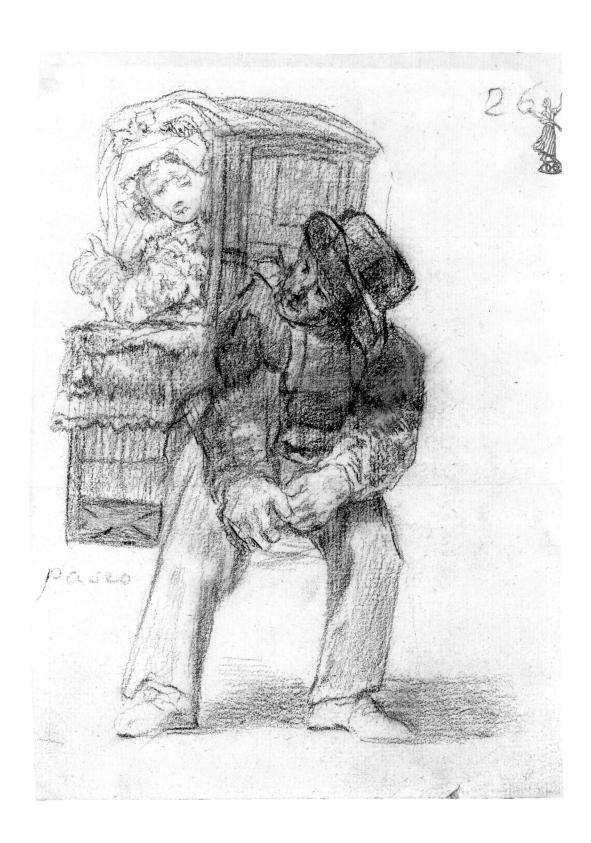

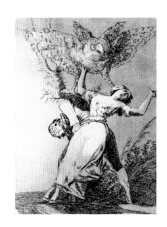

2. Francisco de Goya. *Is There No One to Untie Us?* 1797–98. *The Caprices,* no. 74. The Hispanic Society of America, New York

1. Francisco de Goya. *New Stagecoaches or Shoulder Chairs (To the Theater)* (G.24). 1824–28. Museum of Fine Arts, Boston. Arthur T. Cabot Fund (53.2376)

5.

Francisco de Goya. *Promenade* (G.26). Lithographic crayon on laid paper, 7½ x 5⅜" (19.2 x 13.8 cm). Inscribed at left: *paseo*. Upper right: *26*. Stamp at upper right: L.2785. Inscribed on passe-partout: *5*. Watermark at center of left edge: GH.I. Inv. no. 131-17970
LITERATURE: Loga 1903, no. 611. Lafond 1907, no. 5, p. 7 (ill.). Calvert 1908, pl. 529. Brieger-Wasservogel n.d., p. 30 (ill.). Nemitz 1940, ill. p. 24. Stoll 1954, p. 28, ill. 48. Gassier/Wilson, no. 1732. Gassier I, no. 385, pp. 502, 564, ill. p. 525. Flekel 1974, p. 185.

The drawing, as Gassier notes, depicts a kind of conveyance that Goya saw both in Bordeaux and in Paris. Several sheets from Bordeaux are devoted to portraying strange or unusual means of locomotion – a toy horse (G.10), a wheelbarrow (G.25), a tiny carriage drawn by a dog (G.31). Somewhat earlier (C.35), Goya had depicted an invalid suffering from elephantiasis who was using a small cart. The artist apparently was particularly interested in these simple, homemade devices. On the drawing of the dog-cart he wrote "I saw it in Paris," thus emphasizing the actuality of this strange sight, unexpected in a cosmopolitan capital. *New Stagecoaches or Shoulder Chairs (To the Theater)* (fig. 1; G.24), like the present drawing, shows a means of personal conveyance whose use had been revived at the beginning of the nineteenth century. Gassier links the inscription written on the chair, "To the theater," with Goya's residence in 1824 in Paris on rue Marivaux, just opposite the Opéra Comique. Another sheet, inscribed "Beggars who get about on their own in Bordeaux" (G.29), shows a wheelchair (with a rear caster) apparently constructed by its user. All of these sketches from life have an artistic force that distinguishes them from ordinary slice-of-life genre scenes.

In addition to the shoulder-chair, the present drawing has a further subject: the relations between

3. Francisco de Goya. *Bad Hus-band* (G.13). 1824–28. Museo del Prado, Madrid

men and women, a major concern in Goya's art. With their faces turned toward each other, but only their backs touching, this strange couple – one the bearer and the other the burden – seems to represent the essence of an unhappy marital situation, in which the authority of one spouse and the obedience of the other combine to form the paradox of an incompatible, but indissoluble, union.

Goya's treatments of this subject range from fable to gloomy caricature. In *Is There No One to Untie Us?* (fig. 2; *The Caprices,* no. 74), the element of fable is explicit, as we are presented with an image of the bondage of family life – the ropes tieing the man and woman together; the bare tree, emblem of the sterility of such relations; and the bespeckled owl, suggesting the malign nature of the laws to which human feelings are subjected. The marital moral-izing of *Bad Husband* (fig. 3; G.13) is even more bla-tant. Most disturbing of all, perhaps, is *Disorderly Folly* (fig. 4; *The Follies,* no. 4), which shows a "couple" transformed into the grotesquerie of a single, composite body.

4. Francisco de Goya. *Disorderly Folly.* c. 1815–24. *The Follies,* no. 4. Department of Prints and Drawings, The British Museum, London

# FRANCISCO DE GOYA

**GENEROSITY VERSUS GREED**

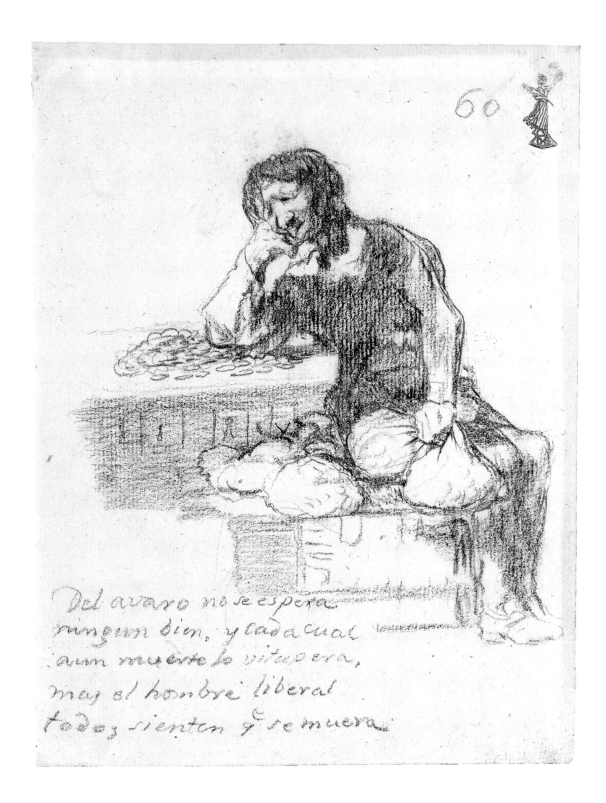

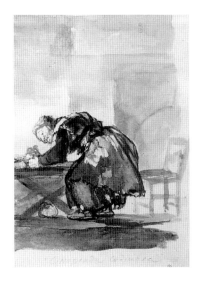

6.

Francisco de Goya. *Generosity versus Greed* (G.60). Lithographic
crayon on laid paper, 7½ x 5¾" (19.2 x 14.5 cm). Inscribed lower
left: *Del avaro no se espera/ningun bien, y cada cual/aun muerto lo
vitupera,/mas el hombre liberal/todos sienten q.ᵉ se muera* ("One can
expect no good from a miser, and even after his death everyone
speaks ill of him, though everyone regrets the death of a generous
man"). Upper right: *60.* Stamp at upper right: L.2785. Inscribed on
passe-partout: 6. Watermark at center of right edge: GH.III. Inv.
no. 131-17971

LITERATURE: Lafond 1907, no. 6, p. 7 (ill.). Calvert 1908, pl. 532.
Rau 1953, ill. 316. Gassier/Wilson, no. 1764. Gassier I, no. 416,
p. 572, ill. p. 556. Held 1980, p. 139 (ill.).

Although it bears a lengthy inscription contrasting
greed with generosity, the present drawing, which is
rather blunt and didactic, confines itself to depicting
greed alone. The inscription is related to folk song
and folk poetry. This text also plays an important role
in the composition and graphic language of the sheet.

The drawing shows the degraded state of a man
who has fulfilled his greatest dream, that of possess-
ing quantities of gold. Given the dejected expression
on his face and his deflated posture, however, one
might almost have taken him for a pauper, and it is
only the coins scattered before him that tell us other-
wise. Indeed, the unopened bags of gold might have
been mistaken for the meager baggage of a vagrant.
Goya's drawing suggests a paradox: The quest for
riches ends in moral impoverishment. In a drawing
made somewhat earlier, *Be Quiet: Time Changes the
Hours* (C.61), Goya had depicted an old woman, lean-
ing her elbow on a tombstone, in almost the same
pose and with the same sadness in her face. The cir-
cumstances of the drama are different, but the result
is the same: Time inexorably deprives us of all we
have. The compositional kinship of these two works

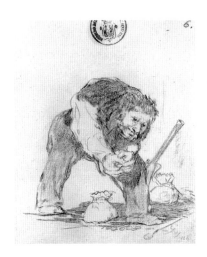

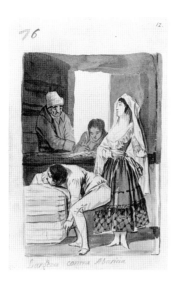

3. Francisco de Goya. *Generosity versus Greed* (B.76). 1796–97. The Metropolitan Museum of Art, New York. Harris Brisbane Dick Fund, 1935 (35.103.12)

thus is not accidental. Goya seems to have deliberately quoted himself.

Goya tended to associate the inordinate desire for wealth with physical ugliness, and in this he does not diverge from the folk tradition of popular prints. In *Worn Out with Greed* (fig. 1; C.56), the artist showed the bent form of an old woman, avidly handling her purses. Another hunched individual looks with unseemly glee at a promising plot of ground in *The Hidden Treasure* (fig. 2; H.6). A grimacing old man gazes at a pile of gold, indifferent to the presence of a beautiful woman (whom the title leads us to associate with altruism), in *Generosity versus Greed* (fig. 3; B.76). That sheet, produced in 1796–97, was the first to interpret this subject in Goya's art, and the present sheet from the Gerstenberg collection was titled after it. *Why Hide Them?* (fig. 4; *The Caprices,* no. 30) had then continued the mockery of avarice, as a group of laughing people surrounds a quaking miser, whose twisted fingers grasp coin-filled bags. Goya's moral follows: "The answer is very simple: the reason he does not want to spend them is that, although he is over eighty years old and has no more than a month left to live, he is still afraid that he won't have enough money to get by on. So mistaken are the calculations of greed."

4. Francisco de Goya. *Why Hide Them?* 1797–98. *The Caprices,* no. 30. The Hispanic Society of America, New York

# FRANCISCO DE **GOYA**

## LOOKING AT WHAT THEY CAN'T SEE

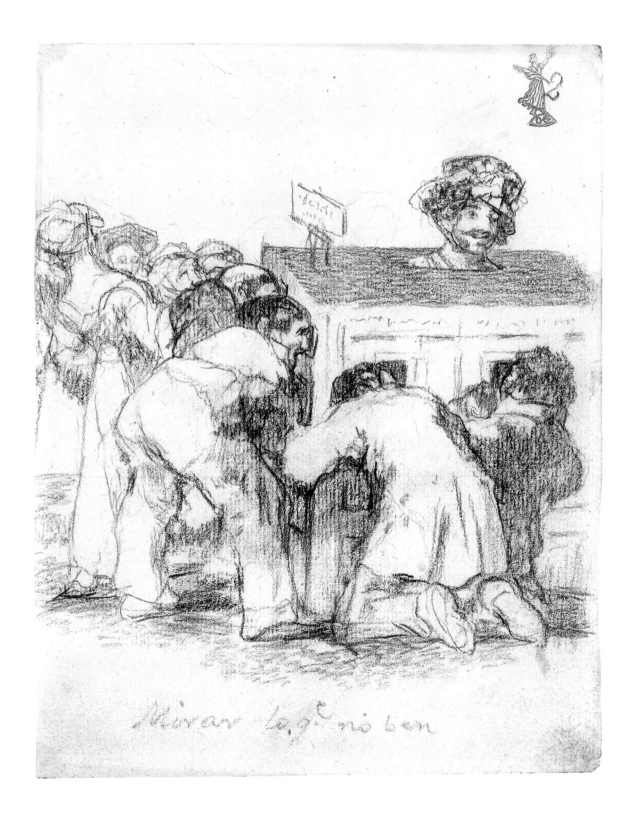

During the period 1760–1800, theatrical entertainment in Spain was not so much an art form as an aspect of social life, encompassing the tastes of the aristocracy and the masses alike. Outside the province of the theater proper, a range of popular spectacles could be seen, from bullfights to the centuries-old public displays related to the Inquisition. A society forced to live with invasion and civil war sought diversion in shows incorporating the too-familiar elements of fear and horror. These entertainments combined the seemingly incompatible qualities of naïve credulity and self-conscious irony.

These complementary elements of popular entertainment were brilliantly reflected in Goya's art. Two drawings – the present work from the Gerstenberg collection and another, earlier sheet, *All the World* (fig. 1; C.71) – specifically point to these features. The two are closely related variations on the same subject. With considerable psychological insight, the Gerstenberg drawing presents a semi-comic scene of people looking into a peep show. The milling crowd of different types, ranging from a monk to a young girl, is drawn by curiosity, and all of them unwittingly become actors in the scene. Goya seems to be satirizing the human weakness for

wanting to see what is hidden. The search for the secret meaning of things often takes a comic turn.

This comic element, reduced to a vulgar vaudeville joke, also appears in *All the World*. The curiosity of this bumpkin, captivated by the imaginary sights within the *tutilimundi* (or "all the world," the Spanish term for a peep show), is akin to the shameless curiosity of the smiling young woman staring at his exposed buttocks. Thus the quest for "all the world" is reduced to farce. One person pays in hopes of penetrating into the unknown, while his futile attempt provides another with voyeuristic pleasure at no expense. Such is the theater of life.

Popular theatrical performances also had fierce opponents. The "Memorandum on the Regulation of Spectacles and Public Entertainments," which was delivered at a meeting of the Royal Academy of History in 1796 by Goya's friend Caspar Melchor de Jovellanos, the famous Spanish educator and politician, contained harsh criticism of such performances. Those "enlightened" public figures who, like Goya, favored the eradication of medieval ways of thinking did not see that these popular amusements, in their traditions and comic origins, went back to the deepest roots of popular culture.

7.

Francisco de Goya. *Looking at What They Can't See* (G.2). Lithographic crayon on laid paper, 7½ x 5⅞" (19.2 x 14.9 cm). Inscribed bottom center: *Mirar lo q.ᵉ no ben*. Stamp at upper right: L.2785. Inscribed on passe-partout: 7. Watermark at center of left edge: GH.II. Inv. no. 131-17972

LITERATURE: Lafond 1907, no. 7, p. 8 (ill.). Calvert 1908, pl. 571. Mayer 1923, ill. 406. Mayer 1932–33, p. 384. Nemitz 1940, ill. p. 31. Gassier/Wilson, no. 1712. Gassier I, no. 366, pp. 502, 559, ill. p. 506. Bozal 1983, p. 287, ill. 117. Gassier 1983, p. 308.

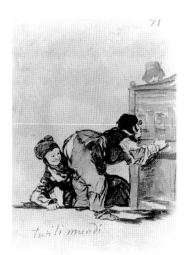

1. Francisco de Goya. *All the World* (C.71). 1803–24. The Hispanic Society of America, New York (A.3314)

# FRANCISCO DE GOYA

## TWO WOMEN IN CHURCH (?)

8.

Francisco de Goya. *Two Women in Church* (?) (H.62). Lithographic crayon on laid paper, 7½ x 6" (19.1 x 15.4 cm). Inscribed upper right: *62.* Stamp at upper right: L.2785. Inscribed on passe-partout: *8.* Watermark at center of left edge: GH.I. Inv. no. 131-17973

LITERATURE: Carderera 1860, p. 227. Lafond, no. 8, p. 8 (ill.). Calvert 1908, pl. 547. Gudiol 1970, vol. 1, p. 401, no. 1.288; vol. 4, ill. p. 1018. Gassier/Wilson, no. 1819. Gassier I, no. 474, pp. 500, 502, 647, ill. p. 630.

The title of this drawing was not assigned by the artist. The title and the identification of the subject come from Valentín Carderera, who, Gassier assumes, could have seen the sheet at the residence of one of its owners, Federico de Madrazo. In an 1860 article in the *Gazette des Beaux-Arts* devoted to Goya's drawings, Carderera noted a sheet depicting "two French ladies at mass," his personal impression of the subject. In Gassier/Wilson, the title *Two Women in Church* is therefore given, but with a question mark. Subsequently, in Gassier I, the question mark is dropped, and it is noted that the drawing could have been done from life, a literal portrayal of a scene the artist had observed in France, or perhaps was anecdotal. Gudiol, in his extensive monograph and catalogue, simply avoids interpreting the subject and limits himself to a descriptive title, *Two Women Kneeling*.

Gudiol's reticence has its logic, for several aspects of the image imply a setting other than the interior of a church. To begin with, the chair standing behind the figure to the right, on which a cloak is carelessly tossed, does not greatly resemble the kind of seating to be found in a church, which would ordinarily have a kneeling stand attached to it. Moreover, only one of the women is in fact kneeling. The other, older figure, on the left, is sitting on a second chair, the high back of which is just visible toward the right. In addition, in the background can be discerned the faint outline of a bending female figure;

the fact that the head of this third woman is uncovered also raises some question about whether the setting is actually a church. The pose of the third figure, who was undoubtedly created by the artist, suggests that she is engaged in some kind of domestic chore, a further hint of a different setting for the scene and, indeed, a different situation. The kneeling young woman might, for instance, be interpreted as humbly listening to the advice of the seated older woman, whose head is turned confidingly toward her. The small books in the women's hands, which may seem to resemble the missals the two would use in church, could as easily be books of almost any kind, including the sentimental novels that were fashionable in the 1820s. It should perhaps be recalled that while living in Bordeaux and gathering material for his projected *New Caprices,* which he planned to execute using the new lithographic technique, Goya is known to have eagerly visited public places of all kinds, ranging from churches to insane asylums.

Doubts regarding the title traditionally assigned to this drawing and alternate hypotheses about the setting of the scene lead one to inquire more closely into the meaning of the picture. This drawing is linked to a recurring theme in Goya's work, and its sources are to be found in *The Caprices* and in the preliminary drawings for those famous works. Lafond, in comparing this drawing with no. 15 of *The Caprices,* titled *Fine Advice* (fig. 1; preliminary drawing, Gassier II, no. 77), had noted that this scene

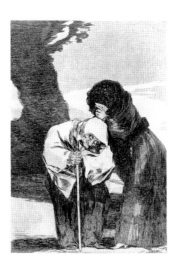

2. Francisco de Goya. *Hush.* 1797–98. *The Caprices,* no. 28. The Hispanic Society of America, New York

can be interpreted more broadly. Though a young woman accompanied by a duenna was a common sight in Spanish daily life, Goya's art often gave this mundane motif the kind of subtext that suggested a wider range of meaning. Thus, the furtive whisper of the older woman seen next to a younger one in *Fine Advice* is poison for the young woman's soul. Typically for *The Caprices,* the title *Fine Advice* is sarcastic, as the caption makes plain: "Advice is worthy of her who gives it. The worst of it is that the girl will follow it absolutely to the letter. Unhappy the man who gets anywhere near her." Number 28 of *The Caprices,* titled *Hush* (fig. 2; preliminary drawing, Gassier II, no. 87), gives another illustration of this "good advice": A twisted old woman, supported only by a cane, is in turn a support for the young woman who naïvely trusts her. And in *They Say Yes* (*The Caprices,* no. 2; preliminary drawing unknown), the duenna of a bride is given the form of a she-devil. In Goya's work, the duenna is sinister, since the betraying of confidences and the manipulation of people's fates link her with evil. In *They Have Flown* (fig. 3; *The Caprices,* no. 61; preliminary drawing, Gassier II, no. 117), a woman newly converted to evil floats aloft on the backs of the devil's consorts; the caption ironically comments: "The fancy lady doesn't in the least need this bunch of witches who serve her as a pedestal – they're just for decoration. Such as she have so much burning gas in their heads that they can soar up into the air without the aid of witches or balloons."

In drawings B.4, B.6, and B.69 from the Madrid album, created in 1796–97, at about the time of *The*

*Caprices,* the duenna also has an influential role to play in the conduct of a young woman. The duenna is ever present, even in intimate scenes, as the life of the young woman becomes the common property of gossips. While in a sense continuing the artistic tradition of contrasting youth and age, Goya raises it to the level of a moral problem. The deterioration of the body in old age acts as a kind of metaphor of the corruption of the soul, pointing to the inevitable corruption of innocent youth.

This subject appears with the same ironic aspect in Goya's paintings such as *Maja and Celestina* of 1808 (March collection, Palma de Mallorca) and in a miniature on ivory with the same title from 1824–25 (formerly collection Sir Kenneth Clark, London), done in the same period as the present drawing, *Two Women in Church.* Such examples confirm the artist's consistent interest in the subject over the course of time, but there is a change in attitude, from sarcasm to irony and from irony to a kind of humor. Naturally, the drawing from the Gerstenberg collection does not have the satirical bite so evident in *The Caprices.* But its implications can be glimpsed in the ambiguous smile of the young woman.

The hortatory and moralizing nature of this subject in Goya's art is obvious. It is no wonder the artist used texts by Jovellanos in his captions to *The Caprices.* Goya, however, presented a broad range of variations on the subject, from genre scenes to symbolic compositions reflecting philosophical problems.

3. Francisco de Goya. *They Have Flown.* 1797–98. *The Caprices,* no. 61. The Hispanic Society of America, New York

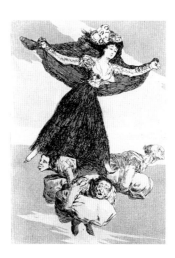

# FRANCISCO DE GOYA

**HE'S SAYING HIS PRAYERS**

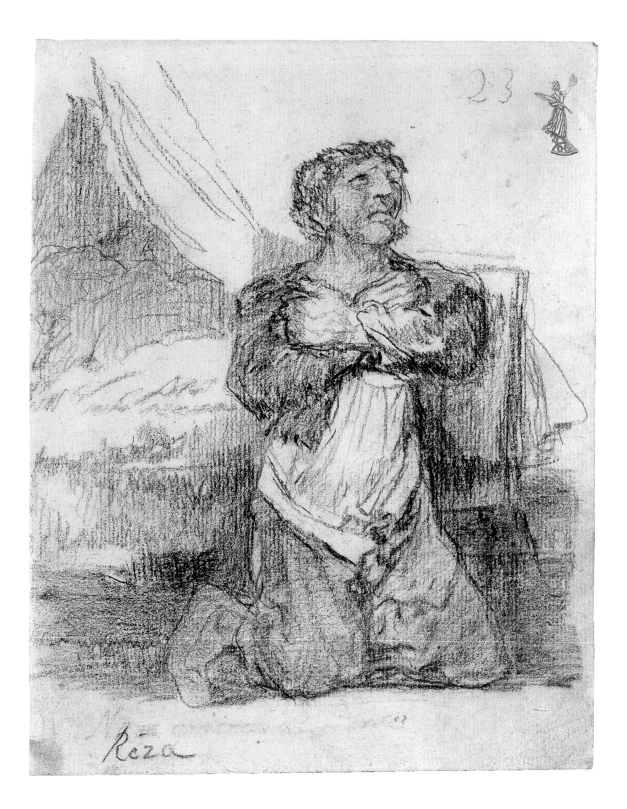

Album G includes two sheets on related themes: the present Gerstenberg drawing, *He's Saying His Prayers;* and a drawing that the artist titled *Weeping and Wailing* (fig. 1; G.50), which is similar to it in composition and in figure type. The same general sort of individual is depicted in both drawings, in each case making an appeal to a higher power. The settings, however, are very different: The man in the Gerstenberg drawing is simply saying his nightly prayers before going to sleep, and the commonplace details of the domestic setting are carefully delineated by the artist; the figure in *Weeping and Wailing,* however, kneels before a blank stone wall, which creates a sense of hopelessness. The implications of the poses, too, are very different: The arms crossed on the chest in *He's Saying His Prayers* suggest a personal, intimate communication, expressing the concerns of a sole individual, while the open gesture of the arms flung wide in *Weeping and Wailing* seems all-encompassing, a desperate entreaty on behalf of suffering humanity. Such broad gestures of entreaty are most forcefully expressed in Goya's art by *Christ on the Mount of Olives* of c. 1819 (fig. 2; Chapel of the Escuelas Pias de San Antón, Madrid), at one extreme, and, at the other, by the central figure in *The Third of May, 1808* of 1814 (fig. 3; Museo del Prado, Madrid).

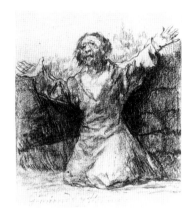

1. Francisco de Goya. *Weeping and Wailing* (G.50). 1824–28. Collection Mrs. Joy Sen Gupta, Calcutta

9.

Francisco de Goya. *He's Saying His Prayers* (G.23). Lithographic crayon on laid paper, 7⅝ x 5⅞" (19.4 x 14.9 cm). Inscribed lower left: *Reza.* Above this, partially legible: *No [. . .] grat[z?]ia a [San . . . ].* Inscribed upper right: *23.* Stamp at upper right: L.2785. Inscribed on passe-partout: 9. Inv. no. 131-17974

LITERATURE: Loga 1903, no. 611. Lafond 1907, no. 9, p. 8 (ill.). Calvert 1908, pl. 574. Gassier/Wilson, no. 1729. Gassier I, no. 382, pp. 504, 563, ill. p. 522.

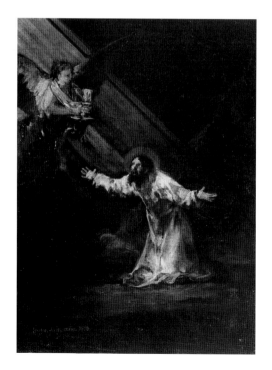

2. Francisco de Goya. *Christ on the Mount of Olives.* c. 1819. Escuelas Pias de San Antón, Madrid

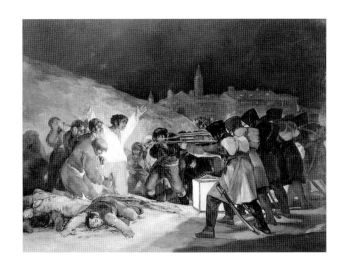

3. Francisco de Goya. *The Third of May, 1808*. 1814. Museo del Prado, Madrid (749)

Goya dealt with the theme of prayer virtually throughout his oeuvre, depicting it in a number of rather traditional compositions: *Saint Isidore, Patron of Madrid* of c. 1775–78 (drawing, Gassier II, no. 23; etching, Gassier/Wilson, no. 53), *Saint Francis of Paula* of c. 1775–80 (drawing, Gassier II, no. 24; etching and drypoint, Gassier/Wilson, no. 55), and the paintings *Saint Lutgarda* of 1787 (Gassier/Wilson, no. 239), *Saint Ambrose* of c. 1796–99 (Gassier/Wilson, no. 713), and *Saint Augustine* of 1796–99 (Gassier/Wilson, no. 714). But it should also be remembered that a kneeling figure, bowed in supplication, opens the cycle *The Disasters of War,* clearly demonstrating the significance that Goya attached to these deeply human acts of prayer and entreaty, linked to the historical upheavals in Spain. The frontispiece of the *Disasters* is titled *Sad Presentiments of What Must Come to Pass* (fig. 4; etching, Gassier/Wilson, no. 993; preliminary drawing, Gassier II, no. 167). As Gassier correctly notes, through the image of this praying figure Goya conveyed all the unjust sufferings of humankind.

In terms of composition, the painting closest to the Gerstenberg drawing is *The Repentant St. Peter* of c. 1820–24 (fig. 5; The Phillips Collection, Washington, D.C.), done shortly before the move to Bordeaux. The prayers of an ordinary individual and those of a founder of the Christian church were, for Goya, essentially similar phenomena.

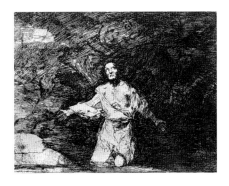

4. Francisco de Goya. *Sad Presentiments of What Must Come to Pass*. c. 1814–20. *The Disasters of War,* no. 1. The Hispanic Society of America, New York

5. Francisco de Goya. *The Repentant St. Peter*. c. 1820–24. The Phillips Collection, Washington, D.C. Acquired 1936

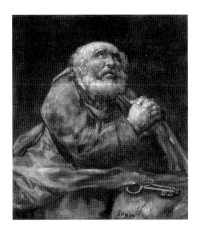

# FRANCISCO DE GOYA

## THE BROKEN POT

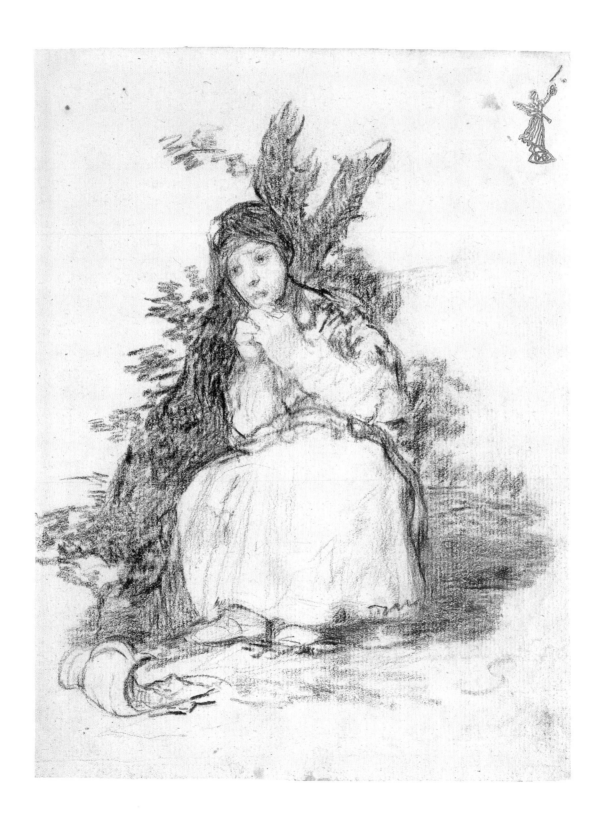

1. Jean-Baptiste Greuze. *The Broken Pot*. 1793. Musée du Louvre, Paris

10.

Francisco de Goya. *The Broken Pot* (H.1). Lithographic crayon on laid paper, 7½ x 5⅝" (19 x 14.2 cm). Signed lower right (partially legible): *Goya*. Inscribed upper right: *1*. Stamp at upper right: L.2785. Inscribed on passe-partout: *10*. Inv. no. 131-17975

LITERATURE: Loga 1903, no. 611, ill. 75 (right); Lafond 1907, no. 10, p. 8 (ill.). Calvert 1908, pl. 565. Levina 1958, pp. 317, 342, ill. p. 321. Gassier/Wilson, no. 1821 H.[a]). Gassier I, no. 476, p. 648, ill. p. 632. Sedova 1973, ill. 187. Flekel 1974, pp. 179, 185.

None of those who have written about this drawing have been aware of the number 1 inscribed in the upper right corner. The number is completely hidden by the mounting. The fact that the number has not been visible in any previous reproduction indicates that the mounting was done before the sheet was first photographed for publication (i.e., prior to Lafond 1907), and thus well before it entered the Gerstenberg collection. This is presumably true of the mounting of all the other drawings as well.

The appearance of this number would seem to solve a problem in the cataloguing of Goya's drawings. Album H has previously been listed as beginning with sheet H.2, lacking a number H.1. At the same time, since the number 1 on the present sheet was not visible, this Gerstenberg drawing was assigned the tentative designation "H.[a]" in the catalogue raisonné (Gassier/Wilson) and in the catalogue of Goya's drawing albums (Gassier I). But since, as Gassier notes, all the drawings in album H that bear a signature appear before sheet H.40 in the artist's numbering, the present drawing, which is signed, would presumably have appeared before that number. This fact, when considered along with the number 1 long hidden under the mounting, provides a further convincing reason for returning this sheet to its proper place as the first of Goya's drawings in album H.

Gassier sees the subject of the drawing as an obvious borrowing from Greuze's famous composition *The Broken Pot* of 1793 (fig. 1; Musée du Louvre, Paris), which to a certain extent illustrates the proverb "The pot goes to the water so often that it finally breaks" ("Tant va la cruche à l'eau qu'à la fin elle se casse"). One should recall, however, that the motifs of broken pots and dead birds in Greuze's art were not as straightforward as they may seem, and were in fact allegories for the loss of virginity. Sentimental French literature and painting of the eighteenth century veiled eroticism with modest

2. Francisco de Goya. *The Milk-maid of Bordeaux*. 1825–27. Museo del Prado, Madrid (2899)

3. Francisco de Goya. *Woman Reading*. 1819 or 1825. Biblioteca Nacional, Madrid (45624)

pastoral motifs, creating a kind of code that was easily understood by contemporaries. Despite the thematic affinity between Goya's drawing and the work of the French master, a direct link seems unlikely. Goya was raised in a different system of values, evident in a folk culture that traditionally combined frenzied, ecstatic religiosity with a direct physicality.

In interpreting this drawing of a woman with a broken pot, the view of the Russian Goya scholar I. Levina (1958) seems more persuasive. Levina identified the literary source of the drawing as one of the fables by an important figure in fourteenth-century Spanish literature, Don Juan Manuel, from his *El Libro del conde Lucanor,* called "On What Happened to a Woman Who Went to Market to Sell a Pot of Honey." The tale of a poor woman who set off for the city market to sell a honey pot – intending to buy eggs, then raise chickens, sell them, buy a pig, and so on, until she would become rich – was common in both European literature (such as La Fontaine's fables) and folklore, and generally had a simple moral. The fable of Juan Manuel laid heavy stress on the edifying aspects of this story, which are fully in keeping with the present Goya drawing.

It may be that this drawing of a woman was also bound up with Goya's personal life in Bordeaux. After suffering a number of illnesses and experiencing some dramatic episodes in a difficult life, in Bordeaux Goya lived among people dear to him. His Spanish and French friends were nearby, and Leocadia Weiss came to live with him, accompanied by her son Guillermo and her young daughter Maria Rosario; Goya doted on the little girl and taught her to draw. In this final period, Goya created a number of remarkable female faces somewhat softened in tone, notably *The Milkmaid of Bordeaux* of 1825–27 (fig. 2; Museo del Prado, Madrid). The earlier lithograph *Woman Reading* of 1819 or 1825 (fig. 3; Gassier/Wilson, no. 1699) shows the same type of young woman; although the motifs of the two works are different, they share a lyrical, peaceful mood.

# FRANCISCO DE GOYA

**WOMAN HELPING A SICK PERSON TO DRINK**

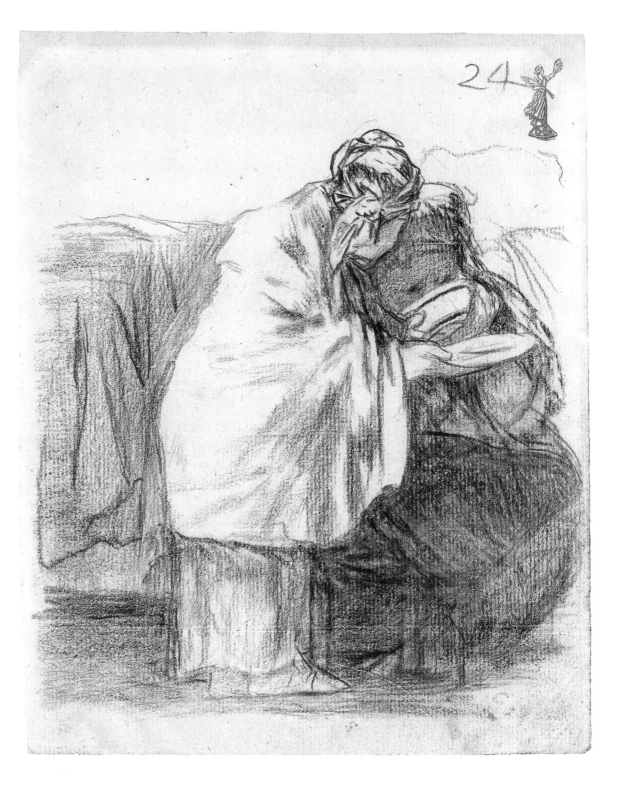

II.

Francisco de Goya. *Woman Helping a Sick Person to Drink* (H.24).
Lithographic crayon on laid paper, 7½ x 5⅞" (19.1 x 15 cm). Signed
lower right (partially legible): *Goya.* Inscribed upper right: *24.*
Stamp at upper right: L.2785. Inscribed on passe-partout: *11.*
Watermark at center of left edge: GH.I. Inv. no. 131-17976
LITERATURE: Loga 1903, no. 611. Lafond 1907, no. 11, p. 8 (ill.).
Calvert 1908, pl. 541. Gassier/Wilson, no. 1787. Gassier I, no. 441,
p. 639, ill. p. 597.

1. Francisco de Goya. *Peasant Carrying a Woman* (F.72). 1812–23. The Hispanic Society of America, New York (A.3315)

2. Francisco de Goya. *Woman Handing a Mug to an Old Man* (F.93). 1812–23. The Metropolitan Museum of Art, New York. Harris Brisbane Dick Fund, 1935 (35.103.48)

In album H there are several drawings notable for sentiment: One of these is the previous drawing, *The Broken Pot* (plate 10; H.1). Two others, *Woman with Two Children* (H.43) and *Woman with a Child on Her Lap* (plate 30; H.49), feature a homey domesticity that is remarkable for its atmosphere of nurturing protectiveness. These are qualities that are particularly treasured during the declining years of life.

In the midst of other sheets that often depict violence, insanity, and imprisonment, along with oddities of various kinds, the intimate lyricism of these drawings strikes a particularly expressive note. In the present drawing, *Woman Helping a Sick Person to Drink,* the two figures almost comprise a single form. Their contours are continuous, with little more than the contrast of light and dark to distinguish between the two individuals; the ministering figure stands in light, while the invalid lies in shadow. From this, Goya masterfully builds a composition that highlights the accurately depicted gesture of help, which is as strikingly placed and as emotionally telling as the light itself. The gestures of the hands, giving and accepting, enact one of the central rituals in human relations: Charity – in its literal sense of Christian love, or *caritas* – repeats the deed of the Good Samaritan.

Certain drawings from album F, done in the previous decade, offer rare but all the more valuable instances of charity: *Peasant Carrying a Woman* (fig. 1; F.72) and especially *Woman Handing a Mug to an Old Man* (fig. 2; F.93). In the latter drawing, as in the Gerstenberg sheet, a life-giving drink is offered to someone in physical distress and racked by thirst. Also somewhat similar is the painting *Self-Portrait with Dr. Arrieta* of 1820 (fig. 3; The Minneapolis Institute of Arts), showing the artist gravely ill and leaning back against his physician. Here, a cup of water from a friendly hand becomes a symbol not only of compassion but of healing as well. Goya painted this canvas in gratitude after his recovery, paying homage to his doctor in an inscription at the bottom.

3. Francisco de Goya. *Self-Portrait with Dr. Arrieta.* 1820. The Minneapolis Institute of Arts. Ethel Morrison Vanderlip Fund (52.14)

# FRANCISCO DE GOYA

**AFRICAN LUNATIC**

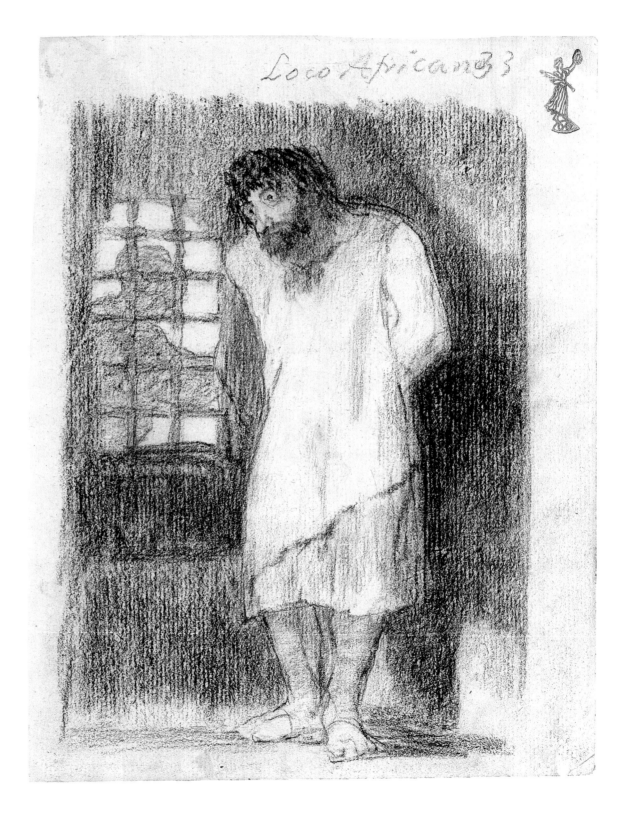

The authors who have discussed the technique of this drawing have not as a rule noted its use of sanguine. This is understandable, since some of the early researchers into Goya's work – Loga, Lafond, and Calvert – had described the techniques of the two Bordeaux albums only in a general way, dealing with the albums as a whole, while later scholars had only limited photographic documentation of the Gerstenberg drawings. In this drawing, the artist used sanguine to depict the color of the figure's skin.

There has been some confusion among scholars about the numbering of the sheet; this is because the right edge of the passe-partout once covered the second numeral in the inscribed *"33,"* and presumably did so when the drawing was first photographed for reproduction, prior to Gerstenberg's acquisition of it. Only now are the full sheets of the Gerstenberg drawings from the two albums finally being reproduced. The catalogue raisonné (Gassier/Wilson) and the catalogue of the drawing albums (Gassier I) therefore erroneously assigned no. 34 to the present drawing. Compounding the problem, Gassier gave the tentative number *"3[3]"* in the catalogue raisonné and *"3(3)?"* in the catalogue of albums to another often reproduced sheet from the same album G, titled *Raging Lunatic* (fig. 1).

These two drawings of the insane form a contrasting pair, showing the subjects' differing behavior in confinement. Placed in the same situation, one individual reacts with furious agitation, making a

1. Francisco de Goya. *Raging Lunatic* (G.3[3]?). 1824–28. Woodner Collection, on loan to the National Gallery of Art, Washington, D.C.

futile attempt to break free, while the other meekly submits, retreating within himself. Levina (1958) assumed that *African Lunatic* was part of Goya's series of prisoners. There is some logic to this, since these subjects are indeed to a certain extent linked. Yet there is an important difference. Even in the harshest prison there is some hope of one day breathing free, but the inner darkness of the disturbed mind can seem truly inescapable.

The catalogue of the important Goya exhibition in Madrid, Boston, and New York (Pérez Sánchez/Sayre 1989, no. 168, pp. 375, 376) cites the interest in mental illness shown by the Spanish émigrés who were Goya's friends in Bordeaux. Their interest was to a great extent inspired by French psychological studies, notably the *Traité de la folie (Treatise on Madness)* published by the Parisian psychiatrist E. J. Georget in 1819. Scientific works on psychology were at times clearly reflected in art, the ten portraits of mentally ill persons painted by Théodore Géricault, a friend of Georget's, being especially well known. Goya's concern with mental anomalies was more personal, however, coinciding with his own illness and his need to consult doctors, primarily French ones, conversant with the latest medical research.

12.

Francisco de Goya. *African Lunatic* (G.33 [34]). Lithographic crayon and sanguine on laid paper, 7½ x 5⅞" (19.2 x 14.8 cm). Inscribed upper right: *Loco Africano 33*. Stamp at upper right: L.2785. Inscribed on passe-partout: *12*. Watermark at center of left edge: GH.I. Inv. no. 131-17977

LITERATURE: Loga 1903, no. 611, ill. 74 (right). Lafond 1907, no. 12, p. 9 (ill.). Calvert 1908, pl. 531. López-Rey 1956, pp. 143, 156, pl. 122. Levina 1958, p. 318, ill. p. 323. Gassier/Wilson, no. 1739 (as G.34). Gassier I, no. 392, pp. 504, 565, ill. p. 532. Bozal 1983, p. 290.

# FRANCISCO DE GOYA

## LUNATIC FROM THE CALLE MAYOR

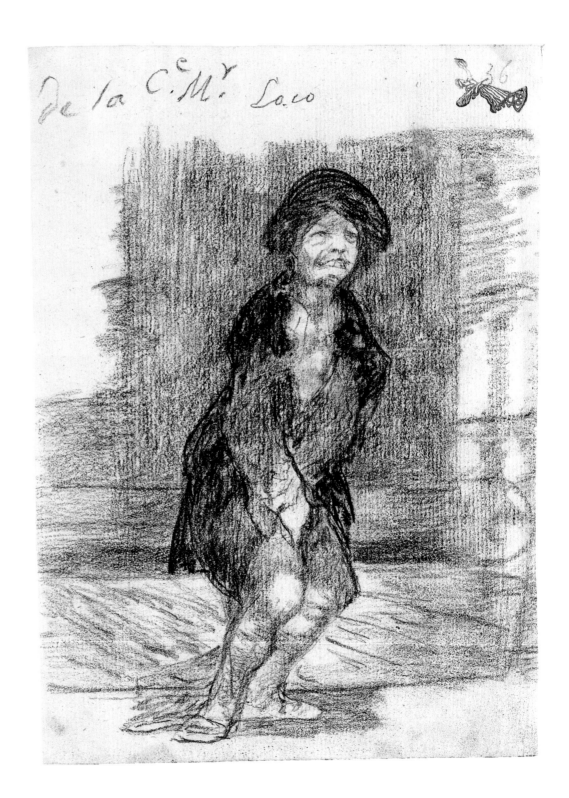

13.

Francisco de Goya. *Lunatic from the Calle Mayor* (G.36). Litho-graphic crayon on laid paper, 7⅝ x 5⅜" (19.3 x 13.5 cm). Inscribed upper left: *de la C.ᵉ M.ʳ Loco.* Upper right: *36.* Stamp at upper right: L.2785. Inscribed on passe-partout: *13.* Watermark at center of left edge: GH.I. Inv. no. 131-17978

LITERATURE: Loga 1903, no. 611. Lafond 1907, no. 13, p. 9 (ill.). Calvert 1908, pl. 543. Mayer 1923, ill. 401. Levina 1958, p. 317. Gassier/Wilson, no. 1741. Gassier I, no. 394, p. 566, ill. p. 534 (as G.3[6]?).

The catalogue of Goya's albums (Gassier I) cites the same number for this drawing, G.36, that had been given earlier in the catalogue raisonné (Gassier/Wilson), but puts the second numeral in editorial brackets and adds a question mark: "G.3[6]?" As with the previous drawing (plate 12), doubts arose about the numbering because only the first numeral was visible in reproductions, and it was, of course, impossible to examine the drawing itself.

The drawing displays Goya's talent for signifi-cant ambiguity. The face of one bereft of reason is rendered grotesque, almost caricatural, by Goya's emphasis on the cruel ambiguity of the smile: The expression that is normally a sign of contentment or pleasure has here hardened into a fixed grin of dementia. Everything else about the appearance of this mad individual is strangely ambiguous, too, making it hard to be sure even about the figure's gender, as the artist, who is usually so precise with details, seems in this case deliberately to "double" the appearance of the clothing. For example, cover-ing the legs, are they carelessly pulled-on stockings that we see, or tight-fitting pants? Over the shoul-ders, is it a man's cloak or a woman's shawl? On the head, a man's cap or a woman's hat? The face itself – as with many seriously ill mental patients suffering from the underdevelopment called oligophrenia – lacks specifically feminine or masculine features, and the pose, too, is oddly difficult to characterize.

For Goya, the physical anomalies of nature that he depicted, whether Siamese twins, a "living skele-ton" (see plate 21), or dwarfs with enlarged heads, were phenomena related to a general, overall pathol-ogy that affected the mental along with the material. Thus in the present drawing, psychological disrup-tion destroys not only mental identity but physical identity as well, reducing the individual to a sexless form. A world that is disordered, in both the spiritual and physical senses, had long been a theme in Goya's art. Prior to the last Bordeaux works on the theme of insanity, Goya most clearly presented such a world in the "black paintings" of the Quinta del Sordo and in the graphic series *The Follies*.

# FRANCISCO DE GOYA

**THE HAPPY MAN**

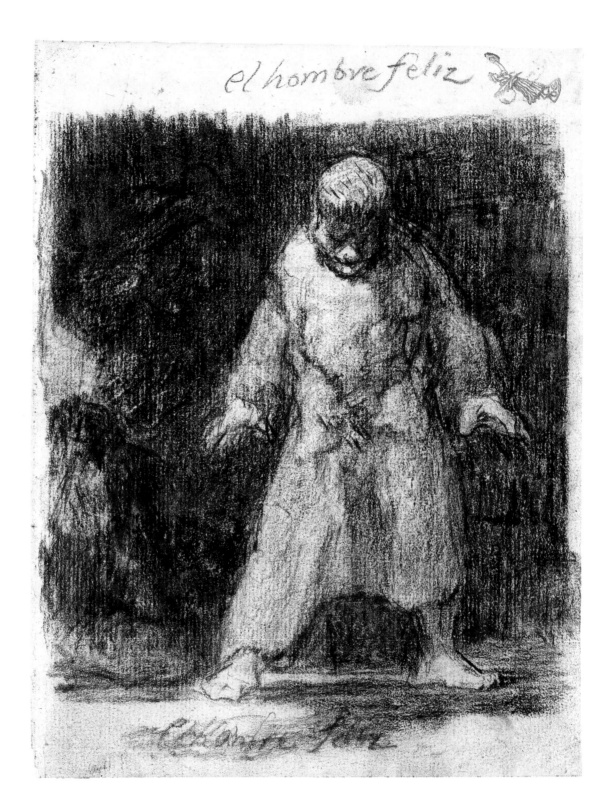

14.

Francisco de Goya. *The Happy Man* (G.38). Lithographic crayon on laid paper, 7½ x 5¾" (19.2 x 14.5 cm). Inscribed top center and bottom center: *el hombre feliz*. Upper right: *38*. Stamp at upper right: L.2785. Inscribed on passe-partout: *14*. Watermark at center of left edge: GH.II. Inv. no. 131-17979

LITERATURE: Loga 1903, no. 611. Lafond 1907, no. 14, p. 9 (ill.). Bertels 1907, ill. 50. Calvert 1908, pl. 558. Rau 1953, ill. 315. Gassier/ Wilson, no. 1743. Gassier I, no. 396, pp. 504, 566, ill. p. 536. Messerer 1983, p. 156. Hölscher 1988, p. 58.

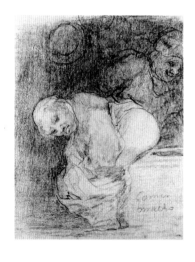

1. Francisco de Goya. *Eat a Lot* (G.[b]). 1824–28. Museo del Prado, Madrid (384)

This sheet, *The Happy Man,* was cited earlier, in the commentary on the drawing from album H called *Idiot* (plate 4; H.60). In both works, light and dark play primary roles: A figure emerging from a deep black background produces a dramatic effect. In such instances, Goya acted in the tradition of Rembrandt, creating through the contrast of light and dark the pictorial space, the composition, and the psychological import of the work.

The uneven, variegated texture of the black background – produced in part by the ribbed texture of the paper and the bulges from the watermark and in part by Goya's way of applying strokes – further intensifies the mysterious darkness from which, ghostlike, a faceless figure appears. The artist seems to have blackened the background with particular care, using both vertical and horizontal strokes and also smearing the lithographic crayon so as to cover the background images, which are barely discernible in the left part of the drawing.

The tragic quality of this lone figure has been remarked on by all who have written about the drawing, and some have spoken of the hopelessness of the benighted spirit and of reason's twilight. The inscription "The Happy Man" was repeated by Goya above and below the image. (The original inscription, on the bottom, was apparently difficult to see because of the layer of shading on the lower part of the sheet, so Goya wrote it again, thus giving it particular importance.) Such an inscription can be interpreted in several different ways: as ironic, as metaphorical, as allegorical – or as literal, a descrip-

tion of a real man experiencing a moment of pleasure. In Goya's art, pictorial and textual meanings are so complexly intertwined that sometimes it is hard to set the boundaries of reasonable interpretation. A simple sketch can be fraught with hidden meanings, while an elaborate metaphor, a symbolic riddle, can turn on the most ordinary aspect of daily life. And so it is in the present drawing. Apparently, no one has noticed that this madman is in fact engaged in the most mundane of activities, for he is simply relieving himself, with his robe opened at the belt and his gaze lowered.

Goya's lunatics are often busily absorbed in their activities. Their desperate concentration can make us shudder and arouses our compassion. Although they may be skating madly (G.32), pretending to be pregnant women (G.43), or quaking from laughter (G.36), they do not make us laugh. Instead, we tend to see them as nightmares from some parallel world, a world that is real to the lunatic.

Judging from his works, Goya was cognizant of such a realm and inclined to accept its reality. *The Disasters of War* had painstakingly portrayed a nightmare become real. Yet in the Bordeaux albums, he recorded that other world with a certain aloofness. The life of the insane could be like the daily life of any sick person, with room for occasional lighter sentiments. The miniatures on ivory of 1825 create a sequence of such images. And in Goya's albums there are often scenes of Rabelaisian frivolity, such as the drawings in albums B and C identified as B.86, C.34, and C.79. Indeed, the same album containing *The Happy Man* also includes a sheet portraying a miserable individual on a chamberpot, with the moral "Eat a lot" (fig. 1; G.[b]).

The strength of Goya's art seems to be that he was able to see reason and madness as merely two aspects of a single reality. No clear-cut boundary can be enforced between them, and the life of any human being partakes of both.

# FRANCISCO DE GOYA

## MAJA WITH PUPPIES

15.

Francisco de Goya. *Maja with Puppies* (H.23). Lithographic crayon
on laid paper, 7½ × 5⅜" (19.2 × 13.5 cm). Inscribed upper right: *23.*
Stamp at upper right: L.2785. Inscribed on passe-partout: *16.*
Watermark at center of left edge: GH.I. Inv. no. 131-17980
LITERATURE: Loga 1903, no. 611. Lafond 1907, no. 16, p. 9 (ill.).
Calvert 1908, pl. 544. Gudiol 1970, vol. I, p. 401, no. 1.287. Gassier/
Wilson, no. 1786. Gassier I, no. 440, pp. 504, 638, 639, ill. p. 596.

1. Francisco de Goya. *The
Parasol.* 1777. Museo del Prado,
Madrid (773)

2. Francisco de Goya. *Francisca
Sabasa y Garcia.* c. 1804–8.
National Gallery of Art, Wash-
ington, D.C. Andrew Mellon
Collection, 1937

According to Gassier, Goya's partially legible signa-
ture can be seen in the lower left corner of this
drawing, below the puppies. No signature can be
detected in a close visual inspection of the drawing,
however, nor did studies conducted in the laboratory
of the State Hermitage Museum find any trace of
one. It can be pointed out that Paul Lafond did not
note any signature at all.

Gassier tells us that *Maja with Puppies,* like sev-
eral other drawings from the Bordeaux albums (G.1,
G.39, H.11, H.22, H.30), was later copied in black
chalk, and the copy (private collection, Paris) was
then taken for the original. In the mid-twentieth
century, a copy appeared done in wash (Sotheby's,
London, May 10, 1961, no. 73). This latter copy was
accompanied by a fictitious title and a number
similar to that of the autograph.

Gassier also believes that the young woman in
*Maja with Puppies* and the one in *Maja and Majo*
(plate 16; H.16) resemble each other. It is true that a
certain similarity can be observed between the
women in these two drawings from the Gerstenberg
collection, but perhaps this can be attributed to their
similar national costumes. It might be more useful
to speak of a certain nostalgia that softens Goya's
depictions of women in his late work. In addition
to these two drawings in album H, there is yet
another sheet, portraying a woman in a mantilla
(H.22). All three women share a kind of romantic
dreaminess. These are figures remembered from the
past, and here the biting irony expended on the friv-
olous *majas* of *The Caprices* or the Madrid album of
1796–97 is gone. Instead, *Maja with Puppies* is remi-
niscent of the famous *Parasol* of 1777 (fig. 1; Museo
del Prado, Madrid) or the portrait *Francisca Sabasa y
Garcia* of c. 1804–8 (fig. 2; National Gallery of Art,
Washington, D.C.).

A different muse presided over these last Bor-
deaux drawings, and this was undoubtedly Leocadia
Weiss, who from 1813 onward shared Goya's life. It
was her sad yet radiant image, which he painted on
one wall of the Quinta del Sordo (*La Leocadia,*
1820–23, Museo del Prado, Madrid), that had sus-
tained him among the nightmare visions of the
"black paintings."

# FRANCISCO DE GOYA

**MAJA AND MAJO**

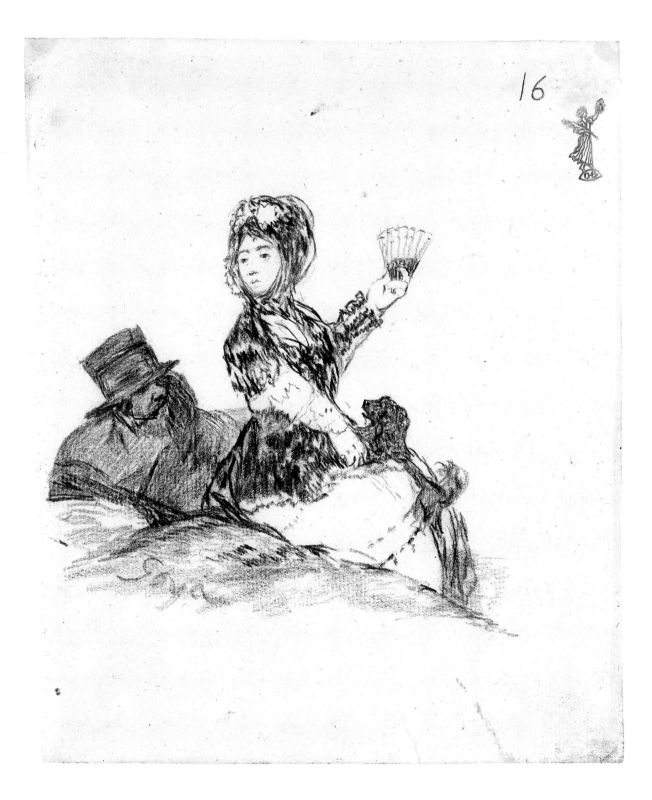

1. Francisco de Goya. *The Duchess of Alba*. 1797. The Hispanic Society of America, New York (A.102)

16.

Francisco de Goya. *Maja and Majo* (H.16). Lithographic crayon on laid paper, 7½ x 6⅛" (19.1 x 15.5 cm). Signed lower left: *Goya.* Inscribed upper right: *16.* Stamp at upper right: L.2785. Inscribed on passe-partout: *17.* Inv. no. 131-17981

LITERATURE: Loga 1903, no. 611, ill. 75 (left). Lafond 1907, no. 17, p. 9 (ill.). Calvert 1908, pl. 535. Gudiol 1970, vol. 1, p. 401, no. 1; vol. 4, p. 1018 (ill.). Gassier/Wilson, no. 1779. Gassier I, no. 433, p. 637, ill. p. 589. Bozal 1983, p. 298, ill. 126.

This drawing depicts a man and woman who seem to resemble the artist and the Duchess of Alba. The subject of the *maja* and *majo,* which Goya had treated in years past, apparently still stirred him. His return to Spanish imagery and to his memories of Spanish tradition was of considerable importance. The *maja* and *majo* represented a whole era of Spanish life and a national manner of behavior and fashion – a way of life and a way of thinking. The dandyism of the *majo* was a form of opposition to the existing political system. In his youth, Goya himself took part in so-called *"majaism,"* which strangely blended serious ideology with trivial mischief. Since it was an integral part of life in the Spanish capital, the world of *majos* and *majas* had naturally found its way into his art, especially in his Madrid album (album B, 1796–97) and in *The Caprices,* where the subject was depicted in a more generalized and artificial way.

In this and other cycles of works, Goya gave extended attention to the relationships between *majas* and *majos* – their dalliances, emotional dramas, betrayals, and reconciliations – and he experienced as well as studied their timeless dance of life. The colorful legends of his own amorous adventures, however, are not based on well-documented fact. His friends and contemporaries left little evidence on this score, while posthumous biographers and, in particular, literary writers simply engaged in conjecture, for the life of the young man from Aragon who became a royal painter stimulated their imaginations. His youth also furnished the stuff of myth, with Goya – an avid bullfight enthusiast with an indomitable temper – supposedly spending more time carousing, seducing, and socializing than in creating art, despite the huge effort demanded by his enormous murals and extensive series of prints.

Opinions differ concerning Goya's relationship with the Duchess of Alba during the years 1795–97, and in recent times scholars have minimized its role in his life and work. After all, there are no more por-

traits by him of this woman, the famous Cayetana, than of other ladies of Spanish court society. Yet the pair of paintings known as *Clothed Maja* and *Naked Maja* (Museo del Prado, Madrid), thought by some to depict the Duchess, was created for one of her lovers, the powerful Manuel Godoy.

It has been proposed that in those two paintings Goya portrayed a different woman (see Prokofiev 1986). Romantic legends tend to persist, especially when documented evidence is scarce, but an artist's creative work is a true touchstone. Thus, the best direct evidence of an intimate, albeit brief, relationship between the Duchess of Alba and Goya would seem to be certain drawings from the Madrid album and from the Sanlúcar album (album A, 1796) made at the Duchess's estate in Sanlúcar. Moreover, the Sanlúcar album drawings (published in Sánchez Cantón 1928), which are more personal, can to a certain extent be considered biographical artifacts. Although the two painted portraits of the Duchess of Alba of 1795 (Casa de Alba Museum, Madrid) and 1797 (fig. 1; The Hispanic Society of America, New York) may remain within the limits of the commissioned formal portrait – notwithstanding the ambiguous inscription on the latter one, "Only Goya" ("Solo Goya") – it is noteworthy that the drawings in the Sanlúcar album, made from life, do include much more personal portrayals of Cayetana (fig. 2). Probably never intended to be seen by anyone else, the drawings later provided material for graphic works.

The present drawing, done shortly before Goya's death in Bordeaux, was a clear allusion to his stay at the Sanlúcar estate. And for the first time, Goya now linked his own likeness to that of the Duchess, openly characterizing their relationship – the man literally and figuratively in the shadow, subordinate to the woman, bound to her by indissoluble but onerous bonds. This Bordeaux drawing is, in essence, his candid final statement about the nature of the relations between the two of them.

2. Francisco de Goya. *The Duchess of Alba Holding Maria de la Luz*. 1796–97. Museo del Prado, Madrid (426)

# FRANCISCO DE GOYA

**MAN PULLING ON A ROPE**

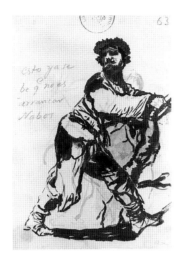

1. Francisco de Goya. *One Can See That This Is Not a Matter of Pulling Up Turnips* (C.63). 1803–24. Museo del Prado, Madrid (289)

17.

Francisco de Goya. *Man Pulling on a Rope* (H.20). Lithographic crayon on laid paper, 7½ x 6" (19.1 x 15.1 cm). Signed lower right: *Goya*. Inscribed upper right: *20*. Stamp at upper right (partly on the passe-partout): L.2785. Inscribed on passe-partout: *18*. Watermark at center of right edge: GH.III. Inv. no. 131-17982

LITERATURE: Loga 1903, no. 611. Lafond 1907, no. 18, p. 9 (ill.). Bertels 1907, ill. 49. Calvert 1908, pl. 564. Mayer 1923, ill. 414. Nemitz 1940, ill. p. 23. Rothe 1943, p. 36, ill. 88. Levina 1950, p. 1102, ill. p. 99. Levina 1958, p. 244, ill. p. 246. Klingender 1968, p. 211, fig. 122. Gassier/Wilson, no. 1783. Gassier I, no. 437, pp. 504, 638, ill. p. 593. Sedova 1973, ill. p. 186. Frankfurt am Main 1981, p. 231 (ill.). Messerer 1983, p. 161.

Goya did not title this drawing. In composition it is somewhat similar to the sheet from album C portraying a man trying to pull a bough from a tree (fig. 1; C.63). The futility of such efforts is made clear by the author's ironic inscription on the latter drawing: "One can see that this is not a matter of pulling up turnips." In the Bordeaux drawing, while largely preserving the pose of the male figure and the sense of powerful physical effort, Goya changes the meaning of the image.

Lafond linked this latter drawing with *May the Rope Break* (fig. 2), no. 77 from *The Disasters of War*. But no matter how hard one searches for an analogy between the priest in clerical robes balancing on a tightrope and the ordinary man pulling, all they share is the existence of the rope. I do not think there is much point, therefore, in juxtaposing these two works or searching for a shared social or political meaning. The two images have little in common except, perhaps, a proverb, "The harder you pull, the sooner the rope breaks." In the etching from *The Disasters of War* Goya quoted part of this saying, and in the drawing he may possibly have meant to imply it. Indeed, in giving the descriptive title *Man Pulling on a Rope* to the present drawing, Gassier cites the saying as a source for the image, while avoiding any political interpretation of it.

The principal artistic interest of this drawing from the Gerstenberg collection lies in its prophecy of Expressionism. The particular power of the composition arises from the sharp disjunction between the figure and the landscape and from the exaggeration of the head and hands. The seemingly ordinary subject of physical exertion is actually one of the most difficult to portray. It is in fact the way that Goya here raises the subject to a high level of expressive power that has made some critics want to associate it with the notion of revolutionary change implicit in *May the Rope Break* – the power to change the order of the world.

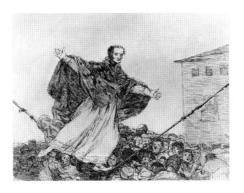

2. Francisco de Goya. *May the Rope Break*. c. 1815–20. *The Disasters of War*, no. 77. The Hispanic Society of America, New York

# FRANCISCO DE GOYA

**THE FRENCH PENALTY**

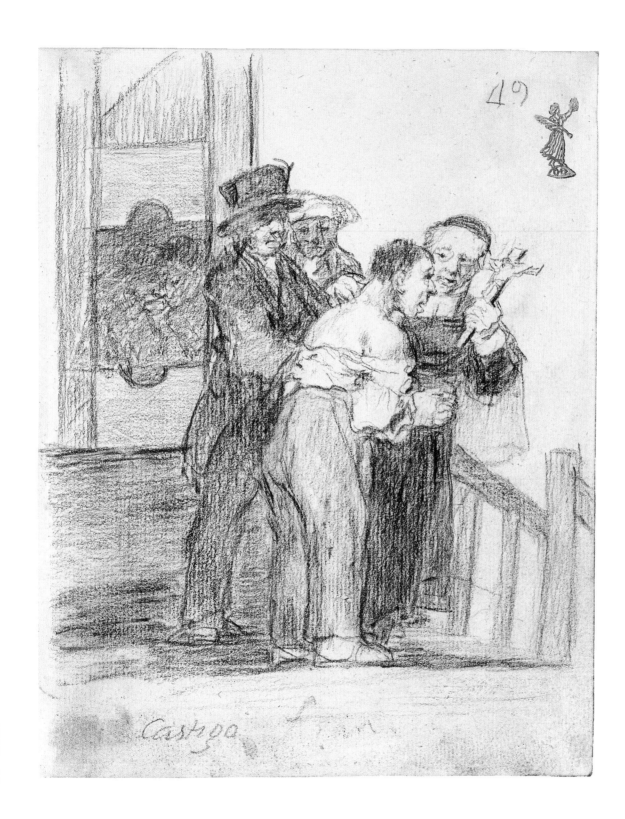

In his album G, Goya marked this drawing no. 49, while the drawing showing the actual execution by guillotine is designated no. 48. Logically, as Gassier notes (Gassier I), the two drawings should be in the reverse sequence. It is quite possible that Goya numbered them as he did simply to indicate the order in which they were created.

The beheading device advocated by the French physician Joseph-Ignace Guillotin was designed not so much to make executions swifter and more "humane," a common view, as to ease the physical labor of the executioner. The great historical irony of the guillotine was that this "rational" product of human inventiveness helped thwart the aspirations of the Enlightenment – and its idealistic belief in the power of reason.

Despite the drawing's emotional restraint and its static composition (at least compared to a scene such as *Hard Is the Way!*, fig. 1), Goya's rendering of the preparations for an execution is telling in its impact. Against the background of the guillotine and the silhouettes of its barely visible attendants are shown four people who manifest several basic human types. These include, first of all, the condemned man, in whom the primal fear of death is palpable. Bereft of hope, this pitiable figure has been reduced to the lowest possible state, and Goya omits no detail in portraying his misery. The three other individuals are busy doing things that have always been done in such circumstances. One of them is carrying out his duty to the law; indicating on the neck of the condemned man the precise place where the blade is to fall, he is as dispassionate in his work as only a bureaucratic functionary can be. The figure to the right is a priest, whose responsibilities are of a higher order. His is a duty before God, understood, first and foremost, as the performance of a comforting ritual. The third individual is not so directly involved; his role is less that of a gawker or curiosity seeker, however, than of a simple bystander who is free of both responsibilities and feelings.

This scene, which has been silently played out countless times in the course of history, takes on a kind of universal meaning in Goya's art. The characters are bound together for eternity; all of them are aspects of human nature, which is capable of cruelty, compassion, or simple indifference.

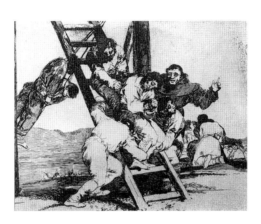

1. Francisco de Goya. *Hard Is the Way!* c. 1810–11. *The Disasters of War,* no. 14. The Hispanic Society of America, New York

18.

Francisco de Goya. *The French Penalty* (G.49). Lithographic crayon on laid paper, 7⅝ x 5⅞" (19.3 x 14.8 cm). Inscribed at bottom (last three letters illegible): *Castigo fran[cés].* Upper right: *49.* Stamp at upper right: L.2785. Inscribed on passe-partout: *19.* Watermark at center of left edge: GH.II. Inv. no. 131-17983

LITERATURE: Carderera 1860, p. 227. Viñaza 1887, p. 142. Loga 1903, no. 611, ill. 74 (left). Lafond 1907, no. 19, p. 9 (ill.). Bertels 1907, ill. 48. Calvert 1908, pl. 568. Mayer 1923, ill. 412. Rothe 1943, pp. 36 (ill.), 85. Levina 1945, p. 39. López-Ray 1956, pp. 142, 156, pl. 121. Levina 1958, p. 317. Saint-Paulien 1965, p. 300. Klingender 1968, p. 211. Gudiol 1970, vol. 1, p. 401, no. 1.281; vol. 4, p. 1016 (ill.). Gassier/Wilson, no. 1754. Gassier I, no. 407, pp. 500, 501, 569, ill. p. 547. Sedova 1973, ill. p. 189. Flekel 1974, p. 179. Gassier 1983, pp. 295, 308, fig. 197. Bozal 1983, pp. 290–92, ill. 121.

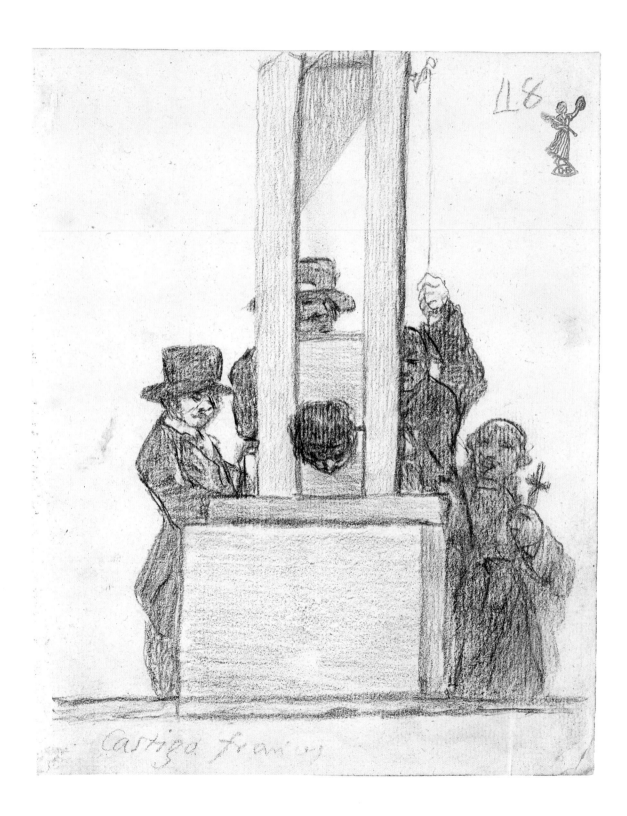

1. Francisco de Goya. *The Garroted Man.* c. 1778–80. Graphische Sammlung Albertina, Vienna (H.2301)

In the famous drawing and etching *The Garroted Man* of 1778–80 (fig. 1; Gassier/Wilson, nos. 122, 123), Goya depicted an execution for the first time. And among the various depictions of victims and the imprisoned in his album C of 1803–24, as mentioned earlier in connection with *Prisoner* (plate 1), a good many are devoted to portrayals of torture and execution (C.91, C.92, C.97, C.99, C.101). In Bordeaux, however, Goya saw a form of execution that was new to him. Although it had been known in the Middle Ages, in the era of the French Revolution it was used as never before (see figs. 2, 3).

In the present composition, which shows the actual execution, or more precisely the moment before it, Goya includes the same individuals as in the companion image (plate 18; G.49). Gassier noted the pictorial device that the artist used to convey the finality of death, a device of the utmost simplicity: all of the individuals who are carrying out the death sentence are distinguished by a heavy application of

19.

Francisco de Goya. *The French Penalty* (G.48). Lithographic crayon on laid paper, 7½ x 5⅞" (19.2 x 15 cm). Inscribed at bottom: *Castigo francés.* Upper right: *48.* Stamp at upper right: L.2785. Inscribed on passe-partout: *20.* Watermark at center of left edge: GH.II. Inv. no. 131-17984

LITERATURE: Viñaza 1887, p. 142. Loga 1903, no. 611. Lafond 1907, no. 20, p. 10 (ill.). Calvert 1908, pl. 538. Rothe 1943, p. 36, ill. 86. Levina 1945, p. 39. López-Ray 1956, pp. 142, 155, pl. 120. Levina 1958, p. 317. Saint-Paulien 1965, p. 300. Klingender 1968, p. 211. Gassier/Wilson, no. 1753. Gassier I, no. 406, pp. 502, 569, ill. p. 546. Broglie 1973, p. 80. Flekel 1974, p. 179. Gassier 1983, pp. 295, 308, fig. 196.

black. Their figures are dark, their facial features are blurred, and the whole somber group looks particularly ominous silhouetted against the light sky.

At the same time, the geometry of the wooden engine of justice imposes its order on the irregular mass of figures: They are sandwiched between the empty white background and the controlling gray shape of the guillotine. Indeed, the entire composition is classical: Comprising a strict triangle, it repeats the visual pattern, established over centuries, that was thought to embody the union of time and eternity. In this context, such implications seem very significant.

3. Théodore Gericault. *Severed Heads*. 1818. Statens Konst-museer, Stockholm (NM 2113)

2. Jacques-Louis David. *Studies of the Head of a Bastille Officer Before and After the Guillotine*. 1789. Bibliothèque National, Paris (B6 rés.)

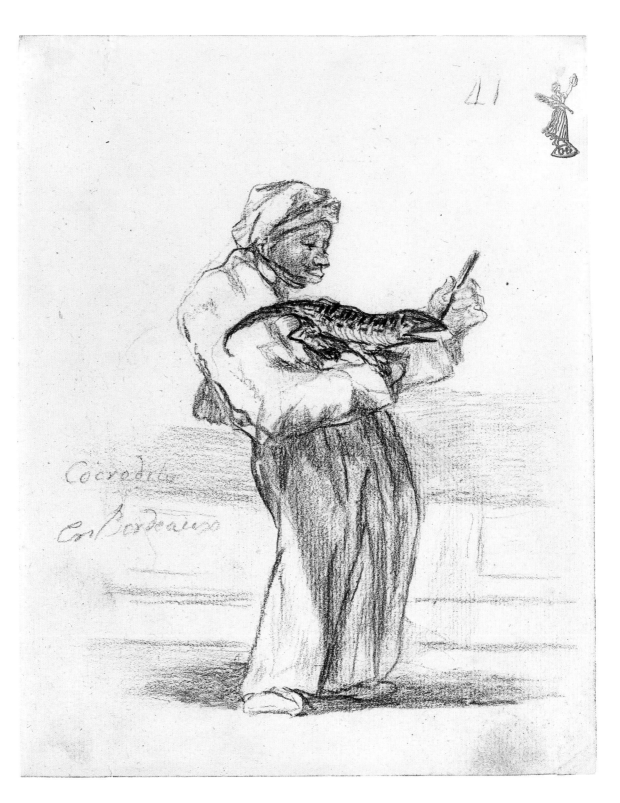

20.

Francisco de Goya. *Crocodile in Bordeaux* (H.41). Lithographic
crayon on laid paper, 7½ x 5⅞" (19.1 x 15 cm). Inscribed left center:
*Cocrodilo/en Bordeaux*. Upper right: *41*. Stamp at upper right:
L.2785. Inscribed on passe-partout: *21*. Inv. no. 131-17985

LITERATURE: Loga 1903, no. 611. Lafond 1907, no. 21, p. 10 (ill.).
Calvert 1908, pl. 563. Gómez-Moreno 1941, p. 157. Rau 1953, ill. 309.
Levina 1958, p. 317. Saint-Paulien 1965, p. 300. Klingender 1968,
p. 211. Gassier/Wilson, no. 1802. Gassier I, no. 456, pp. 502, 642,
643, ill. p. 612. Frankfurt am Main 1981, p. 229 (ill.). Gassier 1983,
p. 308. Bozal 1983, p. 293. Volland 1993, p. 197, ill. 87.

Goya made a considerable number of the Bordeaux
drawings from life, including those created in 1826 at
the fair in Bordeaux. One of them – *Claudio Ambrosio
Surat, Known as the Living Skeleton* (plate 21; H.45) –
bears that date, which made it possible to establish
the date of two related drawings: the present *Crocodile in Bordeaux* and *Serpent Four Yards Long in Bordeaux* (plate 22; H.40).

Goya's interest in the unusual drew him to these
subjects. The present drawing portrays a costumed
African figure wearing a turban and holding a small
crocodile. The performance at the fair involved
opening the trained reptile's jaws with a small stick;
the act being so simple, the trainer's exotic outfit was
an important part of the attraction. The background
of the drawing, showing a fence enclosing the
grounds, suggests something of the fairgrounds.

The first fairs appeared in Goya's album F of
1812–23: *Street Performers* (F.7; Museo del Prado,

1. Francisco de Goya. *Acrobats*
(F.67). 1812–23. The Metropolitan
Museum of Art, New York. Harris
Brisbane Dick Fund, 1935
(35.103.38)

Madrid) and *Acrobats* (fig. 1; The Metropolitan
Museum of Art, New York). It should be noted that
oddities and comic situations are to be found even
in Goya's gloomy album C of 1823–24 (for example,
C.27, C.34, C.35, C.71), although, unlike the Bor-
deaux drawings, they are characterized by didacti-
cism as well as by humor.

An exotic figure in Eastern trousers and a tur-
ban had already appeared in the earlier album E of
1803–12 (fig. 2; Staatliche Museen zu Berlin, Preuss-
ischer Kulturbesitz, Kupferstichkabinett). Gassier
indicates that in this earlier drawing (as in the later
ones from Bordeaux), Goya was depicting an actual-
ity – Mamelukes like the one portrayed here could be
seen in Madrid after the arrival of French troops in
1808 – and not alluding to biblical figures or "Orien-
tal" character types he knew from art, such as those
in the works of the Tiepolos, father and son.

2. Francisco de Goya. *He Is
Learning to See* (E.9[?]). 1808–12.
Staatliche Museen zu Berlin,
Preussischer Kulturbesitz,
Kupferstichkabinett (4393)

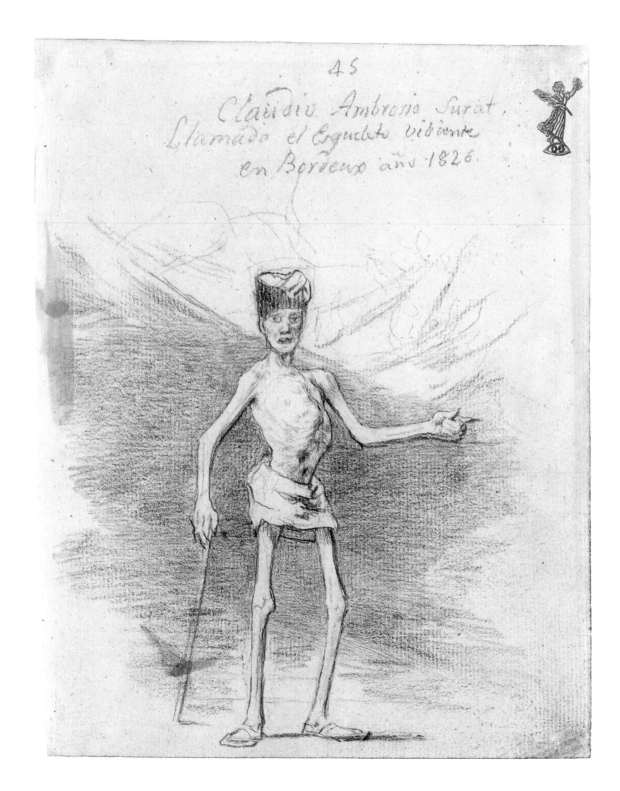

21.

Francisco de Goya. *Claudio Ambrosio Surat, Known as the Living Skeleton* (H.45). Lithographic crayon on laid paper, 7½ x 5¾" (19.2 x 14.7 cm). Inscribed upper center: *Claudio Ambrosio Surat / Llamado el Esquelete vibiente / en Bordeux* [sic] *añs 1826*. In center of upper margin: *45*. Stamp at upper right: L.2785. Inscribed on passe-partout: *22*. Inv. no. 131-17986.

LITERATURE: Viñaza 1887, p. 142. Loga 1903, no. 611. Lafond 1907, no. 22, p. 10 (ill.). Calvert 1908, pl. 537. Mayer 1923, ill. 420. Sánchez Cantón 1930, p. 84. Gómez-Moreno 1941, p. 157. Núñez de Arenas 1950, p. 250. Levina 1958, p. 317. Saint-Paulien 1965, p. 300. Gudiol 1970, vol. 1, p. 401, no. 1.279; vol. 4, p. 1016 (ill.). Gassier/Wilson, no. 1806. Gassier I, no. 460, pp. 501, 502, 643, 644, ill. p. 616. Gassier 1983, p. 308. Bozal 1983, p. 293.

"Living skeletons," like bearded women and other exotica, were fixtures in the fairs of the time. The appearances at a fair in Bordeaux in 1826 of a certain Claude Ambroise Surat, however, apparently astounded his contemporaries, eclipsing all other such attractions. The extreme dystrophy of this individual, who could maintain an upright posture only with the support of a cane, was captured both in the present drawing by Goya and in the lithograph *Living Skeleton* by the Bordeaux artist Louis Burgade.

During his last years, Goya was fascinated by human anomaly, both mental and physical. Putting aside dreams and allegories, he found in the reality around him actual individuals who were akin to the images of his earlier fantasies. It was as though beings from the universe of *The Caprices* could become real and appear in the everyday world, a possibility raised by the actual person named Claude Ambroise Surat. Perhaps what struck Goya most about this "living skeleton" was his borderline condition, suspended between different realms, since this state was characteristic of the artist himself.

# FRANCISCO DE GOYA

## SERPENT FOUR YARDS LONG IN BORDEAUX

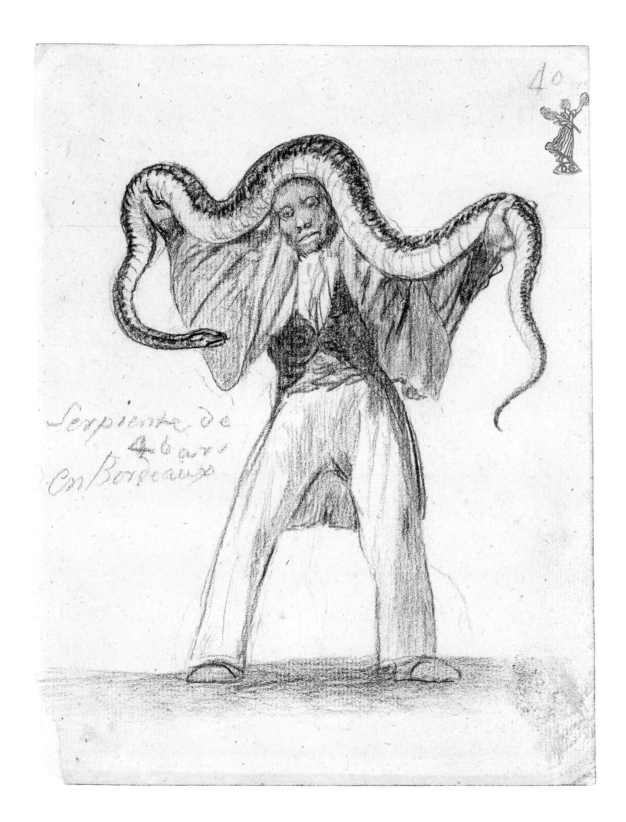

1. Francisco de Goya. *The Wolf's Revenge* (H.5). 1824–28. Museo del Prado, Madrid (375)

22.

Francisco de Goya. *Serpent Four Yards Long in Bordeaux* (H.40). Lithographic crayon on laid paper, 7½ x 5¾" (19.1 x 14.7 cm). Inscribed center left: *Serpiente de/4 bar<sup>s</sup> en Bordeaux.* Upper right: *40.* Stamp at upper right: *L.2785.* Inscribed on passe-partout: *23.*
Inv. no. 131-17987

LITERATURE: Viñaza 1887, p. 142. Loga 1903, no. 611. Lafond 1907, no. 23, p. 10 (ill.). Calvert, 1908, pl. 540. Sánchez Cantón 1930, p. 84. Mayer 1932–33, p. 380. Gómez-Moreno 1941, p. 157. Rau 1953, ill. 310. Levina 1958, p. 317, ill. p. 320. Klingender 1968, p. 211. Gudiol 1970, vol. 1, p. 401, no. 1.280; vol. 4, p. 1016 (ill.). Gassier/Wilson, no. 1801. Gassier I, no. 455, p. 642, ill. p. 611. Frankfurt am Main 1981, p. 229 (ill.). Gassier 1983, pp. 303 (ill.), 308. Bozal 1983, p. 293. Volland 1993, pp. 196, 197.

Goya found this subject, as well as those portrayed in plates 20 and 21, at the fair in Bordeaux. It follows from the inscription that the artist was primarily struck by the unusual size of the serpent. In addition to the three drawings from the Gerstenberg collection, albums G and H contain additional sheets that the Gassier/Wilson catalogue raisonné claims were also based on performances at fairs. They are: *The Wolf's Revenge* (fig. 1; H.5), which Gassier was then calling *The Performing Wolf,* until in 1973 he himself expressed doubt that the sheet deals with a circus performance (see Gassier I, no. 422, p. 634); *Telegraph* (fig. 2; H.54), the title given by the artist being interpreted by Gassier as referring to a circus act in which an acrobat imitates semaphore signals with his legs; and *A Donkey on Two Legs* (fig. 3; G.20). There was also a further drawing, depicting two dwarfs performing at a fair, that Gassier says is lost, its existence documented only by Goya's letter of November 30, 1824, sent from Bordeaux to the Duchess of San Fernando, in which the artist describes his visits to performances at fairs and writes in detail of his sketch of a performance by three dwarfs (Gassier 1983, p. 306).

I believe that Gassier's decision to assign the date 1826 to all the drawings of fairs from the Gerstenberg collection – based solely on the date that

2. Francisco de Goya. *Telegraph*
(H.54). 1824–28. Museo del
Prado, Madrid (377)

Goya inscribed on just one of them (plate 21) – is not
fully justified, since the annual fairs and perfor-
mances attracted the artist's attention as early as the
autumn of 1824, when he returned to Bordeaux
from Paris.

In terms of composition, the present drawing is
unusual in its contours and in the contrast between
two radically different kinds of bodies: the stable,
standing figure of the man and the writhing, sus-
pended coils of the snake. Goya's depiction in the
Bordeaux drawings of trainers with crocodiles and
snakes was interpreted by G. Volland in straight-
forward Freudian terms, as supposedly revealing
the psychological state of the artist at that period of
his life.

Goya's drawings in Bordeaux were primarily
studies from life. Some drawings that Gassier and
Wilson considered "circus" scenes, however – such
as *The Wolf's Revenge* or *A Donkey on Two Legs* – were
in fact based on the anthropomorphic tales and leg-
ends that have been common in European folklore
throughout the centuries.

3. Francisco de Goya. *A Donkey
on Two Legs* (G.20). 1824–28.
Museo del Prado, Madrid (376)

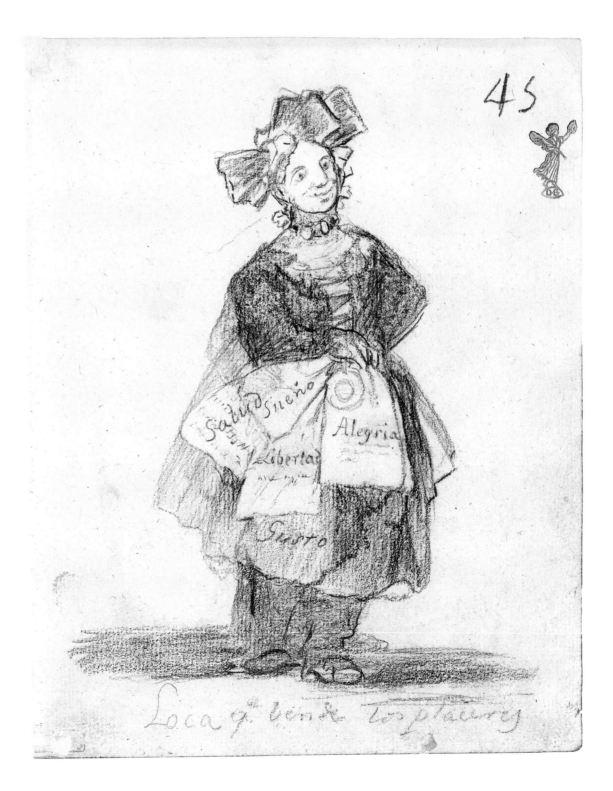

Gassier, who of course knew this drawing only from reproductions, thought that the barely legible inscription below the figure's feet included the words *Es francesa* ("This is a Frenchwoman"). In fact, those words never appeared on the drawing, as has been confirmed by studies in the laboratory at the State Hermitage Museum.

In several places, Goya reworked the image of this figure, and behind the legs there are clearly visible contours that could be the outline of legs or the lower folds of a cloak. Lines probably indicating a veil or scarf are also visible to the left and right of the figure.

In discussing this sheet, Gassier rightly considered that in addition to depicting an actual Bordeaux street vendor, Goya was also presenting a kind of allegory. Gassier did not explain further, however, merely indicating that in France, as in Spain, vendors sold rolled wafers containing printed fortunes, and mentioning that François René de Chateaubriand

made reference to them during the period when Goya produced this drawing. He also noted that Goya amusingly transformed the French word *plaisirs* ("pleasures" or "delights") into *placeres,* although in Spanish these rolled wafers are actually called *barquillos*.

Some writers have seen in this drawing an ironic comment on the loss of ideals that resulted from the political upheavals in Spain during the first two decades of the nineteenth century. Such a view can be found in the work of I. Levina in 1950 and more recently in R. A. Flecha's 1988 book on the ideological and literary aspects of Goya's art. It should be remembered, however, that Goya always showed a passionate devotion to his homeland, and as a kind of political refugee in France he remained in contact with a liberal group of his countrymen in Bordeaux.

Goya could not have failed to intend an irony in his inscriptions on this drawing. The woman selling little bundles of "Health," "Dream," "Freedom," "Joy," and "Pleasure" invites allegorical interpretation. Also the title *Madwoman Who Sells Delights* is perhaps more significant than Gassier assumed. The vendor's face shows little sign of outright dementia, but her eager expression is rather puzzling, as if something further is being left unsaid. It would seem that the artist did not misspeak when he used the word *loca* ("mad").

23.
Francisco de Goya. *Madwoman Who Sells Delights* (G.45). Lithographic crayon on laid paper, 7½ x 5⅞" (19.3 x 14.8 cm). Inscribed lower center: *Loca q.ᵉ bende los placeres.* On the bags held by the figure: *Salud / Sueño / Libertad / Alegria / Gusto.* Upper right: *45*. Stamp at upper right: L.27865. Inscribed on passe-partout, in pencil: *24.* Watermark at center of left edge: GH.II. Inv. no. 131-17988
LITERATURE: Carderera 1860, p. 227. Loga 1903, no. 611. Lafond 1907, no. 24 (ill.). Calvert 1908, pl. 575. Levina 1950, p. 90, ill. 22. Rau 1953, ill. 314. López-Rey 1956, pp. 143, 156, pl. 123. Levina 1958, p. 288. Gassier / Wilson, no. 1750. Gassier I, no. 403, pp. 500, 502, 568, ill. p. 543. Bozal 1983, p. 290. Flecha 1988, p. 472, fig. 193.

# FRANCISCO DE GOYA

## GREAT COLOSSUS ASLEEP

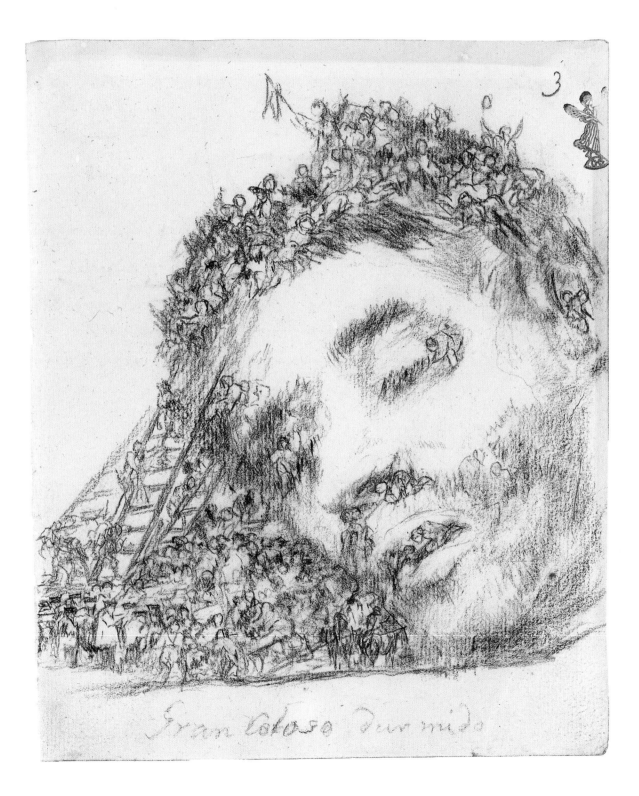

Gran Coloso dur mido

24.

Francisco de Goya. *Great Colossus Asleep* (G.3). Lithographic crayon on laid paper, 7½ x 6" (19.2 x 15.4 cm). Inscribed at bottom center: *Gran Coloso durmido.* Upper right: *3.* Stamp at upper right: L.2785. Inscribed on passe-partout in pencil: *25.* Watermark at center of left edge: GH.II. Inv. no. 131-17989

LITERATURE: Loga 1903, no. 611, ill. 76. Lafond 1907, no. 25 (ill.). Calvert 1908, pl. 555. Mayer 1923, ill. 405. Rothe 1943, p. 37, ill. 100. Levina 1950, p. 104. Rau 1953, ill. 217. Levina 1958, p. 318. Chastenet 1964, séquence 4, no. 19. Klingender 1968, p. 208. Gassier/Wilson, no. 1713. Gassier I, no. 367, pp. 503, 559, 560, ill. p. 507. Gantner 1974, p. 247. Flekel 1974, p. 179. Malraux 1978, pp. 177, 178, ill. 105. Gassier 1983, fig. 198. Bozal 1983, p. 293. Guillaud 1987, p. 260, no. 151, ill. p. 351.

The present drawing, *Great Colossus Asleep,* is among the most famous of Goya's works, and it is closely related to two other images, no less renowned.

One of them is the mezzotint *The Colossus* of 1808–18 (fig. 1). The print shows a male figure of immense proportions seated in a nocturnal landscape. The figure's back is turned to the viewer, while the head directs a puzzled gaze into the remote distance. A crescent moon hangs above. The possible larger meaning of all this has been much discussed in the critical literature. The many diverse interpretations have looked to politics and religion as well as art history and have taken into account everything from the Napoleonic wars and the metaphysical search for an image of the divine to such artistic precedents as Hendrik Goltzius's engraving after the Farnese Hercules.

At about the time of his mezzotint, Goya created the enigmatic canvas *The Colossus* of c. 1808–14 (fig. 2; Museo del Prado, Madrid), the second work related to the Gerstenberg drawing. The same figure is portrayed, this time standing up and towering over a multitude of fleeing men and beasts. The gaze of this superhuman being is fixed on his own clenched fist, however, not the hordes below, and the muscular tension adds to the sense of his concentration. But concentration on what? The painting is usually interpreted either as an allegorical portrayal of Napoleon's invasion, or as the onslaught of barbarians, or even the liberation of humankind from the forces of darkness. A sense of catastrophe pervades the scene, but the specific nature of the disaster is unclear and perhaps unexplainable. We cannot even

tell whether the colossus is attacking the crowd or, perhaps, protecting it from some unseen enemy over the crest of the hill.

The drawing from the Gerstenberg collection completes this unusual triad of depictions of the colossus. Who or what is he? The towering entity who muses over the nighttime world in the print and stands ready to help or to fight in the canvas has, in the present drawing, fallen asleep on the ground and been bound and overrun by tiny creatures. The quality of the concentrated artistic thought in this image may surpass even what Goya achieved in the two earlier works, and the drawing is, if anything, even more puzzling than the other images. For example, the colossus may be more than simply unconscious; cut off at the neck by the edge of the paper, the head is presented in such a way as to leave open the possibility that it has been detached from the torso.

Perhaps, as is commonly thought, this sleeping giant surrounded by antlike figures owes something to the Lilliput episode in Jonathan Swift's *Gulliver's Travels*. The ramifications of the insensate head are broader than that, however, and the image may allude as well to the teeming world that comes into being when conscious control is relaxed – the subject depicted in *The Sleep of Reason Produces Monsters* (Gassier/Wilson, no. 536) from *The Caprices*.

2. Francisco de Goya. *The Colossus*. c. 1808–14. Museo del Prado, Madrid (2785)

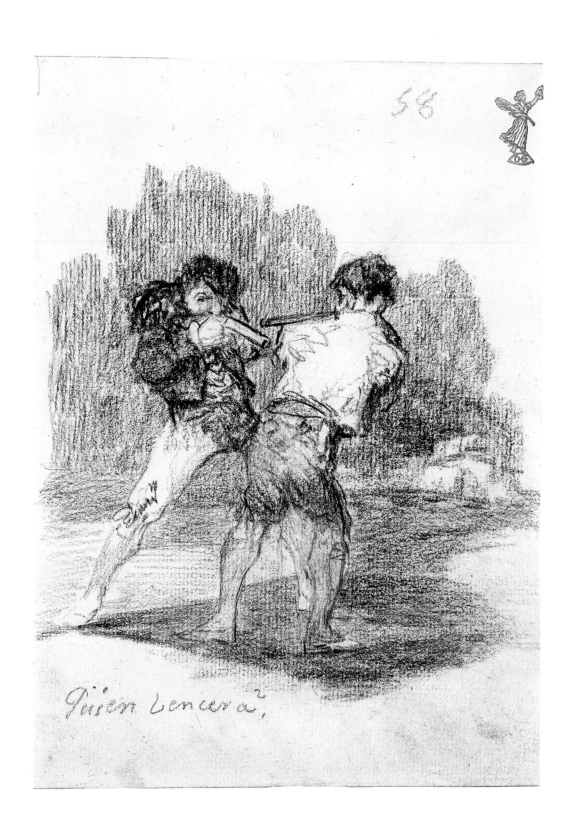

25.

Francisco de Goya. *Who Will Win?* (G.58). Lithographic crayon on
laid paper, 7½ x 5⅜" (19.2 x 13.5 cm). Inscribed lower left: *Quien
vencera?* Upper right: *58.* Stamp at upper right: L.2785. Inscribed on
passe-partout: *26.* Inv. no. 131-17990

LITERATURE: Loga 1903, no. 611. Bertels 1907, ill. 45. Lafond 1907,
no. 26. p. 11 (ill.). Calvert 1908, pl. 542. Brieger-Wasservogel n.d.,
p. 35. Mayer 1923, ill. 419. Gassier/Wilson no. 1762. Flekel 1974,
p. 179. Bozal 1983, p. 291.

1. Francisco de Goya. *Dueling
with Knives* (F.15). 1812–23. Museo
del Prado, Madrid (288)

Duels are the subject of quite a few of Goya's works,
among them drawings, prints, and paintings. In
album F of 1812–23, duels are portrayed no fewer
than six times (F.10 through F.15). For the most part,
they are sword fights, and despite the likelihood of
death they are often portrayed with a certain under-
current of mockery. These duelists can sometimes
look like actors in a melodrama. Of the group from
album F, the sepia drawing *Dueling with Knives* (fig. 1;
Museo del Prado, Madrid) is closest to the Gersten-
berg sheet in terms of composition and emotional
tone. In both works, the two combatants are face-to-
face, fighting at close quarters. The intensity of their
mutual hatred and the impossibility of disengage-
ment seem to fuse the two figures into one. The
force binding them to each other is so strong that
only death can break it. In these two sheets, at least,
there is no mockery.

The Gerstenberg drawing is dynamically con-
structed, and for the sake of sheer expressiveness the
artist permits himself certain anatomical "errors" in
the figures. The anatomically odd position of the
legs of the figure on the left and the flattened and
peculiarly bent body of the figure on the right create
an expressionistic effect.

Gassier thought that two faint silhouettes of
women were visible in the background on the right,
which led him to posit a romantic motive for the
situation, a kind of literary plot. On the far right of
the drawing, lighter areas are in fact visible, but they
depict some kind of building, perhaps a castle. Goya
avoided literary narratives, and no such motivation
"explains" the hatred portrayed here, a hatred whose
force seems intensified by the fact that the protag-

2. Francisco de Goya. *The Death
of Anton Requena* (H.53).
1824–28. The National Gallery of
Canada, Ottawa (2998)

onists use guns and are aiming at each other at point-blank range. Apparently, no one will win this duel, and the question in Goya's title is rhetorical.

The subject of a gunshot at extremely close range can also be found in a drawing from the other Bordeaux album, *The Death of Anton Requena* (fig. 2; H.53, The National Gallery of Canada, Ottawa), wherein a man is treacherously murdered in his sleep. With all its cruelty, the killing in this case apparently did have a story behind it, which was probably well known at the time, although it has since been lost. In stance and facial expression, the murderer repeats the figure on the left in the Gerstenberg drawing.

The subject of single combat seems to have been of particular concern to Goya, for duels occur repeatedly in his works, especially during the latter years of his life. Notable examples include the famous *Duel with Cudgels* from the Quinta del Sordo murals of 1820–23 (fig. 3; Museo del Prado, Madrid) and the panel painting *The Duel* of c. 1820–24 (fig. 4; Alte Pinakothek, Bayerische Staatsgemäldesamm-lungen, Munich).

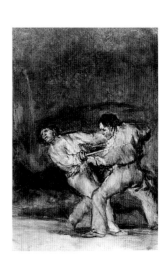

# FRANCISCO DE GOYA

## HERE SOMETHING IS BOUND TO HAPPEN

Francisco de Goya. *Here Something Is Bound to Happen* (G.56). Lithographic crayon on laid paper, 7½ x 5½" (19.2 x 14.3 cm). Inscribed lower left: *Aqui algo/ha de aber*. Upper right: *56*. Stamp at upper right: L.2785. Inscribed on passe-partout: *27*. Watermark at center of left edge: GH.II. Inv. no. 131-17991

LITERATURE: Loga 1903, no. 611. Lafond 1907, no. 27, p. 11 (ill.). Calvert 1908, pl. 539. Gassier/Wilson, no. 1760. Gassier I, no. 412, pp. 503, 571, ill. p. 552.

1. Francisco de Goya. *Embozado with a Gun* (H.31). Museo del Prado, Madrid (319)

As Gassier noted, this mysterious drawing is a kind of reminiscence of the subject of the *embozado,* or cloaked man. Goya's sketch for the tapestry *Walk in Andalusia* from 1777 (Museo del Prado, Madrid), depicting a gypsy woman and several *embozados,* is a well-known early example of this theme.

The *embozados* usually wrapped themselves up to their eyes. This particular national fashion could be found widely in both popular and aristocratic circles. The *embozado* in the present drawing, which the artist gave the intriguing title *Here Something Is Bound to Happen,* is very threatening; a gun barrel can be seen below the edge of his cloak. The figure at the rear is also armed, and the woman turning to the side and holding a bundle in her arms (perhaps a swaddled child) seems to gaze suspiciously at something. Before us are people who may be smugglers or thieves, but they could as easily be simple townspeople prepared to defend their village, as might be expected in a country shaken by the horrors that Goya depicted in *The Disasters of War*. Compared with those images, this picture seems restrained.

Album H contains another sheet depicting an equally somber individual, *Embozado with a Gun* (fig. 1; H.31, Museo del Prado, Madrid). Here the armed man is alone, and instead of a brimmed hat he wears something akin to a fur cap. This drawing has no title inscribed, but is signed by the artist. He attached particular significance to it, since it was a preliminary study for two engravings done in 1825–27 (Gassier/Wilson, nos. 1827 [etching with aquatint] and 1828 [etching]). These were among the last of Goya's graphic works. They are simple in form and tragic in content, for the figure of the armed man is reminiscent of the powerful works of Ribera and Velázquez.

Like the preceding drawing (plate 26), this cruel scene is related to the circumstances of life in the country. Mercilessness and malicious glee are conspicuous features of such horrible "rural events," a term that Goya carefully put in the plural, perhaps to suggest that this was not an isolated or infrequent occurrence. For passersby, the hanged man may be a commonplace event and arouses little curiosity.

In the images of *majas* and *majos* from his last years in Bordeaux, Goya recalled his youth: nostalgic reminiscences tinged with regret. The memories giving rise to such sheets as *Rural Events,* however, are of a different type. This drawing is a kind of throwback to *The Disasters of War,* being a paraphrase of no. 36, *Nor This* (fig. 1), which showed Spaniards hanged on tree stumps with a Napoleonic soldier lounging nearby. Yet there are important differences. This warrior who calmly contemplates his handiwork is more like a connoisseur evaluating a work of art than like the savage murderer in the Gerstenberg drawing. Many images in *The Disasters of War* had exploited this frightening contrast between horror and distanced contemplation.

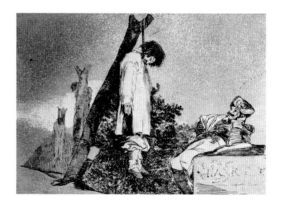

27.

Francisco de Goya. *Rural Events* (G.47). Lithographic crayon on laid paper, 7½ x 5⅞" (19.2 x 15.1 cm). Inscribed lower left: *Sucesos Campestres.* Upper right: *47.* Stamp at upper right: L.2785. Inscribed on passe-partout: *28.* Watermark at center of left edge: GH.II. Inv. no. 131-17992

LITERATURE: Loga 1903, no. 611. Lafond 1907, no. 28, p. 11 (ill.). Bertels 1907, ill. 46. Calvert 1908, pl. 567. Brieger-Wasservogel n.d., p. 35. Mayer 1923, ill. 411. Levina 1958, p. 317. Gudiol 1970, vol. 1, p. 401, no. 1.284; vol. 4, ill. p. 1017. Gassier/Wilson, no. 1752. Gassier I, no. 405, p. 569, ill. p. 545. Hamburg 1980, pp. 135, 136, ill. 69. Bozal 1983, ill. 119.

1. Francisco de Goya. *Nor This.* 1812–14. *The Disasters of War,* no. 36. Museum of Fine Arts, Boston. Bequest of W. G. Russell Allen, by exchange (1973.732)

# FRANCISCO DE GOYA

**LUNATICS**

*Locos*

28.

Francisco de Goya. *Lunatics* (G.37). Lithographic crayon on laid paper, 7½ x 5⅝" (19.2 x 14.4 cm). Inscribed lower center: *Locos*. Upper right: *37*. Stamp at upper right: L.2785. Inscribed on passe-partout: *29*. Watermark at center of left edge: GH.II. Inv. no. 131-17993

LITERATURE: Loga 1903, no. 611. Lafond 1907, no. 29, p. 11 (ill.). Calvert 1908, pl. 534. Rau 1953, ill. 313. Gassier/Wilson, no. 1742. Gassier I, no. 395, p. 566, ill. p. 535. Pérez Sánchez/Sayre 1989, p. 376, fig. 1.

In Goya's album G, this sheet, G.37, was located between two other drawings that were also acquired by Otto Gerstenberg: *Lunatic from the Calle Mayor* (plate 13; G.36) and *The Happy Man* (plate 14; G.38).

This is the last drawing in the Gerstenberg collection devoted to the theme of madness. In each of the drawings on this subject described earlier, one particular manifestation or another of mental illness was depicted in isolation. The present drawing, however, shows in one image the diametrically opposed demeanors of two very different individuals. The two manifest on the one hand profound depression and on the other a frenzied aggressiveness. Despite the contrast between them, the two figures, one standing and one seated, are turned into a single entity by the composition and execution of the drawing, their contours forming a single complex shape. And in psychological terms, the very different expressions of the two individuals are nonetheless united by their clearly evident sense of suffering.

To some extent, the hospital cap on the head of the standing figure resembles the caps placed on the victims of the Inquisition in token of their state. Here, the cap seems to play a somewhat similar role: These afflicted individuals were thus identified as beyond the pale, "condemned" by their illness, and set apart as a danger to others.

This flying female figure is doubtless linked more to Goya's earlier works and to themes that run throughout his creative work than it is to any fresh endeavor. Images of airborne figures make up an intriguing subject in Goya's art. Depicting flights undertaken for a variety of different reasons, the artist returned to this subject repeatedly. Major examples include flying demons and she-devils in *The Caprices;* soaring angels in the murals of the Church of San Antonio de la Florida in Madrid; flying figures that can be categorized as *sueños* ("dreams"); the fall of Icarus (fig. 1; H.52, Museo del Prado, Madrid); and the flight of a balloon (fig. 2; Musée des Beaux-Arts, Agen; there are also two drawings in Hamburg and Madrid).

The present drawing, *Young Woman Floating in the Air,* is one of the most radiant images of a flying figure in Goya's work. If this is a *sueño,* it would seem to be one related to yearnings for the sublime or for some marvelous transformation. Gassier contrasts this sheet with the ink drawing from album E called *Nightmare* of 1803–12 (fig. 3; E.20, The Pierpont Morgan Library, New York), a demonic vision. In addition to the sheets in *The Caprices,* the representation

1. Francisco de Goya. *Daedalus Seeing Icarus Fall* (H.52). 1824–28. Museo del Prado, Madrid (395)

29.

Francisco de Goya. *Young Woman Floating in the Air* (H.59). Lithographic crayon on laid paper, 7½ x 6" (19.1 x 15.4 cm). Inscribed upper right: *59.* Stamp at upper right: L.2785. Inscribed on passepartout: *30.* Watermark at center of left edge: GH.I. Inv. no. 131-17994

LITERATURE: Loga 1903, no. 611. Lafond 1907, no. 30, p. 11 (ill.). Gassier/Wilson, no. 1817. Gassier I, no. 471, p. 646, ill. p. 627.

2. Francisco de Goya. *The Balloon.* 1808–12. Musée des Beaux-Arts, Agen

of a female being flying through the air has another prototype: *Flight of Witches* of 1797–98 (Museo del Prado, Madrid). A nude young sorceress galloping on a ram or on demons becomes a kind of allegory of diabolical beauty and the ruinous force of the passions. Goya also frequently depicted figures who are leaping or are suspended in the air (such as drawings D.2 through D.4; see fig. 4).

The drawings associated with flight are often extraordinarily compelling in their composition, making effective use of the proportions of the sheet. The largely empty white of the paper around the figures is no less important than the figures themselves, helping them to soar in open space. And so it is in the Gerstenberg drawing, where a rather voluminous and material figure seems to achieve a state of weightlessness. The faint hints of a cloud or veil to the right serve to deepen and extend the sense of space. *Young Woman Floating in the Air* doubtless depicts an unearthly figure, but her unreality is of an ethereal kind, antithetical to the demonic world of Goya's nightmares.

4. Francisco de Goya. *Mirth* (D.4).
1801–3. The Hispanic Society of
America, New York (A.3308)

# FRANCISCO DE GOYA

## WOMAN WITH A CHILD ON HER LAP

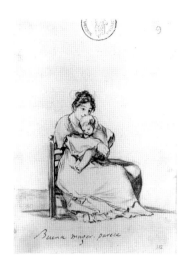

1. Francisco de Goya. *A Good Woman, Apparently* (C.9). 1803–24. Museo del Prado, Madrid (13)

30.

Francisco de Goya. *Woman with a Child on Her Lap* (H.49). Lithographic crayon on laid paper, 7½ × 5⅞" (19.2 × 15 cm). Inscribed upper right: *49*. Stamp at upper right: L.2785. Inscribed on passepartout: *31*. Watermark at center of left edge: GH.I. Inv. no. 131-17995

LITERATURE: Loga 1903, no. 611. Lafond 1907, no. 31, p. 11 (ill.). Calvert 1908, pl. 566. Gassier/Wilson, no. 1809. Gassier I, no. 463, pp. 503, 644, ill. p. 619. Flekel 1974, p. 183.

Goya made a number of images of women holding or caring for children, and all of them are different. Sometimes they have a hint of irony about them, as in the drawing *A Good Woman, Apparently* of 1803–24 (fig. 1; C.9, Museo del Prado, Madrid), where maternal goodness seems to pose for admiration. At other times the images are eccentric, such as the drawing designated E.22(?) of 1803–12 (fig. 2; private collection, United States), in which Goya showed a bearded woman with a child in her arms and added the inscription "This woman was painted in Naples by José Ribera called Lo Spagnoletto around the year 1640." What most distinguishes the present treatment of the subject, however, is its light and shadow.

Gassier notes that along with sheets H.60 (plate 4) and H.61, this drawing is one of the most darkly rendered in album H. The thick vertical and horizontal strokes, in some places rubbed into the paper, create a dense black background against which the light figure stands out sharply. Despite the homey nature of the image – a woman holding a baby – some have seen here a hint of the mystical in the treatment of light and dark. The woman and, in particular, the sleeping child are bathed in light from some unspecified source.

Gassier compares this drawing with the works of Eugène Carrière, the French master of the late nineteenth century who in his art, particularly his lithographs, also made use of the device of having figures float out of darkness or mist. I believe that while this comparison may be useful in terms of understanding one particular technical device, it tells us little about the objectives pursued by these two very different artists and the ultimate meaning of their works. For Goya, any symbolic qualities inherent in light and dark were part of a natural, organic system of thought; for Carrière, however, the handling of light related to his interest in spiritual mysteries.

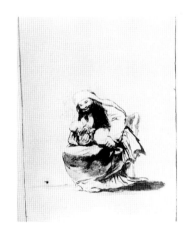

2. Francisco de Goya. *This Woman Was Painted in Naples by José Ribera Called Lo Spagnoletto Around the Year 1640* (E.22[?]). 1803–12. Private collection, United States

# FRANCISCO DE GOYA

**THE SKATERS**

1. Francisco de Goya. *The Skaters* (F.30). 1812–23. Museum of Fine Arts, Boston. Otis Nocross Fund and Gift of Mrs. Thomas B. Card (61.166)

31.

Francisco de Goya. *The Skaters*. Pen and ink on laid paper, 5 x 7⅜" (12.8 x 18.6 cm). Stamp at upper right (diagonally): L.2785. At upper center on mounting sheet: *XXXVII*. Inscribed on passe-partout: *32*. Watermark at center of lower edge: cartouche with a vine and the word *CAPELLADE*. Inv. no. 131-17996

LITERATURE: Loga 1903, no. 611. Lafond 1907, no. 32 (ill.). Bertels 1907, ill. 51. Calvert 1908, pl. 552. Levina 1958, p. 317. Gudiol 1970, vol. 1, p. 401, no. 1.224; vol. 4, p. 985 (ill.). Gassier/Wilson, no. 1837. Gassier II, no. 387, p. 561 (ill.).

In his 1907 publication of the drawings, which at that time were still in the Aureliano de Beruete collection, Lafond recounted the collector's opinion of this sheet. Beruete believed that this India-ink drawing was made in Paris in 1824. Lafond, however, correctly pointed out that when Goya was in the French capital – from June to September – he could not have seen anything of this sort, and that most probably the drawing was done in Bordeaux that winter. The winter of 1824–25, as Goya's friend Moratin related, was unusually severe in this region, and the artist went to see people from Bordeaux skating on the frozen marshes near Garonne.

Goya had already done a sepia drawing of ice skating in album F, *The Skaters* of 1812–23 (fig. 1; Museum of Fine Arts, Boston). Gassier assumed that this kind of recreation, rare in Spain, could have been possible during the harsh winters sometimes seen even in these southern latitudes. He proposed a specific setting, the Casa de Campo near Madrid.

The present drawing is somewhat similar to an etching or drypoint, as the artist, in manipulating his pen, wittingly or unwittingly imitated those techniques; the broken lines very rarely merge into continuous areas of color, emphasizing the similarity to those graphic techniques. The drawing is also noteworthy in terms of composition and space, for it manages to mingle depth with flatness and attention to small details with a concern for the coherence of the overall scheme. This small sheet contains all the components necessary for a major canvas, and its carefully wrought decorative design creates a deep and multileveled space.

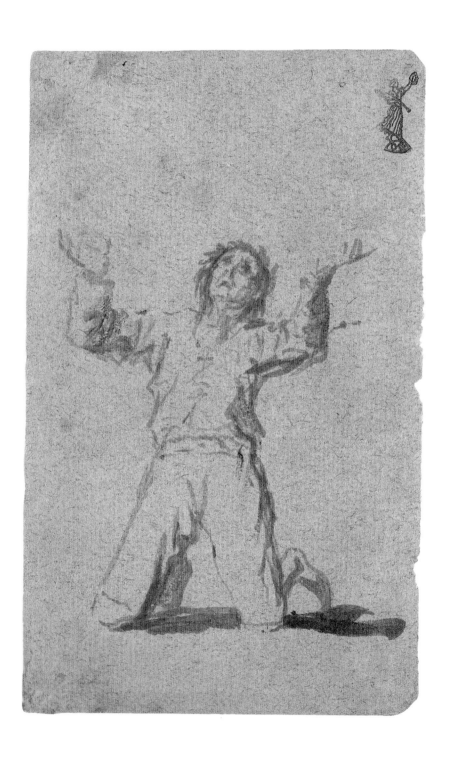

This drawing, which was published by Lafond, was not included in the Gassier/Wilson catalogue raisonné or in the two-volume catalogue of Goya's drawings (Gassier I, II). The present sheet represents a frequent subject of Goya's, related to supplication, repentance, and religious ecstasy. There are a great many analogous compositions in his work. The major ones were cited earlier, in connection with the drawing *He's Saying His Prayers* (plate 9; G.23), and they include the painting *Christ on the Mount of Olives* of about 1819; compositions portraying praying saints (Gassier/Wilson, nos. 53, 55, 239, 713, 714); the first etching in *The Disasters of War,* called *Sad Presentiments of What Must Come to Pass;* and a drawing from album G, *Weeping and Wailing* (G.50). To these, the drawing from album C called *Divine Liberty* of 1820–24 (fig. 1; C.115) can be added, which shows a figure in a very similar pose.

*The Prayer,* identified with the letter "A," is executed in the same manner and on the same paper as sheet "B" (plate 33), which follows it. Stylistically, it is quite consistent with Goya's other creative work and deserves to be acknowledged as part of his oeuvre.

32.
Francisco de Goya. *The Prayer*. Watercolor on rag paper with blue and red threads, 6¾ x 4⅛" (17.2 x 10.5 cm). Stamp at upper right: L.2785. Inscribed on passe-partout: *A*. Inv. no. 131-17997
LITERATURE: Loga 1903, no. 611. Lafond 1907, no. A, p. 12 (ill.). Calvert 1908, pl. 573. Gudiol 1970, vol. 1, p. 397, fig. 860; vol. 4, p. 712 (ill).

1. Francisco de Goya. *Divine Liberty* (C.115). 1820–24. Museo del Prado, Madrid (346)

# FRANCISCO DE GOYA

**MONK**

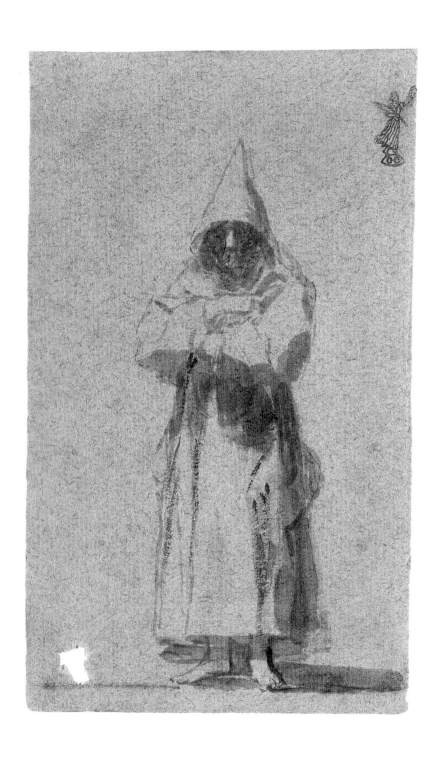

In his drawings catalogue, Gassier links this sheet
to the lithograph *Monk* (fig. 1), done shortly before
Goya's departure for France in 1824. Earlier, the Goya
catalogue raisonné had given a different date for this
lithograph (Gassier/Wilson, no. 1698), indicating the
span 1819–25. The two works are similar only in that
each depicts a standing monk wearing a hooded
habit. Otherwise, they are quite different. The litho-
graph portrays action, for the monk with a cross in
his right hand is clearly among people, and the sharp
turn of his head responds to the group in which he
finds himself. The sheet from the Gerstenberg col-
lection, on the other hand, shows a lone figure,
removed from the world, and it is sometimes known
as *Monk in Meditation*.

33.

Francisco de Goya. *Monk*. Watercolor on rag paper with blue and
red threads, 6¾ x 4" (17.2 x 10.1 cm). Stamp at upper right: L.2785.
Inscribed on passe-partout: *B*. Inv. no. 131-17998
LITERATURE: Loga 1903, no. 611. Lafond 1907, no. B, p. 12 (ill.).
Calvert 1908, pl. 576. Gassier/Wilson, no. 1531. Gassier II, no. 374,
p. 548 (ill.).

1. Francisco de Goya. *Monk*.
c. 1824. Staatliche Museen zu
Berlin, Preussischer Kulturbesitz,
Kupferstichkabinett (201-1905)

# FRANCISCO DE GOYA

## JACOB AND HIS SONS WITH THE BLOODY TUNIC

Traditionally, this sheet has been called *Jacob and His Sons with the Bloody Tunic*. Nevertheless, in his catalogue of Goya's drawing albums Gassier gave it a new title, *Reclining Old Man Receiving Two Visitors*. Gassier, who was working from an old photograph and did not have access to the original work, doubted that it was Joseph's tunic which was depicted in the visitors' hands. The image of the cloth appeared to him to be more like something hanging on a stick. It is true that Joseph's garment is not shown by the artist as the single, suspended mass of clothing one might have expected, but rather as a light piece of fabric stained and spotted with dried blood. Unfortunately, no inscribed title can be deciphered. The treatment of the subject, however, leaves no room for doubt. Goya, always accurate in his details, adheres strictly to the traditional iconography of this biblical scene. Even in such a small work, executed in a dark and rough style, Goya delineates the psychological states of his characters: the horrified amazement of the elderly Jacob, who has suddenly recognized in the bloody rags the clothing of his beloved son; and the bent backs of two of Joseph's brothers, conveying shame rather than grief.

In album F, in which Goya worked from 1812 to 1823, there are many compositions structured in ways roughly similar to this Gerstenberg sheet: The image is viewed through architectural features, often an arch, which frame it. (Compare drawings F.19–F.21, F.28(?), F.33, F.36, F.37, F.59, F.93, and F.a in this regard.) As a rule, in this album Goya also inscribed titles in the upper part of the sheet. Sometimes he left them visible, as in drawing F.86, and sometimes he covered them over, as in F.a.

34.

Francisco de Goya. *Jacob and His Sons with the Bloody Tunic* (F.62[?]). Pen, brush, and ink on laid paper, 6⅞ x 5⅜" (17.4 x 13.5 cm). Inscribed upper right (under a layer of ink and barely legible): 62. Stamp at upper right: L.2785. Inscribed on passepartout: *D*. Watermark at center of left edge: F.II. Paper glued at upper left, possibly by the artist. Inv. no. 131-17999

LITERATURE: Loga 1903, no. 611. Lafond 1907, no. D, p. 12 (ill.). Calvert 1908, pl. 570. Gassier/Wilson, no. 1483. Gassier I, no. 328, p. 488, ill. p. 440.

# FRANCISCO DE GOYA

**PAUPERS**

The sheet, which Gassier placed under the heading "Various Drawings" and dated c. 1810–20, portrays paupers warming themselves at a fire under an arch. An arch also appeared in the previous composition, *Jacob and His Sons with the Bloody Tunic* (plate 34). The group is shown as a dense, compact mass in a space clearly defined by the heavy archway looming over them. Arches appear most frequently in those compositions of Goya's that depict confinement, whether in prisons or asylums, and those that portray states of dependence.

35.
Francisco de Goya. *Paupers*. Watercolor, wash, and pencil on laid paper, 10 x 6" (25.5 x 15.4 cm). Stamp at lower right: L.2785. Inscribed on passe-partout: *E*. Paper glued at center of sheet, within composition, possibly by the artist. Inv. no. 131-18000
LITERATURE: Loga 1903, no. 611. Lafond 1907, no. E, p. 12 (ill.). Calvert 1908, pl. 545. Gudiol 1970, vol. 1, p. 400, no. 1.218; vol. 4, p. 979 (ill.). Gassier/Wilson, no. 1528. Gassier II, no. 371, p. 545 (ill.).

36.

Thomas Rowlandson (1756, London–1827, London). *Dog Fighters Club*. Ink, watercolor, and wash, 4¾ x 7⅜" (12.2 x 18.8 cm). Signed and dated lower right in ink: *1816/Rowlandson*. Inscribed lower left in ink: *Dog Fighters Club in Fothill Street Westminster*. Inscribed on back of frame: *H.B. Inv. no. 151-21644*

PROVENANCE: Helene Bechstein, Berlin.

1. Thomas Rowlandson. *A Dog Fight (The Westminster Pit)*. 1811. Private collection

2. Thomas Rowlandson. *The Hunt Supper*. c. 1790. Victoria and Albert Museum, London

In May 1811, Rowlandson produced *A Dog Fight (The Westminster Pit)* (fig. 1; Grego 1880, vol. 2, p. 206, ill. p. 207). Grego noted that this work was apparently not published because of a ban on such brutal sports. Dog fights were usually arranged in the Westminster area, where those seeking such experiences gathered in arenas like the one depicted. Here, Rowlandson effectively conveyed the atmosphere of this bloody pastime.

The present drawing represents not the practice of the sport itself but a group of dog trainers or owners. Were it not for the artist's inscription, which identifies this as a club for aficionados and handlers of fighting dogs, the drawing could be taken as showing any of London's numerous clubs for sportsmen and amateur enthusiasts. The British passion for hobby clubs was a particular target of satire. Rowlandson, who seems to have spared no aspect of the life of his countrymen in his art, devoted a considerable number of works to such subjects. Meetings of these clubs – devoted to the hunt, horses, boxing, antiquities, rare coins and medals, and so on – generally follow similar scenarios, and their typical finale is brilliantly portrayed in *The Hunt Supper* (fig. 2; Victoria and Albert Museum, London).

Until recently, a more finished and developed version of the present drawing was to be found in the collection of Major Leonard Dent, London (fig. 1; see London 1984, no. 26, ill. p. 39), a sheet that is not signed but which bears the same inscribed title: *Selling a Wife*. The differences between the two sheets are minor: The background of the drawing formerly in the Dent collection is more developed, architectural details are introduced, and the action takes place on a city square that features a column in its center. The central female figure in the London sheet is essentially the same, aside from a few insignificant changes in the style of her hat. The gesture of the soldier's right hand has been changed. In the London sheet he points to the woman with his finger, while in the present drawing he proffers a coin. The secondary figures are slightly different. Judging from the soldier's uniform, both drawings can be dated 1812–14.

Robust women from the common people, shown with arms akimbo, occur frequently in Rowlandson's art, as do street scenes, often involving disputes. The woman on a tether in the present drawing, calmly being sold by her husband, is just the opposite of the outspoken female figure in the famous *Quarrel* of 1794 (fig. 2; Fitzwilliam Museum, University of Cambridge), despite the similar pose.

1. Thomas Rowlandson. *Selling a Wife*. 1812–14. Private collection

37.

Thomas Rowlandson. *Selling a Wife*. Ink, watercolor, and pencil, 4¾ x 8" (12.2 x 20.4 cm). Signed lower right in brown pencil: *Rowlandson*. Inscribed lower left in pencil: *Selling a Wife*. Label on back of frame: *Gebrüder Röhlich / 12. Leipziger-Str. 12. / K. Hoflieferanten / Berlin. W.* Inscribed on back of frame: *H.B.* Inv. no. 151-21646

PROVENANCE: Helene Bechstein, Berlin.

2. Thomas Rowlandson. *The Quarrel*. 1794. Fitzwilliam Museum, University of Cambridge

# THOMAS ROWLANDSON

**THE SMITHY**

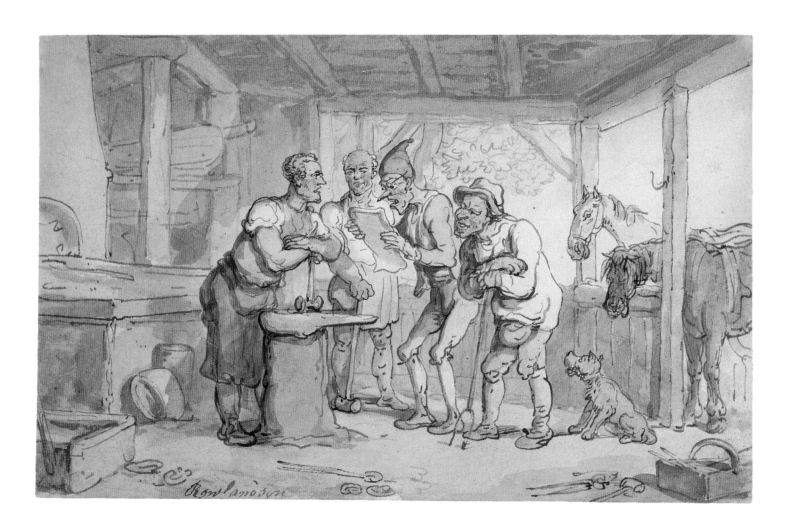

Throughout his creative work, Rowlandson depicted people reading newspapers or broadsides and responding to accounts of political or sporting events. In this drawing, a blacksmith has been distracted from his labor. His work may well suffer for it, since metal heated in preparation for hammering in the forge should not be allowed to cool.

Rowlandson produced a considerable number of scenes of daily rural life, as in *Tour in a Post Chaise* of 1784. The interior of a smithy and the process of a blacksmith's work are depicted in the drawing *Shoeing: The Village Forge* (fig. 1; Henry E. Huntington Library and Art Gallery, San Marino, California; engraved 1787, Grego 1880, vol. 1, no. 212).

1. Thomas Rowlandson. *Shoeing: The Village Forge*. 1787. Henry E. Huntington Library and Art Gallery, San Marino, California

38.

Thomas Rowlandson. *The Smithy*. Ink, watercolor, and pencil, 5 x 7⅝" (12.6 x 19.5 cm). Signed lower left in ink: *Rowlandson*. Label on back of frame: *Gebrüder Röhlich / 12. Leipziger-Str. 12. / K. Hoflieferanten / Berlin. W.* Inscribed on back of frame: *H.B.* Inv. no. 151-21645

PROVENANCE: Helene Bechstein, Berlin.

# THOMAS ROWLANDSON

## JUSTICE OF THE PEACE

Justice of the Peace

Rowlandson

Judging by the dress of the figures, this drawing was made in the 1790s. This scene from daily life shows the indictment of a village poacher. The composition does not display the satirical features usually characteristic of Rowlandson; rather, it reveals the impact of sentimental and edifying literature.

Generally speaking, the artist's distinctive technique remained unchanged throughout the decades. Rowlandson created most of his works on paper using a light pencil sketch, energetic drawing in pen, and transparent watercolor wash.

39.

Thomas Rowlandson. *Justice of the Peace*. Ink and watercolor, 4⅝ x 7⅝" (11.6 x 19.5 cm). Signed lower right in ink: *Rowlandson*. Inscribed lower center in brown ink: *Justice of the Peace*. Label on back of frame: *Gebrüder Röhlich / 12. Leipziger-Str. 12 / K. Hoflieferanten / Berlin. W*. Inscribed on back of frame: *H.B.* Inv. no. 151-21647

PROVENANCE: Helene Bechstein, Berlin.

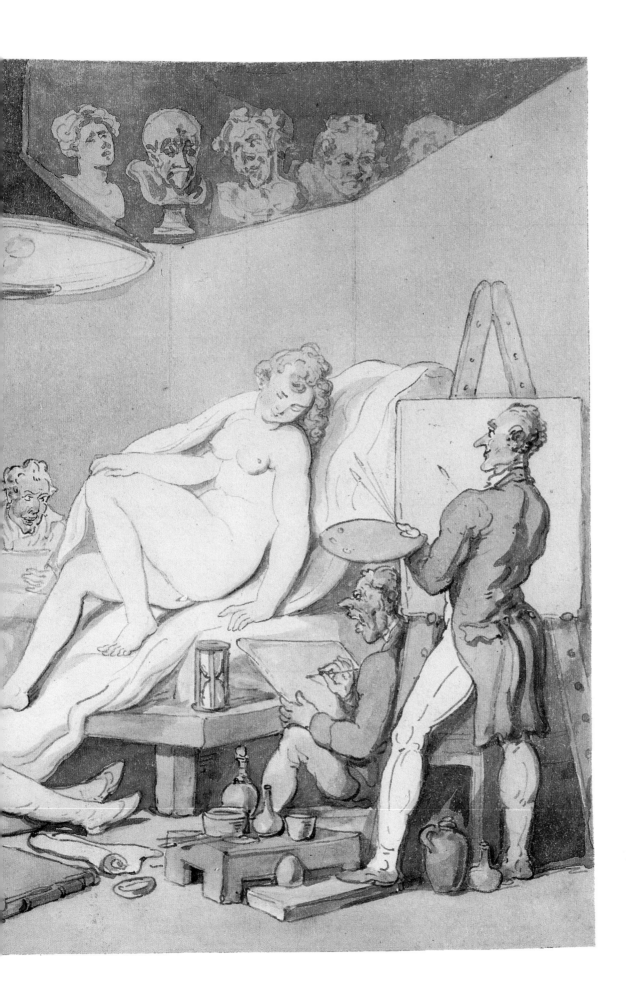

# THOMAS ROWLANDSON

## LIFE CLASS

1. Thomas Rowlandson. *Dutch Academy*. 1792. The British Museum, London. Department of Print and Drawings

40.

Thomas Rowlandson. *Life Class*. Ink, watercolor, and pencil, 8 x 11½" (20.3 x 29.3 cm). Signed lower right on old mounting in pencil: *T. Rowlandson*. Inscribed lower left on old mounting in pencil: *no. 4*. Label on back of frame: MURRAY & HEATH LONDON 625 AO. Inscribed on back of frame: *H.B.* Inv. no. 130-21149

PROVENANCE: Helene Bechstein, Berlin.

The subject of a life class first appeared in Rowlandson's work in 1776 in the drawing *Artists' Studio* (private collection, England). Throughout his creative life, the artist frequently returned to this subject, as in the drawing *French Academy* (Harvard University Art Museums, Cambridge, Massachusetts). In March 1792, *Dutch Academy* was published (fig. 1), which satirically depicted a corpulent model with artists who seemed to be the descendants of the minor Dutch masters. The drawings for this print are in the Harvard University Art Museums and in the Leger Gallery, London. This subject was the first illustrated in the publication *Microcosm of London* (1808). The last prints showing life classes were done in 1824–25 (Grego 1880, vol. 2, p. 378).

The drawing from the Bechstein collection has apparently not been published previously, and it now rejoins Rowlandson's oeuvre. It is a variant of the well-known sheet that the artist gave to his friend John Thomas Smith, an antiquarian and the custodian of drawings and prints at the British Museum. The Smith drawing, *Life Class at the Royal Academy* (fig. 2; private collection; Sotheby's, London, July 11, 1991), bears the artist's signature, an inscription in pen and brown ink – "Given to my Old Friend Smith Ths. Rowlandson" – and a watermark indicating the year the paper was made, 1798. Hayes dates the drawing to that same year (Hayes 1990, no. 71, p. 170, ill. p. 171). Grego noted that this was the best of all of the drawings given to Smith (Grego 1880, vol. 2, p. 16). The strength of the composition, as Paulson

has suggested, lies not only in the contrast between the heroic sculptures and the somewhat grotesque would-be artists, but also in the juxtaposition of the beautiful female model and the men who are staring at her, one of whom, near the center, is noticeably younger and more handsome than the others (Paulson 1972, pp. 27–28). The Academy's rules stipulated that only respectable married men – not students – be permitted to work from a life model.

While these men are portrayed satirically, the figure at the easel is untouched by caricature. That figure is traditionally considered to be a self-portrait of the artist. Grego, and Hayes following him, noted that Rowlandson depicted himself as considerably younger than he actually was; in 1798, he was forty-two years old. Rowlandson was frequently painted by his contemporaries. In the two portraits done by his friends John Raphael Smith and John Bannister in 1795 (both in the British Museum, London), Rowlandson looks much younger than in the self-portrait in *Life Class at the Royal Academy,* which was probably produced only three years later. It is very similar to the late portrait from 1815 by George Henry Harlow (National Portrait Gallery, London). It can be assumed that works concerned with life classes were created between 1800 and 1810, and not in the late 1790s. Nevertheless, Robert Wark considers one of the versions of this subject (fig. 3; Henry E. Huntington Library and Art Gallery, San Marino, California) in which the artist also portrayed himself – but from another angle – as an earlier work, and dates it to the 1780s (Wark 1975, no. 82, p. 53). I believe that all three drawings are retrospective in character and can be interpreted as Rowlandson's later reminiscences of the years spent at the Academy.

2. Thomas Rowlandson. *Life Class at the Royal Academy*. 1798. Private collection

3. Thomas Rowlandson. *Life Class*. c. 1798. Henry E. Huntington Library and Art Gallery, San Marino, California

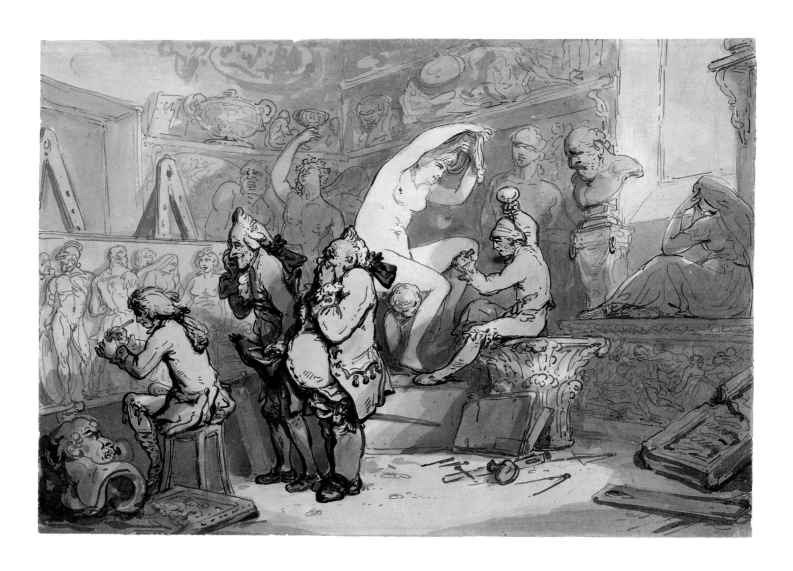

41.

Thomas Rowlandson. *The Sculptor Shop*. Ink, watercolor, and pencil on laid paper, 9½ x 13⅝" (24 x 34.5 cm). Inscribed on verso in pencil: *The Sculptor Shop*. Watermark at center. Label on back of frame: *MURRAY & HEATH/LONDON*. Inscribed on back of frame in oil: *H.B.* Inv. no. 130-21150

PROVENANCE: Helene Bechstein, Berlin.

In this composition, which was probably executed in the 1780s or 1790s, Rowlandson simultaneously portrayed three subjects: creating art, looking at art, and trading in art. The satirical nature of the work is evident first and foremost in the depiction of the "connoisseurs." Their awkward figures are in sharp contrast to the classically sculpted forms of the ancient gods, heroes, and philosophers. On the other hand, the sculptor and his creation – which seems almost alive – are presented with a tinge of eroticism, apparently hinting at the story of Pygmalion and Galatea; the incongruous disproportion between their scales, however, makes the ancient myth of love seem faintly ridiculous.

The subject of a studio and of a sculptor carving a classical statue was rather caustically represented in Rowlandson's well-known *Preparations for the Academy* or *Old Joseph Nollekens and His Venus* of 1800 (Grego 1880, vol. 2, p. 16; Oppe, 1923, pl. 48). The caricatured image of Nollekens was humorously presented by John Thomas Smith in his biographical notes *Life of the Sculptor Nollekens*. As Grego indicated, Rowlandson's compositions showing life classes, and in particular the personalities of the artists working from the model, clearly hint at the colorful figure of Nollekens.

The figure of an observer, standing to one side and calmly scrutinizing the scene, recurs frequently in Rowlandson's work. This character moved from drawing to drawing in virtually unchanged form. His impassive figure was incorporated into the most different kinds of situations, be it watching an artist at work, as in the present drawing, or witnessing the amputation of a leg (fig. 1; engraved 1783; Grego 1880, vol. 1, p. 107).

1. Thomas Rowlandson. *Amputation*. 1783. Published in J. Grego, *Rowlandson the Caracaturist* (London, 1880), vol. 1, p. 107

42.

Jean-Auguste-Dominique Ingres (1780, Montauban, Tarn-et-Garonne–1867, Paris). *Portrait of Madame Victor Mottez (Julie-Colette Odevaere)*. Pencil and white chalk on brown paper mounted on cardboard, 13¾ x 10⅝" (35 x 27.1 cm). Inscribed lower left in pencil: *Ingres à Son/Eleve et ami/Mottez 1844*. Inv. no. 131-17956

PROVENANCE: Victor Mottez (posthumous Mottez sale, Hôtel Drouot, Paris, April 4, 1898, no. 47). Henri Haro (posthumous Haro sale, Hôtel Drouot, Paris, February 3, 1912, no. 142; sold to van Riel for 165,000 francs). Henri Lapauze, Paris. Otto Gerstenberg, Berlin. Margarete Scharf, Berlin.

EXHIBITIONS: "Dessins (d'Ingres) tirés de collections d'amateurs," Salon des Arts-Unis, Paris, 1861. "Ingres," Galeries Georges Petit, Paris, 1911, no. 157.

LITERATURE: Galichon 1861, p. 47. Delaborde 1870, no. 377. Duplessis 1896, no. 19, ill. (first reprod., photo by E. Charreyre). Leroi 1894–1900, p. 818. Lapauze 1901, p. 267. Lapauze 1911, ill. p. 386. Giard 1934, p. 153 (letter from Mottez to his friend Fockedey, summer 1841), p. 157 (letter to Fockedey, February 22, 1842), pp. 164, 165, n. 3. Naef 1977–80, vol. 3, n. 167, pp. 364–71, ill. 1; vol. 5, p. 288, no. 401 (ill.).

This drawing, which Ingres executed in 1844, portrays Julie-Colette Odevaere (1805–1845), the wife of the artist's friend Victor Mottez, and was made a year before her untimely death from tuberculosis. Among Ingres's students, who included Eugène Amaury-Duval, Hippolyte and Paul Flandrin, and Paul and Raymond Balze, Mottez was the artist's favorite and the one with whom he had the closest relationship. According to Amaury-Duval, Ingres was quite fond of Mottez and had a high opinion of his talent (see Amaury-Duval 1878). Victor Mottez (1809–1897) came to Ingres's studio in Paris in 1830, and their friendship continued in Italy, where Mottez went with his wife to study classical antiquity in 1835, the same year that Ingres, who had been appointed director of the French Academy in Rome, also went to Italy. In addition to studying the Roman sights, Mottez collected classical objects and traveled with his wife throughout Italy.

Julie-Colette did not merely share her husband's interests; she was an artist herself with a keen interest in antiquity. Ingres warmly supported the Mottez couple's passion for art. In a letter to his friend Fockedey in 1835, Mottez reported that Ingres had sought out for Julie-Colette an old volume on classical mosaics, a subject that particularly interested her at the time. In Italy, Madame Mottez acquired a mosaic that she intended to restore, and asked for Victor's and Ingres's professional advice. For her, art, and in particular classical art, was not merely a pastime or part of a desire to share her husband's work; it was her own passion and her own creative life. Her early death cut short the many artistic projects that she and her husband had planned.

Several artists made portraits of Madame Mottez. In a letter to Fockedey of February 22, 1842, Victor noted that Ingres had made two portraits, of him and of his wife. Portraits of Julie-Colette were also done by Amaury-Duval in 1836 and by Théodore Chassériau in 1841 (fig. 1; Harvard University Art Museums, Cambridge, Massachusetts), and

Victor Mottez himself made portraits of his wife in 1840 (Musée du Louvre, Paris) and 1843 (fig. 2; Musée du Petit Palais, Paris). In 1850, after her death, Mottez recalled in a letter written from London: "She was very obliging, understanding, and posed willingly. The company of a woman who is posing, particularly when this woman is beautiful, is the only way to keep on working because she not only helps you with your ideas, but at every moment she naturally prompts the creation of other ideas."

Ingres to a certain extent continued the venerable French tradition of the pencil portrait, and here he obtained impressive results, both artistically and in terms of psychological insight. Nevertheless, this was something he viewed as secondary, a preliminary to the subsequent creation of painted portraits or merely something necessary to satisfy the unending requests of friends, acquaintances, and people in the social scene. "I live in Paris like someone chained to an anvil. . . . I am exasperated by everything that deprives me of freedom. . . . All of Paris is forcing

1. Théodore Chassériau. *Portrait of Madame Mottez*. 1841. Fogg Art Museum, Harvard University Art Museums, Cambridge, Massachusetts. Bequest of Meta and Paul J. Sachs

me to draw!" Ingres complained in a letter to his patron Marcotte of June 28, 1845 (see Alain 1949), during the period when he was working on one of his most brilliant portraits, that of the Comtesse d'Haussonville (The Frick Collection, New York). The portrait of Julie-Colette Mottez can be considered one of Ingres's outstanding creations. Like most of his portrait drawings, it was done with a very sharp pencil, in one session (Ingres astonished everyone who observed him working on the pencil portraits by his lightning manner of sketching). The condition of the paper has suffered from the effects of exposure to light over the course of time, taking on a dull tone that has muted the image somewhat and obscured some of the subtler lines. Since the white chalk, however, has retained its freshness, it now appears, by comparison, as something far stronger than the mere color accent that the artist intended it to be. The viewer must make an effort to imagine the original interplay between graphite and

chalk. The light pressure on the pencil and the subtle modulations of tone create a light and refined form, which appears almost immaterial. The mysterious form of the young woman painter, whose aesthetic interests Ingres himself shared, is portrayed with an incipient Romanticism that calls into question the distinction between Neoclassicism and Romanticism over which the supporters of Ingres and Eugène Delacroix fought so desperately. Yet it may still be true to say that Neoclassicism defined a style, while Romanticism defined a worldview, and that the era of Ingres and Delacroix marked the beginning of the still unfinished history of intensely personal self-expression in art.

2. Victor Mottez. *Madame Victor Mottez*. 1843. Musée du Petit Palais, Paris

# EUGÈNE DELACROIX

## ARAB RIDERS ON A SCOUTING MISSION

This watercolor was selected by Baron Schwiter from the posthumous sale of Delacroix's works. In his will, Delacroix offered his old friend, whose passion for collecting he had always supported, a choice of any of his works. Robaut in this connection cited the letter to de Salcy of January 13, 1861, in which Delacroix reported on Baron Schwiter's acquisitions.

The work is not signed or dated. Robaut dated it 1862, and was the first to point to the links between its subject and the canvas once called *Arab Chief Visiting a Tribe* (until 1970 in the collection of the Vicomtesse de Noailles, now in a private collection in Paris), which was painted in 1862. Arama (1987) gives that picture a more precise title – *The Offering of Milk* – although Daguerre de Hurlaux (1993) went back to the old title in his extensive monograph on Delacroix. The present watercolor is in fact a variant of part of that composition, especially in the portrayal of the horseman carrying a raised spear. It is hard to say with certainty whether the watercolor

43.

Eugène Delacroix (1798, Charenton-St.-Maurice–1863, Paris).

*Arab Riders on a Scouting Mission.* Watercolor and gouache, 8⅞ x 17¼" (22.7 x 44 cm). Inv. no. 131-17957

PROVENANCE: Baron Schwiter. Otto Gerstenberg, Berlin. Margarete Scharf, Berlin.

LITERATURE: Robaut/Chesneau 1885, no. 1417, ill. p. 380.

was preparatory to the painting, or made simultaneously with it, or later on.

In these years, Delacroix frequently returned to subjects from his 1832 trip to Morocco. For three decades, he had freely made use of the motifs, compositions, and individual figures from the early works. Despite its obvious reference to the trip, therefore, the present watercolor is nonetheless an independent work, its style characteristic of a later period. It does not seek the sense of lightness that is so attractive in Delacroix's drawings made from nature in the Moroccan sketchbooks and elsewhere.

Delacroix's later work is associated with the monumental commissions for the Louvre's Galerie d'Apollon, the Hôtel de Ville, and the Saint-Sulpice cathedral, and with religious, allegorical, and literary subjects. The richly decorative quality in Delacroix and his desire to create a Romantic style for historical subjects could not fail to be reflected in his smaller works. His late watercolors, as a rule, are "finished" sheets, and in the density of their artistic structure they are comparable to oils.

*Arab Riders on a Scouting Mission* returns to subjects treated in the past. Like the rider on the right, the rider on the left is also a variation, this time of the main figure in the 1862 picture, and the composition as a whole looks back to such canvases as *Arab Horseman Giving a Signal* of 1851 (fig. 1; The Chrysler Museum, Norfolk, Virginia) and the famous canvas of 1837, *The Offering of Milk (Moroccan Caïd Visiting a Tribe)* (fig. 2; Musée des Beaux-Arts, Nantes), exhibited at the Salon in 1838. The 1837 picture shows the

figure – later echoed in the present watercolor from the Gerstenberg-Scharf collection and in the 1862 canvas – of a rider with a banner, to the left in the background. The scene was based on Delacroix's memory of an episode that occurred on April 9, 1832, in Alcassar-el-Kebir (see Delacroix 1932, vol. 1, p. 148). It was there that the French diplomatic mission of Count de Mornay, which included the artist, met part of the Tangiers garrison going to Marrakesh. In his diary, Delacroix described the ceremony of the offering of gifts, including a dish with milk and figs, which he saw on that day. The description gave Arama grounds for changing the title of the 1862 picture, by analogy with that of the 1837 picture. Most writers on Delacroix now use this title (in addition to Arama's monograph, see Johnson 1986, vol. 3, p. 210, no. 416, pl. 225).

1. Eugène Delacroix. *Arab Horseman Giving a Signal*. 1851. The Chrysler Museum, Norfolk, Virginia. Gift of Walter P. Chrysler, Jr.

2. Eugène Delacroix. *The Offering of Milk (Moroccan Caïd Visiting a Tribe)*. 1837. Musée des Beaux-Arts, Nantes

44.

Honoré Daumier (1808, Marseilles–1879, Valmondois). *At the Gare*
*Saint-Lazare.* Charcoal, ink, watercolor, and gouache, 15¼ x 21⅝"
(38.7 x 55.1 cm). Signed lower left in ink (twice): *h. Daumier.* Inv.
no. 131-17964

PROVENANCE: Fassin collection, Paris. Guyotin collection, Paris.
Otto Gerstenberg, Berlin. Margarete Scharf, Berlin.

EXHIBITIONS: "Exposition des peintures et des dessins de H.
Daumier," Galerie Durand-Ruel, Paris, 1878, no. 162. "Ausstellung
Honoré Daumier: Gemälde, Aquarelle und Zeichnungen,"
Galerie Matthiesen, Berlin, 1926, no. 75, ill. p. 127.

LITERATURE: Alexandre 1888, p. 377. Geffroy 1901, p. 11. *Kunst*
*und Künstler,* vol. 10 (1912), p. 452. Klossowski 1923, no. 251.
Escholier 1923, p. 156. *L'Amour de l'art* (1926), p. 161. Fuchs 1927,
p. 219. Maison 1968, vol. 2, no. 311, p. 106, pl. 85.

1. Honoré Daumier. *Pleasure*
*Train.* 1864. The Armand
Hammer Museum of Art and
Cultural Center, Los Angeles

*At the Gare Saint-Lazare* is a sketch of Parisian daily
life. Railroad stations appeared in France in the 1830s
and were still a technological marvel in the 1860s. In
1853, Daumier began using the railroad to visit his
friends Victor Geoffroy-Dechaume, Jean-François
Millet, Théodore Rousseau, and Charles-François
Daubigny, who were living in Valmondois and Barbi-
zon. Daumier also enjoyed Sunday trips to Auvers-
sur-Oise. Earlier, in 1844, the artist had done sixteen
lithographs on the subject of the railroad. The theme
of the railroad in Daumier's art includes not merely
the portrayal of the trains themselves but also the
stations, their entrances and exits and waiting
rooms, the crush of crowds (see fig. 1), and people
sitting in the train. Quite a few works are devoted to
this last subject: the diversity of types of people in a
similar situation, waiting inside the railroad car, lan-
guishing in expectation of their arrival at their desti-
nation. Major works depicting this slice of life of the
1850s and 1860s are in the Metropolitan Museum of

Art, New York; the National Museum of Wales, Cardiff; and the Bakalar collection, Boston.

*At the Gare Saint-Lazare* was executed, like most of Daumier's larger drawings, in a complex technique involving several mediums – charcoal, ink, watercolor, and gouache. The drawing is not assigned a precise date in Maison's catalogue raisonné. Daumier usually did not inscribe a date, and it is indeed very difficult to date his works accurately. He could pursue a subject over several years, returning to it again and again. The right part of this work from the Gerstenberg-Scharf collection, showing a couple in a hurry, has a direct analogy with the man and woman in *The Departure of the Train* (fig. 2; private collection, New York; Maison 1968, vol. 2, no. 310), which is dated c. 1862–64 in a recent Metropolitan Museum exhibition catalogue (Ives/ Stuffmann/Sonnabend 1993, no. 47). In a penciled note in a copy of the Maison catalogue belonging to the drawings department of the Metropolitan Museum, Reff extends the date of the New York sheet to 1860–65.

The composition of the sheet from the Gerstenberg-Scharf collection is carefully worked out. As distinguished from *The Departure of the Train,* it includes several independent groups which are united solely by the architecture of the Saint-Lazare station. In this, it clearly demonstrates the artist's skill at constructing a complex story line. The impact of French literature, especially the novel, is clearly felt here. Daumier created his own novel, in which a teeming crowd of varied characters adds up to a single picture of contemporary reality. In Daumier's art, the specific subject of an ordinary Paris day within the walls of the station became not simply a moment, but a view of the larger world of the mid-nineteenth century.

2. Honoré Daumier. *The Departure of the Train.* c. 1862–64. Private collection, New York

# HONORÉ DAUMIER
## THE IMAGINARY INVALID

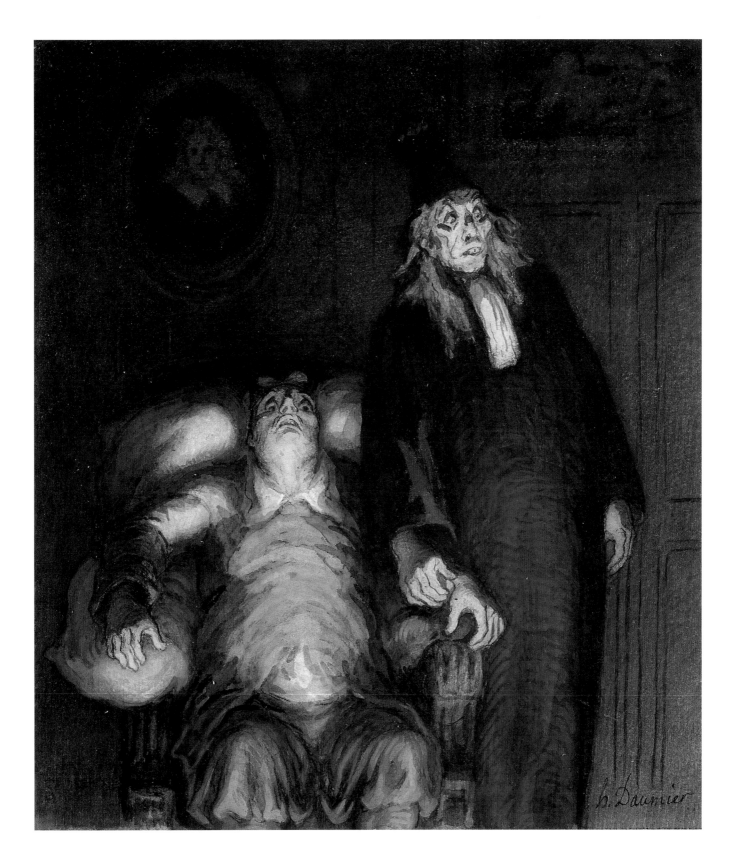

This drawing is one of many versions of the subject. In this case, the subject is linked to Daumier's passion for the theater, and in particular for the works of Molière. In the second half of the 1850s, the Comédie-Française performed two Molière plays that Daumier saw several times: *Les Fourberies de Scapin* and *Le Malade imaginaire*. Molière's protagonists, however, took on a different form in Daumier's works based on them. These cannot be characterized as literal "illustrations." Rather, they are free variations on the themes of Molière's comedies, the drawing from the Gerstenberg-Scharf collection, for example, being a variation on the charged relationship between doctor and patient. As distinguished from Molière's character, Daumier's patient seems actually to be ill, perhaps dying. It is with good reason that one of the sheets of this series is called *The Two Doctors and Death* (Sammlung Oskar Reinhart, Winterthur). There, while two medical know-it-alls point to reference books, Death with his scythe carries off the sufferer. This is characteristic of the drawings on medical subjects (see figs. 1–3); it is the doctors who are consistently depicted as frauds,

45.

Honoré Daumier. *The Imaginary Invalid.* Charcoal, ink, watercolor, and gouache on laid paper, 11½ x 9¾" (29.3 x 24.9 cm). Signed lower right in ink: *h. Daumier.* Watermark in center of right margin in the form of a cartouche. Inv. no. 131-17959

PROVENANCE: P. Bureau, Paris. Probably Matthiesen collection, Berlin. Otto Gerstenberg, Berlin. Margarete Scharf, Berlin.

EXHIBITIONS: "Exposition des peintres et dessins de H. Daumier," Galerie Durand-Ruel, Paris, 1878, no. 115. "Exposition de peintures, aquarelles, dessins et lithographies de maîtres français de la caricature," Ecole des Beaux-Arts, Paris, 1888, no. 406. "Exposition internationale universelle," Paris, 1900, no. 856. "Exposition Daumier," Ecole des Beaux-Arts, Paris, 1901, no. 133.

LITERATURE: Alexandre 1888, p. 376, plate facing p. 165. Marcel 1907, p. 80. Rosenthal n.d., pl. 32. Klossowski 1923, no. 68, pl. 54. Waldmann 1923, pl. 13. Paris 1927, no. 77. *L'Amour de l'art* (1927), p. 151. *Bulletin de l'art ancien et moderne*, no. 738 (1927), p. 171. Fuchs 1927, no. 263b. Escholier 1930, pl. 10. Fleischmann 1937, pl. 42. Adhémar 1954, pl. 35. Maison 1968, vol. 2, no. 476, p. 160, ill. p. 161. Flekel 1974, p. 261.

1. Honoré Daumier. *The Imaginary Invalid.* n.d. Yale University Art Gallery, New Haven, Connecticut. Bequest of Edith Malvina K. Wetmore

2. Honoré Daumier. *The Imaginary Illness.* c. 1860–62. Philadelphia Museum of Art

3. Honoré Daumier. *The Imaginary Illness.* n.d. Courtauld Institute Galleries, London

while the idea of the *malade imaginaire* who is a faker or hypochondriac is relegated to the background. In Daumier's work, the doctors have the same repulsive faces and personalities as the lawyers. These are the two professional categories whose portrayal seems to contain no real humor. The supposed "defenders" of human souls, as represented by the cohorts of barristers, and the "healers" of the human body share a single malevolent essence.

Adhémar dates the work from the Gerstenberg-Scharf collection as 1857, by analogy with the lithograph *Thirty-two Degrees* (Maison 1968, vol. 2, no. 475). In terms of psychology, the Gerstenberg-Scharf sheet is close to the drawing from the Yale University Art Gallery (fig. 1), but that work is executed in a different technique (pen and brush), shows three individuals (two doctors and one patient), and is even more emotionally loaded. The patient, quietly expiring in his armchair, seems hemmed in on both sides. There is no way out; the end is clear. In the art of Daumier, Molière's comedy becomes grim farce.

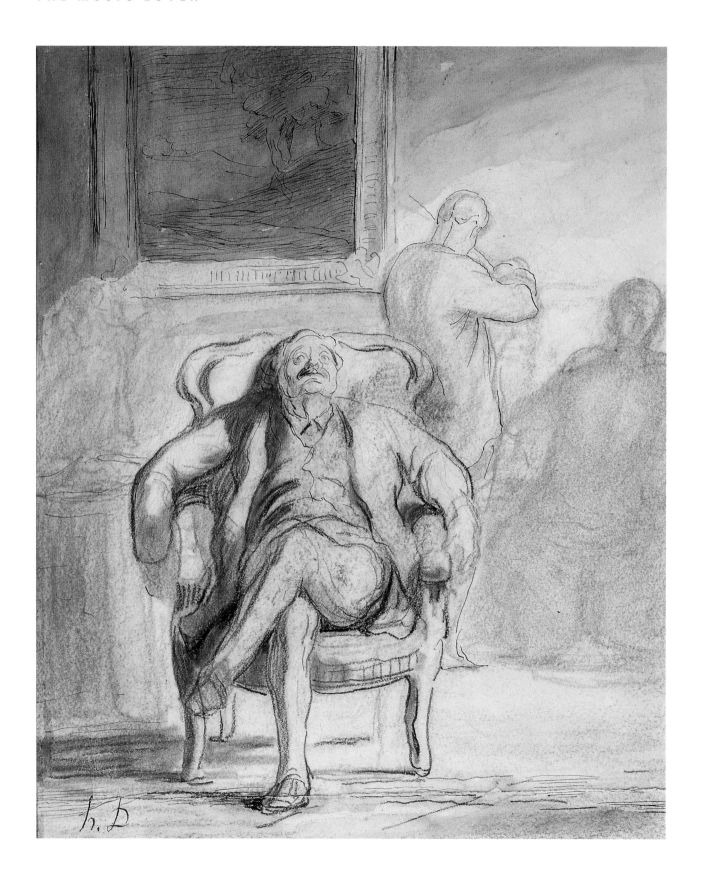

46.

Honoré Daumier. *The Music Lover*. Charcoal, ink, and black and
brown chalk, 11¼ x 9" (28.6 x 23 cm). Initialed lower left in ink:
*h.D.* Inv. no. 131-17961

PROVENANCE: H. Rouart, Paris. Otto Gerstenberg, Berlin.
Margarete Scharf, Berlin.

EXHIBITIONS: "Ausstellung Honoré Daumier: Gemälde,
Aquarelle und Zeichnungen," Galerie Matthiessen, Berlin, 1926,
no. 129, ill. (listed as belonging to F.H., Berlin).

LITERATURE: Paris 1912, no. 34. *Kunst und Künstler,* vol. 9 (1913),
p. 224. *International Studio,* vol. 58 (1913), p. 190. Marées Gesell-
schaft 1918, pl. 5. Klossowski 1923, no. 345, pl. 149. Ars Graphica
1924, pl. 3. *L'Amour de l'art* (1926), p. 164. Fuchs 1927, no. 209b.
Fleischmann 1937, pl. 59. Lassaigne 1938, pl. 70. Cassou 1949, pl. 34.
Adhémar 1954, pl. 36. Maison 1960, no. 113 (ill.). Maison 1968,
vol. 2, no. 346, p. 117, pl. 105. Flekel 1974, p. 249, ill. 108.

From 1850 to 1872, Daumier created series of litho-
graphs devoted to the subject of art and its percep-
tion. In his lithographic works, which were intended
for a mass audience, the caricatural aspect was domi-
nant. Parisian philistines, who considered it their
social duty and moral obligation to visit the Salons,
were portrayed by Daumier with withering sarcasm.
And it was specifically sarcasm, and not humor, that
he used, for nowhere are so many vapidities uttered
as in front of a painting. In mocking the visitors to
the Salons or the idlers in front of windows display-
ing works of art, Daumier acted less as a critic of art
than as a critic of morals. For him, a Salon painting
was dedicated to the self-importance of its viewer.

There are two main subjects concerning the art
world in Daumier's work: the portrayal of the con-
sumers of art, and the portrayal of its creators. The
artist contemplating the work of his own hands is
perhaps Daumier's most deeply felt subject. The
images depicting genuine admirers, connoisseurs,
and collectors of art have some of that same contem-
plative quality. One of the most outstanding is *The
Connoisseur* (fig. 1; The Metropolitan Museum of Art,
New York). A collector gazing at a copy of the *Venus
de Milo* and surrounded by artworks partakes of the

1. Honoré Daumier. *The Connois-
seur.* c. 1860. The Metropolitan
Museum of Art, New York. The
H. O. Havemeyer Collection,
Bequest of Mrs. H. O. Havemeyer,
1929 (29.00.200)

aura of the paintings, sculpture, and drawings belonging to him. And so Daumier's connoisseurs – be they lovers of the fine arts, devotees of literature, or listeners to musical works – as a rule are free of true caricature. His people listening to music are concentrated and absorbed (fig. 2; Museum Boymans–van Beuningen, Rotterdam), and there is only a light touch of humor in these works.

This drawing from the Gerstenberg-Scharf collection is unfinished, though this is not obvious and does not hamper appreciation of the work. The unfinished quality – in the depiction of the seated figure's right hand, the background, and the female figure to the right – creates its own atmosphere. The chalk with which the female figure is drawn creates a soft tonality, and together with the expressive drawing of the central figure seems to convey the "harmony" of the scene.

2. Honoré Daumier. *Study of a Man Listening to Music*. n.d. Museum Boymans–van Beuningen, Rotterdam

# HONORÉ DAUMIER

## INTERMISSION AT THE COMÉDIE-FRANÇAISE

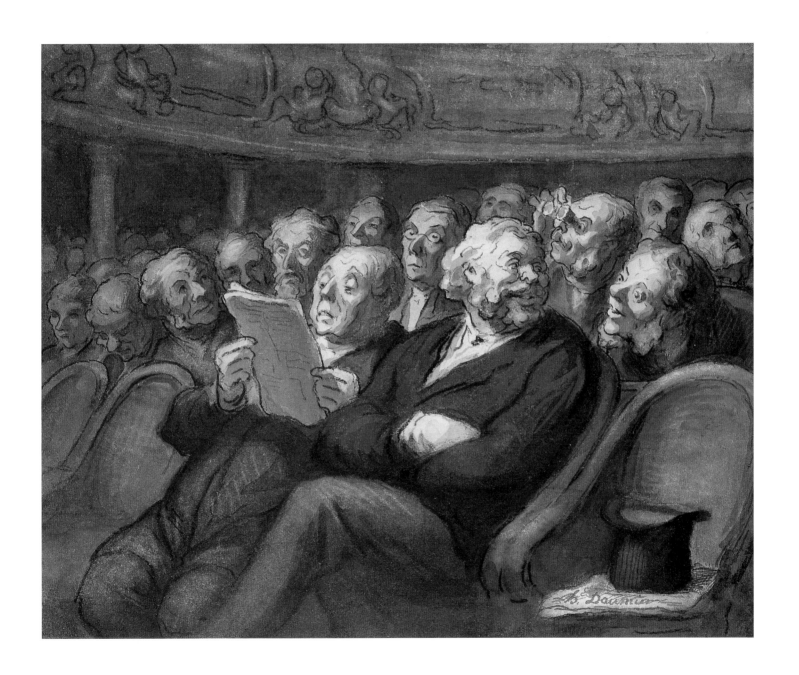

47.

Honoré Daumier. *Intermission at the Comédie-Française*. Charcoal, ink, watercolor, and gouache, 8⅛ x 9⅝" (20.7 x 24.5 cm). Signed lower right in ink: *h. Daumier*. Inv. no. 131-17958

PROVENANCE: Boulard collection, Paris. P. Bureau, Paris. Otto Gerstenberg, Berlin. Margarete Scharf, Berlin.

EXHIBITIONS: "Exposition des peintures et dessins de H. Daumier," Galerie Durand-Ruel, Paris, 1878, no. 184. "Exposition de peintures, aquarelles, dessins et lithographies de maîtres français de la caricature," Ecole des Beaux-Arts, Paris, 1888, no. 388. "Exposition Daumier," Ecole des Beaux-Arts, Paris, 1901, no. 147.

LITERATURE: Alexandre 1888, p. 377. Paris 1900a, no. 151. Geffroy 1901, p. 2. Escholier 1923, plate facing p. 68. Klossowski 1923, no. 101. *L'Amour de l'art* (1927), p. 154. *Bulletin de l'art ancien et moderne* (1927), p. 169. Fuchs 1927, no. 252b. Paris 1927, no. 75. Escholier 1930, pl. 53. Maison 1968, vol. 2, no. 501, p. 168, pl. 171.

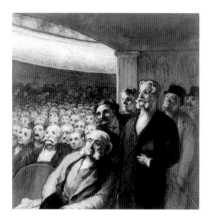

1. Honoré Daumier. *A Theater Audience*. n.d. The Metropolitan Museum of Art, New York. Bequest of Walter C. Baker (1972.118.203)

2. Honoré Daumier. *During the Intermission*. 1858. Sammlung Oskar Reinhart, Winterthur

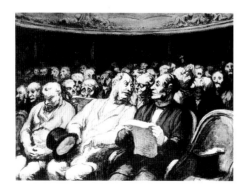

Daumier's passion for the theater was logical and natural, for he himself was a great portrayer of the human comedy. In his own works, Daumier showed the "acting" that is part of daily social and political life, and he had an instinctive grasp of theatrical acting as well. When he depicted the theater, it was not only the actors who were playing roles, but also the viewers and the critics in the audience as well (see fig. 1). There are as many compositions devoted to theatergoers and critics as there are to performers on the stage.

According to Maison, *Intermission at the Comédie-Francaise* was engraved by A. Lepère and reproduced in the *Monde illustré* of May 4, 1878, in connection with an exhibition at the Galerie Durand-Ruel. That was the last Daumier work published during his lifetime. In composition and subject, this drawing is close to one from the Sammlung Oskar Reinhart, Winterthur (fig. 2). Both sheets show members of the audience in the front rows during intermission, most likely theater critics. They look bored to be there but still exude an overbearing sense of professional self-importance.

Daumier's "finished" drawings are more than drawings. The use of the brush and the covering of the entire surface make these compositions more akin to paintings. The drawing aspect as such is felt principally in the charcoal and pen contours, and it is through them that the artist characterizes his figures.

# HONORÉ DAUMIER

**THE DEFENSE PLEA**

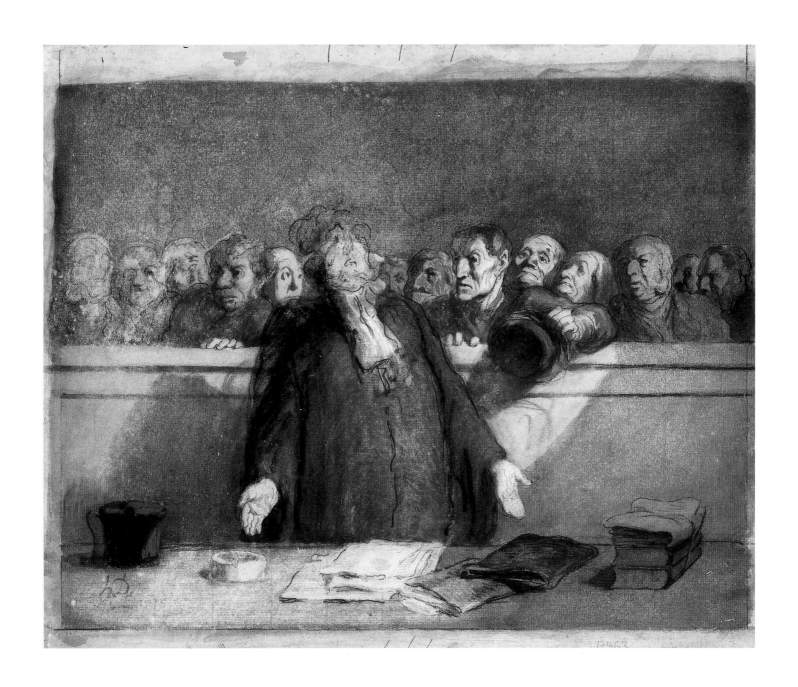

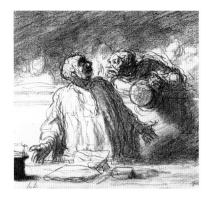

1. Honoré Daumier. *In the Court-room.* c. mid-1860s. Collection the Honorable Samuel J. and Mrs. Ethel LeFrak and Family, New York

48.

Honoré Daumier. *The Defense Plea.* Charcoal, ink, gouache, and white chalk on laid paper, 11¾ x 13½" (29.8 x 34.4 cm). Initialed lower left in black chalk: *h.D.* Black chalk outline around margins. Inv. no. 131-17963

PROVENANCE: Probably Durand-Ruel, Paris. A. Tavernier collection. Probably Bernheim-Jeune, Paris. Otto Gerstenberg, Berlin. Margarete Scharf, Berlin.

EXHIBITIONS: "Exposition Daumier," Ecole des Beaux-Arts, Paris, 1901, no. 280. "Ausstellung Honoré Daumier: Gemälde, Aquarelle und Zeichnungen," Galerie Matthiessen, Berlin, 1926, no. 78.

LITERATURE: Paris 1900b, no. 111. Paris 1907, no. 66. Rosenthal n.d., pl. 44. Marées Gesellschaft 1918, pl. 4. Escholier 1923, plate facing p. 106. Klossowski 1923, no. 120, pl. 69. Waldmann 1923, ill. 10. Ars Graphica 1924, pl. 16. Sadleir 1924, pl. 36. Fuchs 1927, no. 190b. Escholier 1930, pl. 59. Fosca 1933, plate facing p. 56. Lassaigne 1938, pl. 78. Scheiwiller 1942, pl. 20. Maison 1960, ill. 141. Maison 1968, vol. 2, no. 655, p. 217, pl. 248.

The dating of Daumier's works can be intriguing but frustrating. The artist pursued a subject sometimes for several decades, using various techniques – oil, ink, gouache, watercolor, wood engraving, lithograph. And over time, little changed in his attitude to the images he portrayed. The present drawing, *The Defense Plea,* can be dated to approximately the mid-1860s by comparing it with the sheet called *In the Courtroom* (fig. 1; LeFrak collection, New York; Maison 1968, vol. 2, no. 652). The central group in the Gerstenberg-Scharf drawing, consisting of a lawyer and a man behind the railing, was used repeatedly by the artist. It first appeared in one of the lithographs of the series *Les Gens de Justice,* published in *Charivari* on August 24, 1846. In addition to the LeFrak drawing, there are related works in the Victoria and Albert Museum, London (fig. 2), and the J. Paul Getty Museum, Malibu, California (fig. 3). All of these works depict different aspects of the relationship between lawyer and defendant.

In the present drawing, aside from the lawyer only the courtroom audience is shown. A man hold-

2. Honoré Daumier. *A Pleading Lawyer.* n.d. Victoria and Albert Museum, London

3. Honoré Daumier. *A Criminal Case*. c. 1860. The J. Paul Getty Museum, Malibu, California

a series of thirty-nine lithographs published in *Charivari*. There were also wood engravings. Around 1846, the artist began his first painting on the subject of the legal system. It is interesting that in the paintings he depicted only his favorite characters, the lawyers, while in the other works the judicial spectacle included numerous and varied protagonists. Daumier worked on this subject down to the 1870s, repeating, varying, and reworking his compositions. Maison's catalogue lists 18 paintings on this subject and 131 drawings and prints.

It is the court officials who are subjected to the most merciless criticism in Daumier's work. Jules de Goncourt made the following entry in his diary on March 15, 1865: "Recently, while walking along Taitbout street, I saw Daumier's extraordinary watercolors. They depict the get-togethers of the legal brotherhood, meetings of lawyers, processions of judges, on a dark background, in gloomy buildings, for example in the dark office of the investigator or in the dimly lit corridor of the Palais de Justice. This is executed in sinister India ink, in gloomy, dark tones. The faces are revolting, and their grimaces and laughter are horrifying. These people in black are as ugly as frightening ancient masks which have landed in the office of the court. The smiling lawyers resemble the priests of Cybele. There is something reminiscent of fauns in these participants in the judicial dance of death."

ing a top hat, carefully listening to the lawyer's speech, could hardly be taken for the accused. Only the particular tension in his face and hands betrays passionate concern rather than idle curiosity. It is interesting to note that Daumier reworked the entire left part of this sheet, including the figure of the lawyer: The faces of the people at the extreme left are half-erased from the artist's corrections. There were major changes in the figure of the lawyer: The position of the left shoulder was redrawn with charcoal strokes; the palm of the left hand was hinted at; and, most important, the turn of the head and the expression of the face were entirely changed. Originally, the features had been only sketched. The impression is created that Daumier turned the lawyer's face from a profile to a frontal view. This left the other central figure, who still seemed to be speaking with him, without an interlocutor, and his tense facial expression therefore does not seem sufficiently motivated. The major subject of the Gerstenberg-Scharf drawing was originally probably intended, following the example of the works mentioned earlier, to be the secret exchanges between attorney and client.

Daumier was familiar with the subject of the court and all its representatives, including its victims. From March 1845 to October 1848, he produced

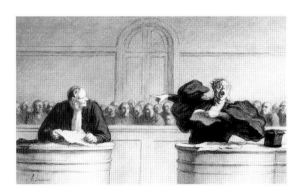

4. Honoré Daumier. *The Speech for the Defense*. n.d. Private collection

# HONORÉ DAUMIER

**ORCHESTRA SEAT**

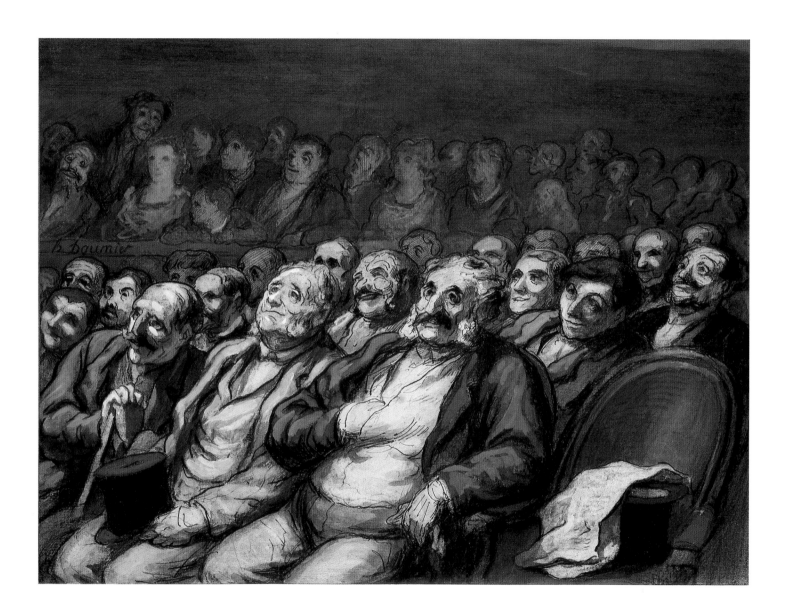

49.

Honoré Daumier. *Orchestra Seat*. Ink, charcoal, watercolor, and gouache on laid paper, 10½ x 14" (26.6 x 34.5 cm). Signed upper left in ink (on the railing of the dress circle): *h. Daumier*. Inv. no. 131-17960

PROVENANCE: Verdier collection, Paris. Doria collection. Probably Durand-Ruel, Paris. Otto Gerstenberg, Berlin. Margarete Scharf, Berlin.

EXHIBITIONS: "Exposition des peintures et dessins de H. Daumier," Galerie Durand-Ruel, Paris, 1878, no. 208. "Exposition de peintures, aquarelles, dessins et lithographies de maîtres français de la caricature," Ecole des Beaux-Arts, Paris, 1888, no. 394. "Exposition Daumier," Ecole des Beaux-Arts, Paris, 1901, no. 194. Sezession, Berlin, 1913. "Ausstellung Honoré Daumier: Gemälde, Aquarelle und Zeichnungen," Galerie Matthiesen, Berlin, 1926, no. 80, ill. p. 55.

LITERATURE: Alexandre 1888, p. 377. Geffroy 1901, p. 3. *Kunst und Künstler* (1913), p. 193. Marées Gesellschaft 1918, pl. 12. New York 1922, ill. p. viii. Klossowski 1923, no. 102, pl. 59. Escholier 1923, p. 148. Sadleir 1924, pl. 12. Ars Graphica 1924, pl. 40. *L'Amour de l'art* (1926), p. 159. Fuchs 1927, no. 250. Escholier 1930, pl. 54. Escholier 1938, p. 107. Lassaigne 1938, pl. 133. Maison 1960, ill. 105. Maison 1968, vol. 2, no. 505, p. 169.

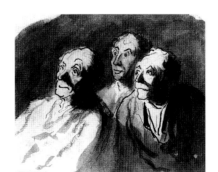

Daumier produced twenty-five paintings and three dozen drawings and watercolors on the subject of the theater (see figs. 1–5), not including those works concerning the circus and the lives of traveling performers. From September 1856 to May 1857, the periodical *Charivari* published his lithographic series of theater sketches and at the same time he began his first paintings on this subject.

Maison considered this drawing from the Gerstenberg-Scharf collection to be the best of the entire theatrical series. He also offered several alternative titles for it. Daumier himself, however, preferred not to give titles to his drawings, and even without one, the subject of this drawing is clear. It is a performance within a performance, in which the main characters are people looking at the stage. The various objects visible have also become characters and are to be understood in the same way as the people. The empty seat with the top hat and newspaper left on it plays its own role, indifferent to what is taking place on the stage.

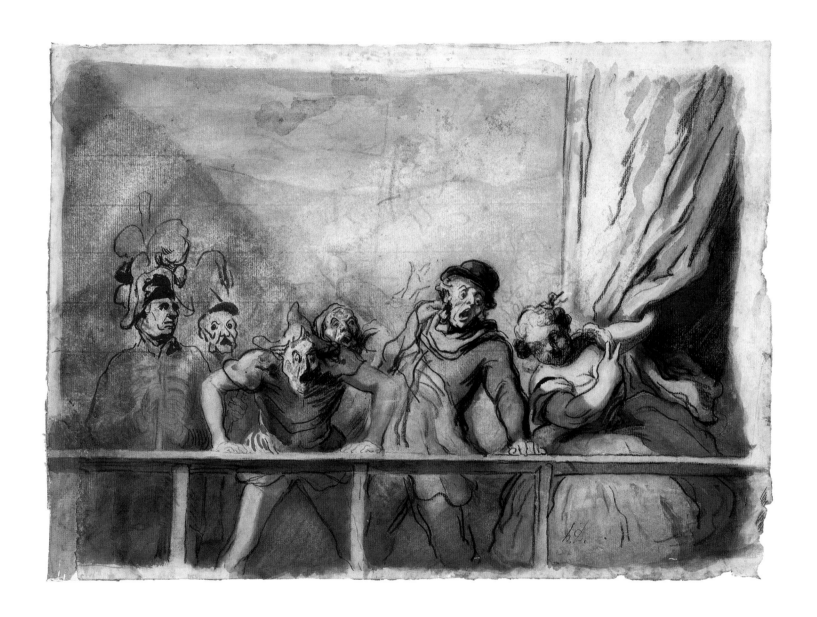

The subject of what the French called the *parade* – a free outdoor sideshow for publicity purposes which took place before the actual performance – appeared in the lithograph *Parade du Charivari,* published January 6, 1839 (an example is in the collection of the Metropolitan Museum of Art, New York). Here Daumier depicted his friends from the Charivari publishing house and himself, playing a woodwind instrument. This lithograph was followed by two drawings (Maison 1968, vol. 2, nos. 523, 524). Daumier returned to the subject of the *parade* several times. A drawing in the Szépmüvészeti Múzeum, Budapest (Maison 1968, vol. 2, no. 554), can be considered a preliminary sketch for the central figures who are fully developed in the Gerstenberg-Scharf drawing. Veronica Kaposy dates the Budapest sheet 1864–65 (see Kaposy 1968, pp. 255–73). Two watercolors – one in the Armand Hammer Museum of Art and Cultural Center, Los Angeles (fig. 1; not in Maison), and one in the Louvre (fig. 2; Maison 1968, vol. 2, no. 556) – are variations on this composition.

The Maison catalogue includes several paintings and graphic works linked to the *parade* subject (vol. 1, no. 142; vol. 2, nos. 508, 509). It has been suggested that the drawing from the Gerstenberg-Scharf collection and the Los Angeles sheet are preliminary works for the more fully realized composition in the Louvre (see Ives/Stuffmann/Sonnabend 1993, no. 104, p. 213).

The artistic merit of the present sheet is in no way inferior to that of the Los Angeles or Paris works. The drawing records the artist's search for a different, blunter kind of expression. First of all, he changed the gesture of the right hand of the barker in the bowler hat. The partially erased image of the hand, which originally extended upward and back in a traditional gesture, remains quite clearly visible. Second, behind the two central male figures another character was added who is absent from all the other versions. Daumier clearly added him later, since it is precisely because of this figure's energetic gesture with his left arm that changes were then made to the

50.

Honoré Daumier. *The Sideshow*. Charcoal, ink, watercolor, and gouache on laid paper, 11⅝ x 15⅜" (29.6 x 39.8 cm). Initialed lower right in ink: *h.D.* On verso: charcoal tracing of the outline of the head and upper torso of the central figure in the bowler hat shown on the recto. Watermark in center: cartouche with a crown and the letters *HB* and, lower, HALLINES. Inv. no. 131-17962

PROVENANCE: P. Bureau, Paris. Otto Gerstenberg, Berlin. Margarete Scharf, Berlin.

EXHIBITIONS: "Exposition des peintures et dessins de H. Daumier," Galerie Durand-Ruel, Paris, 1878, no. 110. "Exposition Daumier," Ecole des Beaux-Arts, Paris, 1901, no. 128. "Exposition de la vente P. Bureau," Paris, 1927, no. 74.

LITERATURE: Alexandre 1888, p. 377. Klossowski 1923, no. 189. *Cicerone,* vol. 19 (1927), p. 297. Fuchs 1927, no. 331a. Paris 1927, no. 74. Escholier 1930, pl. 77. Escholier 1938, pl. 169. Adhémar 1954, pl. 17. Maison 1968, vol. 2, no. 555, p. 186, pl. 201.

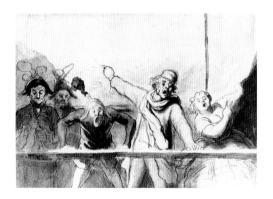

1. Honoré Daumier. *The Sideshow*. n.d. The Armand Hammer Museum of Art and Cultural Center, Los Angeles

2. Honoré Daumier. *The Sideshow*. n.d. Musée du Louvre, Paris. Département des Arts Graphiques (RF 4164)

3. Verso of plate 50, *The Sideshow*

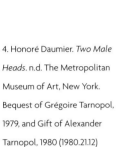

4. Honoré Daumier. *Two Male Heads*. n.d. The Metropolitan Museum of Art, New York. Bequest of Grégoire Tarnopol, 1979, and Gift of Alexander Tarnopol, 1980 (1980.21.12)

barker in the foreground. The gesture of the left arm, apparently echoing the direction of the arm of the female figure raising the curtain, cut across the pointing hand of the main barker. The barker's figure is now turned, and the expression on his face intensifies the effect of shouting. (It can be noted that there is a tracing of the barker's head on the verso; see fig. 3.) The figure in a fool's cap and clown outfit is also depicted in a more expressive manner. The Metropolitan Museum has a sketch of two heads (fig. 4), the one on the right representing a shouting barker. Its mood is close to that of the Gerstenberg-Scharf drawing. Because of its sketch-like nature, the entire composition of the present sheet is expressive and dynamic. Compared to other works on the subject of the *parade,* here all the artistic elements are intensified, and the energetic strokes of the pen and the more heavily emphasized play of chiaroscuro create a genuinely innovative work.

Maison indicated that the figure of the landlord in the present drawing repeats the figure in the composition *Seated Man, Seen in Profile* (whereabouts unknown; Maison 1968, vol. 2, no. 111).

In style of execution, the present drawing belongs to Daumier's later works, when he often worked in pen, sometimes also using charcoal or chalk. The basic composition and the shading were established with charcoal. On top of this went the rapid pen drawing, completing the composition and highlighting the psychological aspects of the scene.

The drawing was intended for a Parisian actor, Daumier's friend Alfred Baron, known by the stage name Cléophas, who performed at the Porte Saint-Martin theater, which the artist frequented. It is not known whether this drawing was a gift or was purchased from Daumier. Passeron (1979) cites evidence that Cléophas intended to buy one of Daumier's works. In any case, there are other works inscribed by the artist "for Cléophas," such as one of the variants of *The Connoisseur* (Museum Boymans–van Beuningen, Rotterdam).

51.

Honoré Daumier. *At the Landlord's*. Brown ink and charcoal, 14⅜ x 12⅝" (36.5 x 32 cm). Inscribed lower left in ink: *h.D. a Cleophas*. In ink on verso of passe-partout: *offert à mon ami/Charles de Bériot/Cleophas/fevrier 1880*. Inv. no. 131-17965

PROVENANCE: Alfred Baron, Paris. Charles de Bériot, Paris. Otto Gerstenberg, Berlin. Margarete Scharf, Berlin.

EXHIBITIONS: "Ausstellung Honoré Daumier: Gemälde, Aquarelle und Zeichnungen," Galerie Matthiesen, Berlin, 1926, no. 84.

LITERATURE: Paris 1907, no. 82. Paris 1911, no. 35. Marées Gesellschaft 1918, pl. 15. Klossowski 1923, no. 450, pl. 119. Ars Graphica 1924, pl. 33. Fuchs 1927, no. 234b. Adhémar 1954, pl. 37. Maison 1968, vol. 2, no. 707, p. 236, pl. 277. Flekel 1974, p. 236, ill. 101.

# JEAN-FRANÇOIS MILLET

**FARM NEAR VICHY**

This Millet landscape was considered by the Scharf family to depict Auvergne. A series of seven sheets is devoted to the same locale shown in the present drawing, a small farm outside Vichy. All seven drawings are variants of the same motif, drawn by Millet in 1866. They differ only in point of view, showing the farm from different positions along the path leading to it. The cycle of drawings constitutes a single panoramic depiction of this scene. The artist circled around the houses that enchanted him, which were located in the middle of a wheat field with sparse trees, and viewed the scene both from close up and from far away. The center of all his images, whether he narrowed or widened his focus, was always the farm.

Four drawings from this series were shown in the centennial exhibitions of 1975–76 at the Grand Palais, Paris, and the Hayward Gallery, London (Paris 1975, nos. 206, 207, 208; in London 1976, no. 122 replaced 208). Of the four sheets exhibited in Paris and London, one is in the Kunsthalle, Bremen (fig. 1; no. 208); two are in the Louvre (figs. 2, 3; nos. 206, 207); and one is in a private collection in Paris (no. 122). Of the three other works depicting the farm motif, one was exhibited at an anonymous sale in Frankfurt in 1927 (Prestel, Frankfurt am Main,

52.

Jean-François Millet (1814, Gruchy, near Gréville, Manche–1875, Barbizon). *Farm Near Vichy*. Pencil and brown ink on laid paper mounted on cardboard, 9¾ x 14¾" (24.7 x 37.5 cm). Stamped lower right: *J.F.M.* (L. Suppl. 1460). Inscribed upper center in ink: *32½ – 47*. Upper right in ink: *tembre jaune passée – filets gris*. Oval stamp on verso from the sale of Millet's works: *1875* (L. Suppl. 1816a). Inv. no. 131-17926

PROVENANCE: H. J. Cottereau, Paris. Otto Gerstenberg, Berlin (acquired in 1912 at the Cottereau sale, Paris). Margarete Scharf, Berlin.

1. Jean-François Millet. *Land-scape with Wheat Field*. 1866. Kunsthalle, Bremen (1963/565)

October 22–November 6, 1927, no. 571, ill.), one is in the Louvre, and one is in the Museum of Fine Arts, Boston.

The drawing that Otto Gerstenberg acquired in 1912 was not known to Millet's biographers and was not included in a single study of his work. It is now returned to Millet's oeuvre, rejoining the 1866 landscapes of the farm near Vichy. Closest in composition is the sheet from Bremen (fig. 1). The different state of the mowed field next to the path in the two drawings would seem to suggest that they were created perhaps a day apart. The Gerstenberg-Scharf drawing was probably executed first, as it shows the left part of the field still unmowed. Then, with the Bremen drawing, the artist moved slightly to the right, crossing from the path into the field itself. The two other drawings (figs. 2, 3; nos. 206, 207) take different vantage points. Millet seems to have chosen his positions so as to put the farm in the center rather than presenting a panoramic sweep.

Sérullaz's idea (Sérullaz 1950, pp. 87–92) – that in such drawings Millet was influenced by Japanese prints (which he had begun enthusiastically collecting and studying in 1863) – seems convincing. This is most clearly seen in the fact that Millet is equally occupied with distant and with close-up planes, both foreground and background; their interaction comprises part of his artistic understanding of space.

2. Jean-François Millet. *Farm Near Vichy*. 1866. Musée du Louvre, Paris. Département des Arts Graphiques

3. Jean-François Millet. *Path Near Vichy*. 1866. Musée du Louvre, Paris. Département des Arts Graphiques

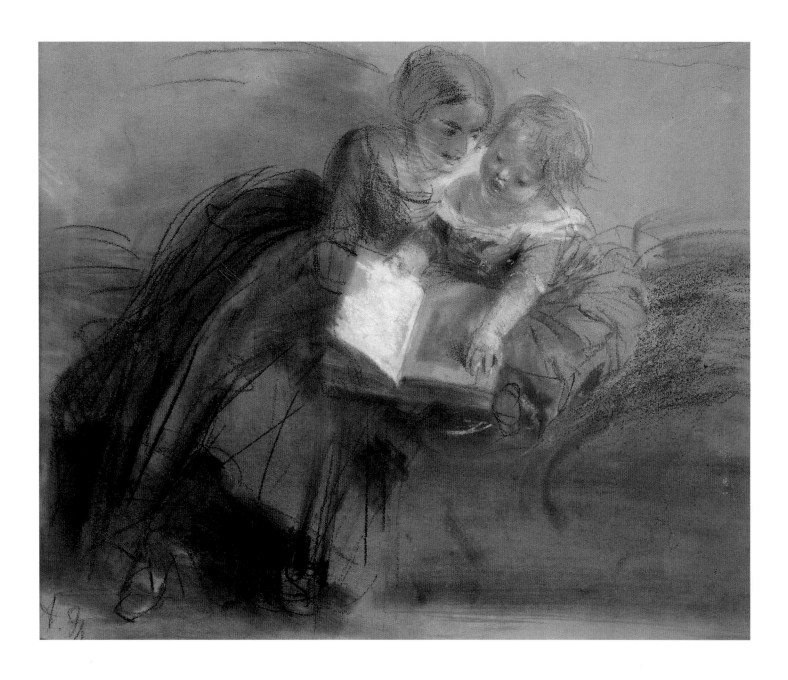

53.

Adolph von Menzel (1815, Breslau–1905, Berlin). *Young Woman with a Child*. Pencil, charcoal, pastel, sanguine, watercolor, and wash on brown paper mounted on cardboard, 10 x 11½" (25.4 x 29.1 cm). Inscribed lower left in charcoal : *A.M.* Inscribed on verso in pencil (partially legible): *Kriger-Menzel.* Inv. no. 77-11917

PROVENANCE: Kriger-Menzel collection, Berlin. Friedrich-Karl Siemens, Berlin.

LITERATURE: Kaiser 1975, p. 80 (ill.; reproduction from Bruckmann archive, Munich, with no title, date, or provenance indicated)

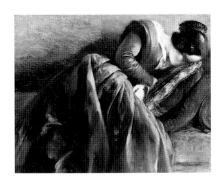

1. Adolph von Menzel. *Emilie Menzel Sleeping*. 1848. Kunsthalle, Hamburg

The characteristics of this work suggest a date of execution in the middle or late 1840s. It was during this period that Menzel began working in pastel and colored pencil. The primary subjects of the works from these years are taken from household daily life and from impressions of the artist's immediate surroundings. This is true of Menzel's famous small compositions, whether paintings or drawings. In the most unremarkable things – a fluttering curtain, an open window, a made bed, a corner of a room – Menzel found significant subjects and motifs. Hearth and home were always linked for him to his sister and brother, to friends and children. The well-known small painting *Emilie Menzel Sleeping* of about 1848 (fig. 1; Kunsthalle, Hamburg), executed in oil on paper, conveys both the effect of artificial light and the intimacy of home. Like that painting, the sheet from the Siemens collection is done in an energetic, expressive style. Brusque charcoal strokes blend with gouache and with pastel shading to create a texture comparable to that of a painting, an effect enhanced by the use of toned paper mounted on cardboard. The nearly impressionistic lightness of execution and the virtuosity with which a fleeting moment is conveyed do not lessen the solidity of the image. The pastel of a woman dressing a child – *Young Woman with a Child* of about 1845 (Wolff 1920, ill. 36) – probably depicts the same individuals who are shown in the Siemens work.

In succeeding decades, Menzel continued his domestic scenes. From 1860 on, he lived with his sister's family in a house on Marienstrasse in Berlin; with the birth of his nephews, Menzel witnessed the world of childhood at close range, and it became an integral part of his art. The series of drawings known as *Symphonia domestica,* done between 1861 and 1863, lyrically depicts this domestic subject. Some of the sheets are in the Kunsthalle, Bremen (see fig. 2); the rest are in private collections in Hamburg and Bavaria.

2. Adolph von Menzel. *Two Seated Women with a Child.* 1861–63. Kunsthalle, Bremen (1950/1278)

# ADOLPH VON MENZEL

## STUDY OF A FEMALE FIGURE IN PROFILE

54.

Adolph von Menzel. *Study of a Female Figure in Profile.* Pencil, 8⅜ x 5⅛" (21.3 x 13 cm). Inscribed at bottom in pencil: *A.M./91.* Inv. no. 77-11915

PROVENANCE: Helene Bechstein, Berlin.

This sheet and the three following ones (plates 55–57) display the characteristic style that Menzel had begun using in the 1850s. Drawings in pencil, sometimes gone over in charcoal, filled the pages of his sketchbooks, some done as studies for paintings and others pursued essentially for their own sake. But whether they were preparatory to paintings or not, Menzel's drawings were "studies" in the true sense of the term. For him, drawing from life was simply a part of learning how to see the world more accurately. The instincts of a researcher into the natural sciences compelled him to record the surrounding environment on a sheet of paper, and he devoted equal care to the natural phenomena he saw outdoors and the intimate details of domestic life.

As part of his studies, the artist often returned to the same subjects again and again, seeking to master the full range of appearances. Moreover, in his process of visual note taking he often drew more than one version of a subject on the same sheet. In this case, the doubled image of a young woman busy at her housework captures both the outward and inward life of the subject. As the artist "zooms in," so to speak, on her face, her pensive features are highlighted, suggesting something of her inner life. Yet at the same time, the overall figure remains placed before her work, her activity firmly located within the domestic scene.

Here as elsewhere, Menzel's doubling of an image on a single sheet of paper adumbrates a kind of miniature series, giving a sense of physical movement. This is a well-known technique for capturing a subject's quality of being alive, by showing it in multiple aspects. In the present drawing, Menzel further enhanced this "living" quality through his attention to ephemeral lighting effects, using energetic but lightly applied accents and shading to create dappled areas of light and space.

# ADOLPH VON MENZEL

## STUDY OF A FEMALE FIGURE IN PROFILE, WITH RELATED STUDIES OF A HAT AND RIGHT HAND

By the 1890s, toward the end of a long creative career, Menzel had developed an extremely expressive graphic style. In studies and sketches of daily life, the artist created genuinely impressive, even majestic, images. The energy of sweeping areas of space is conveyed through a lush and velvety black tone, which encompasses a subtle, sophisticated range of tonal transitions. The somewhat metallic color of pencil is here filled with light, a glimmering surface showing the grain of the paper. Whatman paper, with its rough texture, was a good choice, for it can create a sense of depth under strong pressure of the pencil, yet also provides a vibrant, radiant surface even when the pencil barely touches it.

The separate sketches of the hat and right hand, seemingly so casual, nevertheless form a compositional whole with the figure. The placement of these supplementary studies helps to balance the sheet. So does the artist's signature at the lower right – a decorative element that plays the same role as the written characters in Japanese prints.

Singer, in an undated publication from between 1920 and 1930, reproduced this sheet, but without citing documentation or a collection.

55.

Adolph von Menzel. *Study of a Female Figure in Profile, with Related Studies of a Hat and Right Hand*. Pencil, 7⅞ x 4⅞" (20.1 x 12.3 cm). Inscribed lower right in pencil: *A.M. /91*. Inv. no. 77-11916

PROVENANCE: Helene Bechstein, Berlin.

LITERATURE: Singer n.d., pl. 28.

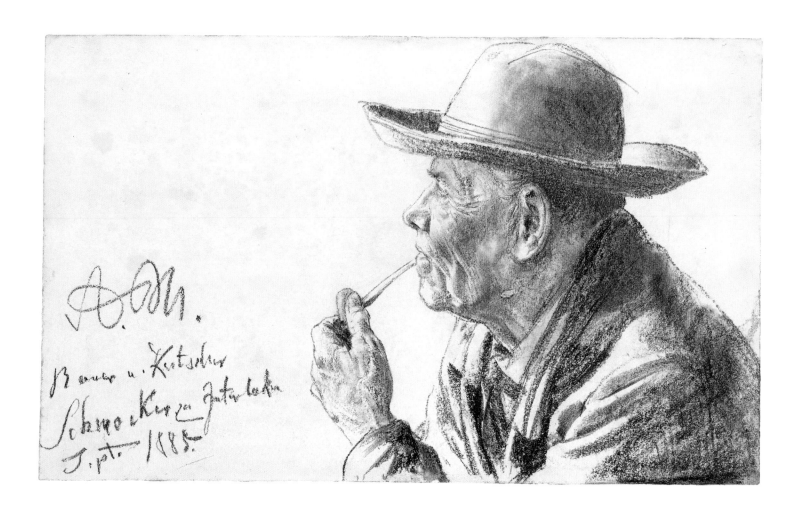

56.

Adolph von Menzel. *Study of a Man in a Hat with a Pipe*. Pencil, 5 x 8¼" (12.9 x 21.1 cm). Inscribed lower left in pencil: *A.M. Bauer u. Kutscher/Schmocker zu Interlaken/S. pt. 1885*. On verso: two labels, one of them inscribed in pencil: *Bauern/Zimmer*. Inv. no. 77-11913

PROVENANCE: Helene Bechstein, Berlin.

Nearly every summer, Menzel went to the countryside. He was particularly fond of the Bavarian and Swiss Alps. In 1885, after the opening of the Paris exhibition in honor of his seventieth birthday, he set off for Switzerland.

This drawing was made in September at Interlaken. There, the artist created a whole series of works. Instead of the majesty of the Alpine landscape, however, the artist focused on aspects of the town which at first glance seem unremarkable: dilapidated buildings, wooden footways, old bridges, and fountains. In addition, he executed a series of drawings of the local people, including the well-known studies of a coachman (see fig. 1; Staatliche Museen zu Berlin, Preussischer Kulturbesitz, Kupferstichkabinett). Writers on Menzel have remarked upon those dynamic drawings, which portray movement from unusual angles. The present drawing most probably depicts the same coachman, but during a moment of rest.

1. Adolph von Menzel. *Study of a Coachman*. 1885. Staatliche Museen zu Berlin, Preussischer Kulturbesitz, Kupferstichkabinett

57.

Adolph von Menzel. *Study of Two Female Figures*. Pencil, 4¾ x 7⅜"
(12.1 x 18.7 cm). Inscribed at bottom in pencil: *A.M./91*. Inv. no.
77-11913

PROVENANCE: Helene Bechstein, Berlin.

In his late work, Menzel more frequently made
images of elderly people. Older faces interested him
because they recorded long experience of life and at
times seemed to suggest an almost biblical wisdom.
There is therefore a certain logic to the frequent
comparison made between Menzel's late portraits
and the elderly people in Rembrandt's work.

The old woman depicted in this drawing from
the Bechstein collection also appears in other of
Menzel's works of the 1880s and 1890s. Sheets in
the Kunsthalle, Bremen (fig. 1); the Kunsthalle,
Hamburg; and the Germanisches Nationalmuseum,
Nuremberg, can be cited as examples. Many works
of the time portray if not the identical model, then
at least the same facial type – with sagging cheeks, a
sharp nose, and furrowed brows – which apparently
held the artist's attention. As a rule, the old woman
was depicted as lost in thought and remote from her
surroundings. That Menzel intended not only to por-
tray actual individuals but also to make a larger
statement is suggested by the fact that he used the
same model in creating his *Fate* of 1890 (fig. 2;
Kunsthalle, Hamburg).

The second image in the Bechstein drawing,
showing a middle-aged woman, heightens the sense
of age by establishing a contrast between two differ-
ent stages of life.

1. Adolph von Menzel. *Old
Woman.* 1891. Kunsthalle,
Bremen (1956/232)

2. Adolph von Menzel. *Fate*.
1890. Kunsthalle, Hamburg

# PAUL CÉZANNE

## ECORCHÉ (AFTER HOUDON)

1. Jean-Antoine Houdon. *Ecorché.* 1792. Ecole Nationale Supérieure des Beaux-Arts, Paris

This drawing depicts the sculpture by Jean-Antoine Houdon (1741–1828) that shows the anatomy of a man's muscles (fig. 1). The drawing was made between 1892 and 1895. During this time, Cézanne's renown was growing, and in 1895 his position was firmly established, especially among the younger generation, when he had his first solo show, organized by the dealer Ambroise Vollard.

Cézanne's relationship to the Old Masters and to the art of previous eras has been thoroughly investigated. His drawings vividly demonstrate his way of responding to, and reinterpreting, classical art, the art of the Renaissance, and French Neoclassical art. Three-quarters of the works in Cézanne's drawings oeuvre are in one way or another linked to the study and interpretation of works created by previous artists. At the same time, the human body, its physical structure in space, and its interaction with this space are probably the most important elements for understanding his art. Enclosed within a single, harmonious form, the human body existed both autonomously and in a dynamic relationship with nature and space. Mont Sainte-Victoire, which Cézanne doggedly and persistently studied and re-

created, was for him as subjective and animate a thing as the human form, interacting with the world around it.

Cézanne made several drawings of the Houdon sculpture, the present drawing being unusually large for works in the group. Two of the other drawings are in New York, in the Mrs. Enid A. Haupt collection and in the Metropolitan Museum of Art (fig. 2); both are sketchbook pages (Chappuis 1973, nos. 1110, 1111). In all of these sheets, the male figure is shown full length from the back and there are hints of objects surrounding it. The New York drawings are sketches, grasping and analyzing the basic elements of form; they seek the inner dynamics of muscular tension. The present drawing, however, is truly monumental. The image is remote both from the prototype sculpture and from any other concrete object. The autonomous form exists on its own, within its own space. It should be noted, moreover, that Cézanne was not interested solely in the anatomy of musculature, which was the subject of Houdon's creation. To Cézanne, the structure of the muscles of the human body was part of the solidity and roundness of form in general. His most universalized depictions of the nude body appeared in his famous Bathers. All the other constructions of human forms in space were preparations for them.

58.

Paul Cézanne (1839, Aix-en-Provence–1906, Aix-en-Provence).
*Ecorché (after Houdon).* Brown chalk on laid paper, 18⅞ x 12⅜"
(48 x 31.5 cm). Signed on verso in center in pencil: *Paul Cézanne 1.*
Stamped lower left in blue: RECETTE PARTIC[. . .] de l'EST/ PARIS.
Watermark at lower left: *MBM.* Inv. no. 79-12462
PROVENANCE: A. Flechtheim, Berlin. Silberberg collection,
Breslau. Paul Graupe, Berlin. Graupe sale, March 25, 1935, Berlin,
cat. no. 31 (ill.).
EXHIBITIONS: Galerie Flechtheim, Berlin, 1927, no. 39, ill. "Seit
Cézanne in Paris," Galerie Flechtheim, Berlin, 1929, no. 27.
LITERATURE: Venturi 1936, no. 1626. Berthold 1958. Chappuis
1973, no. 1109.

2. Paul Cézanne. *Study after Houdon's "Ecorché."* 1894–98. The Metropolitan Museum of Art, New York. Maria Dewitt Jesup Fund, 1951, from the Museum of Modern Art, Lillie P. Bliss Collection (55.21.2)

VINCENT VAN **GOGH**

**BOATS AT SAINTES-MARIES**

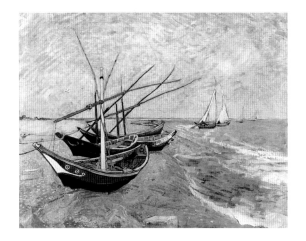

59.

Vincent van Gogh (1853, Groot-Zundert, Holland–1890, Auvers-sur-Oise, France). *Boats at Saintes-Maries*. Pencil, ink, watercolor, and gouache, 15⅞ x 21⅞" (40.4 x 55.5 cm). Inscribed in black chalk on reverse of passe-partout: *Sammlung Bernard Koehler*. Three inscribed labels: (1) *Gustav Knauer, Berlin / 7934 / Kunst-Abteilung*; (2) *MINISTERE DU COMMERCE / ET L'INDUSTRIE / EXPOSITION INTERNA-TIONALE / PARIS 1937 / Groupe I Classe 3*; [in pencil:] *Knauer 224* / [in ink:] *M. Bernard Koehler / Brandenburgstrasse 34 / Berlin / par Gustave Knauer, 8 rue Halévy, Paris*; (3) [stamp of the Berlin office, and in ink:] *Vincent van Gogh / "Barques à Saintes-Maries" / Sammlung Bernhard Koehler / Berlin*. Watermark: *J. WHATMAN*. Inv. no. 78-13895

PROVENANCE: Johanna van Gogh-Bonger. J. H. Bois, The Hague. Alfred Flechtheim, Düsseldorf. Bernhard Koehler, Berlin.

EXHIBITIONS: Galerie Alfred Flechtheim, Düsseldorf, 1913. Galerie Paul Cassirer, Berlin, 1914, no. 88. "Exposition internationale," Paris, 1937.

LITERATURE: *Van Gogh Letters*, nos. LT499, LT500, B6. Uhde 1936, p. 14, cat. 42 (color ill., photograph by R. Piper). Meier-Graefe 1904, vol. 3, pl. 510. De la Faille 1970, no. 1429. Hulsker 1973, pp. 133–35. Hulsker 1977, no. 1459, pp. 326, 328, ill. Pickvance 1984, p. 87. Feilchenfeld 1988, p. 131, no. F 1429. Schmidt 1988, p. 89. Erpel 1990. Walter/Metzger 1993, pp. 333, 356–57, ill. p. 358.

This watercolor was executed by van Gogh in June 1888 at the seaside in Saintes-Maries, a small village on the Mediterranean coast near Arles. A whole series – including seven drawings in pen, a watercolor, and paintings – shows sailboats at Saintes-Maries (see figs. 1–5). The dating of the drawings and watercolor is based on van Gogh's letters to his brother Theo and to Emile Bernard, whom van Gogh had met and become friendly with in Paris. While various specific dates for the drawings depicting boats in Saintes-Maries are given in the van Gogh literature, there is general agreement about their overall time frame: between the beginning of June and the beginning of August 1888. (On the sequence in which the seven drawings of the compositions with boats were produced, see the 1990 study by Fritz Erpel.)

There are two motifs of sailboats in Saintes-Maries: boats at sea and boats on the shore. In a letter to Bernard, van Gogh included a sketch of the composition with boats on the shore. This suggests that van Gogh attached significance to the motif. Perhaps the boats grouped together were linked to the idea of friendship. In the present watercolor, and in the related painting (fig. 1; Rijksmuseum Vincent van Gogh, Amsterdam) and reed-pen drawing (fig. 2; private collection), one of the boats is inscribed "Amitié."

2. Vincent van Gogh. *Fishing Boats on the Beach*. 1888. Private collection

3. Vincent van Gogh. *Fishing Boats at Sea*. 1888. Staatliche Museen zu Berlin, Preussischer Kulturbesitz, Kupferstich-kabinett

4. Vincent van Gogh. *Fishing Boats at Saintes-Maries*. 1888. The Saint Louis Art Museum. Gift of Mr. and Mrs. Joseph Pulitzer, Jr.

Van Gogh arrived in Arles from Paris in February 1888, full of creative plans and hoping to found in the south a school of modern painters who had developed out of the tradition of Impressionism. He saw this school as a society of friends and comrades. His creative work of the first few months in the south was imbued with the most joyous and pure intentions, free from the distress that had often characterized his previous art. Aspects of Eastern philosophy, which influenced van Gogh on both a creative and a philosophical level, doubtless affected this dream of creative cooperation. His idealism blended in a strange way with the prosaic and often unpleasant side of ordinary living. He built his world of illusions, which allowed him to create and construct, far from the difficulties of daily life.

The watercolor of boats at Saintes-Maries is one of the most radiant and idealized images in van Gogh's art. Four boats, the launches on which the local fishermen usually went to sea, are shown in a row on the beach. At first glance, they look like a single unit: Their masts form a network. The space around them is made up of sand, sky, and sea, and it preserves this mysterious sense of community. Van Gogh's watercolor unites light and color, dream and reality. The related canvas (fig. 1) and ink study (fig. 2) are the immediate companions of the present work. But it is precisely the watercolor that embodies in purest form the longings of a seeker of the eternal.

5. Vincent van Gogh. *Fishing Boats at Sea*. 1888. Musée d'Art Moderne, Musées Royaux des Beaux-Arts de Belgique, Brussels

Paul Signac is known in the history of art as a fervent advocate of Neo-Impressionism – and the use of "pointillism," as it is sometimes called, with separate dots or points of paint – which derived from the work of Georges Seurat. Despite his unswerving devotion to Neo-Impressionism, Signac was nonetheless subject to many other artistic influences. In his youth, he was attracted to Impressionism, and in particular to the paintings of Claude Monet, while his canvases and drawings of the 1880s have some affinity with the naturalistic landscapes of the Barbizon School. The influence of Vincent van Gogh, with whom Signac was friendly and whom he visited at Arles in March 1889, was also quite significant. And in the first decade of the twentieth century, he was clearly affected by the Fauves. Until the end of his life, however, Signac continually returned to the technique of the separate, individual dot of paint and never really abandoned it. All of his other interests remained merely experiments.

In addition to conducting his creative work, Signac felt a need to provide a theoretical basis for his art. He became known as an aesthetician, a critic, and an art historian, as well as an active organizer of art associations and exhibitions. His critical study *D'Eugène Delacroix au néo-impressionisme,* published in Paris in 1898, and his monograph on the work of the Dutch painter Johan Jongkind, published in 1927, are still read today. The latter contains not only an analysis of Jongkind but also a statement of Signac's own artistic vision and method. In the chapter on the Dutch artist's watercolors, for example, in addition to evaluating Jongkind's work he gives his own, independent ideas on watercolor technique and on the artistic significance of the medium. Like van Gogh, Delacroix, and Paul Klee, Signac was one of those rare artists able and willing to write effectively about the creative process. And not content with simply explaining his own work, he produced a body of aesthetic doctrine.

Committed to pointillism, Signac constructed an aesthetic theory to support it. For him, as for Seurat, the technique of separate points or dots was a method that had to do not only with the making of art but with the nature of optical perception itself. Their art attempted to apply to painterly practice the work of such scientists as the Scotsman James Maxwell, the Frenchmen Michel-Eugène Chevreul and Charles Henry, and the American Ogden N. Rood, along with the ideas of the Swiss artist David Sutter, who believed that the laws of natural science should be strictly respected in art. Scientific discoveries about perception made in the latter part of the nineteenth century provided disciples of Neo-Impressionism with a wealth of possible theoretical constructs and ways of applying them in practice. Most notably, the traditional mixing of colored pigments on the artist's palette was replaced in their work by the application of separate dots of pure color to the canvas, which were to be mixed only in the eye of the beholder.

While the theory underlying pointillism strove to incorporate a range of scientific ideas regarding perception, the true benefit that it produced for the Neo-Impressionists in practice was, essentially, a decorative style. On this score, Signac's paintings, including even those that did not use the pointillist technique per se, can be said to have been overly constrained at times by the prescriptions of theory. But the watercolors, which Signac considered a kind of note taking, preliminary to the creation of paintings, were allowed greater freedom. As Signac wrote in his study of Jongkind, "Watercolors are only a way to make notes, a kind of souvenir, a quick and fruitful means of allowing the artist to enrich his repertoire with elements that are too ephemeral to be captured in the slow medium of oil paint." Their brushwork is therefore quick and improvisatory. Since the watercolor medium does not of its nature allow for later corrections, the artist had to apply

color with unfettered virtuosity in order to get it just right the first time.

Nonetheless, there was still a certain order to be observed, especially regarding the interaction between the various colors and between color and line. The arabesque linear elements in Signac's watercolors are all carefully thought through and interconnected. This deliberation, however, is not obvious, for it has been put in the service of expressing rapidly changing impressions. Color, as a rule unmixed, fills the space within or around the contours in short, broad brushstrokes. Line and color are allowed virtually equal significance.

Sometimes Signac drew in color, but in general he preferred drawing in graphite pencil – which permitted great variety in the thickness and darkness of lines – with color accents in watercolor or gouache. He generally did not fill in the colors solidly; the important thing in the watercolor was to note that correlation of elements which defined a particular motif, condition of light, and state of the atmosphere. In his watercolors, Signac therefore remained true to some of the principal goals of Impressionism. Yet his watercolors were also greatly influenced by Cézanne's, which he first saw at an exhibition in 1908 at the Galerie Druet, Paris. He learned much from Cézanne's way of deploying short, broad brushstrokes and, like him, attached great importance to leaving some empty, uncolored space on the paper around the color patches. In his study of Jongkind he wrote, "It is impossible to achieve beautiful colors in a watercolor without bringing the white of the paper into play, both by letting it show through and by leaving it in various proportions around each dab. This radiant intermediary intensifies each color and brings it into harmony with the neighboring ones." Signac also acknowledged the importance of the drawing paper's texture in achieving the desired effect. Rather than thick, porous drawing papers – which he derided as "blotters" – he preferred thin, smooth paper "on which . . . the pencil can slip freely and the dabs of paint can stand for a few seconds in small pools, so that the whims of the drying process will distribute the paint in infinitely varied concentrations." Signac explained his frequent use of gouache and wash accents by citing the ability of this technique, when used in "rational" proportions, as he put it,

to "multiply not only the shades of the colors, but also the colors themselves."

Beginning about 1886, Signac executed his works on paper either in pencil, blurring the contours of objects and trying to convey the subtlest gradations of light and shadow; or in watercolor "stippling," with which he created sophisticated color designs. The special characteristics of small works on paper had an effect quite different from that of his paintings. The hoped-for mixing of pure color dots in a canvas viewed from a certain distance had little meaning in a small sheet of paper seen close up. As a result, the essence of pointillism changed. Here, the Neo-Impressionist method shed its scientific trappings and became merely the play of mosaic drops of light, fascinating the viewer by its inventiveness. And despite the theories propounded by the Neo-Impressionists, this is largely the effect achieved in the paintings as well. While the natural artistic gifts of Seurat and Signac allowed them to avoid doctrinaire monotony in this art, the same cannot always be said of the works of some of their disciples and other users of pointillism.

In the 1890s and 1900s, Signac's drawing technique changed to a certain extent under the posthumous influence of van Gogh. Signac's drawings began to show nervous contours, broken strokes, and winding lines. This should be considered largely the effect of imitation, however, for van Gogh's agitated energy remained alien to Signac's more harmonious inclinations. Over time, Signac's style became more securely established. Though he would never be entirely free of prior influences, his work grew more highly individual and direct.

The watercolors are among the finest and most characteristic manifestations of Signac's talent. As a rule, he avoided figure compositions, and that is the case with the works reproduced here. In depicting urban sites and rural landscapes, he did not pay much attention to the human figure, and when it does appear it is just another feature of the terrain. Instead, Signac's seascapes and landscapes are filled with light and surrounded by a radiant atmosphere. In his landscapes of urban sites, whether showing a town square, a little street, or a wider view of a city, the artist largely ignored what others might have thought of as the urban essence; he painted these scenes as "pure" landscapes, responding to the

natural phenomena that permeated them.

A yachtsman, Signac was in love with the sea. He was familiar with most of the French coastline, its ports and bays, and sailed along many rivers and canals. In this changing environment of water, air, and light, he found his natural element. He was particularly drawn to the Mediterranean and discovered Saint-Tropez in the 1890s, long before it became fashionable for painters. He was also attracted by the Norman seacoast, and from 1923 to 1929 went every summer to Lezardrier, on the northern coast of Brittany. Tugboats, barges, rowboats, and sailboats, out on the water or moored at a pier, became favorite motifs.

Signac can be considered one of the most subtle and sophisticated of marine painters. His intimate knowledge of the atmospheric effects of light and color over bodies of water was ideally expressed in the wholly sympathetic medium of watercolor. In the best works, a single, complex visual experience arises out of the filigree-fine gradations of light and the virtuoso drawing.

1. Paul Signac. *Le Pont des Arts*.
1928. Musée du Petit Palais, Paris.
(See plate 61)

# PAUL SIGNAC

## SUSPENSION BRIDGE IN LES ANDELYS

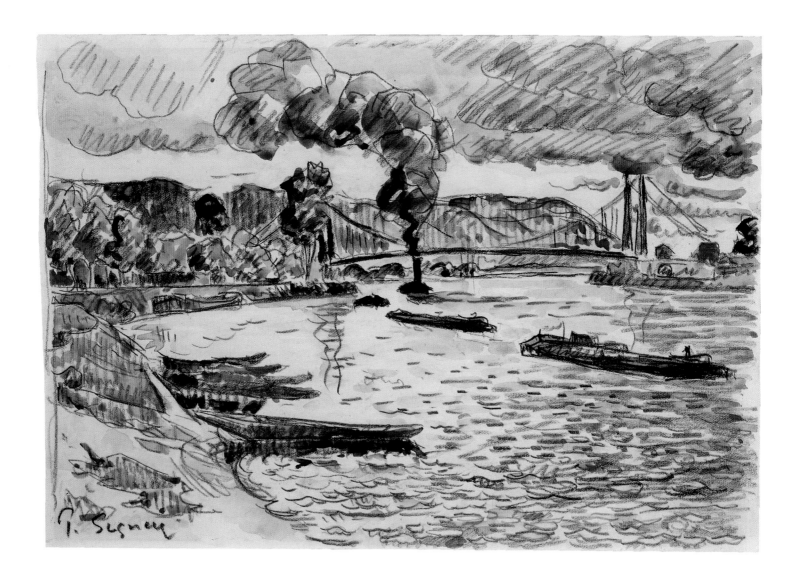

60.

Paul Signac (1863, Paris–1935, Paris). *Suspension Bridge in Les Andelys*. Pencil, watercolor, and gouache, 8 x 11⅛" (20.4 x 28.3 cm). Signed lower left in lithographic crayon: *P. Signac*. Watermark in center of left margin: BOND. Stamp on verso: *8516*. Inscribed in pencil: *K. Inv. no. 155-82*

PROVENANCE: Otto Krebs, Holzdorf.

For plates 60, 62–71, 73, and 74, the identities of the locales depicted and the dates of the works were determined by Marina Ferretti di Castelferretto, who – together with Paul Signac's granddaughter Françoise Cachin, Conservateur Général des Musées Nationaux de France – is compiling a complete catalogue of Signac's works. The present work was executed around 1920.

P. Signac

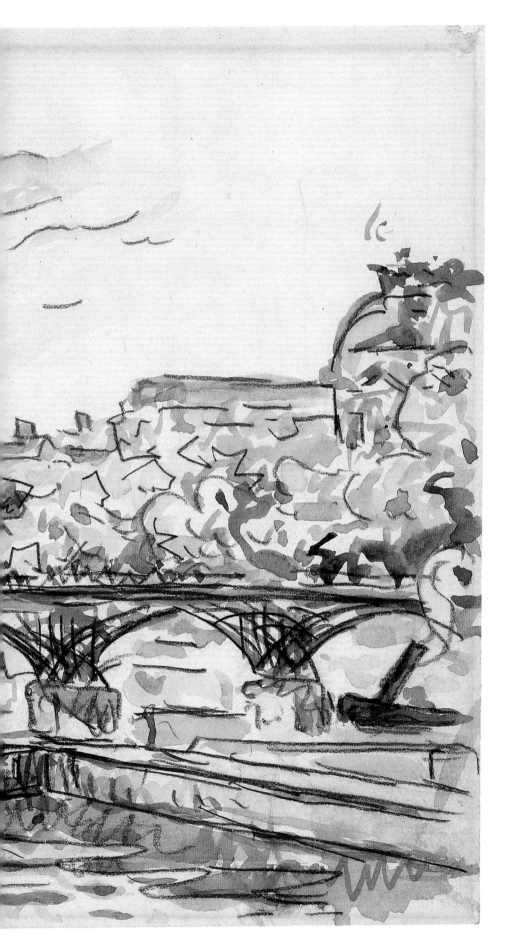

# PAUL SIGNAC

## BANK OF THE SEINE NEAR THE PONT DES ARTS WITH A VIEW OF THE LOUVRE

61.

Paul Signac. *Bank of the Seine Near the Pont des Arts with a View of the Louvre*. Pencil, charcoal, watercolor, and gouache on laid paper, 8⅜ x 10¼" (21.2 x 26 cm). Signed lower left in pencil: *P. Signac*. Inv. no. 155-84

PROVENANCE: Otto Krebs, Holzdorf.

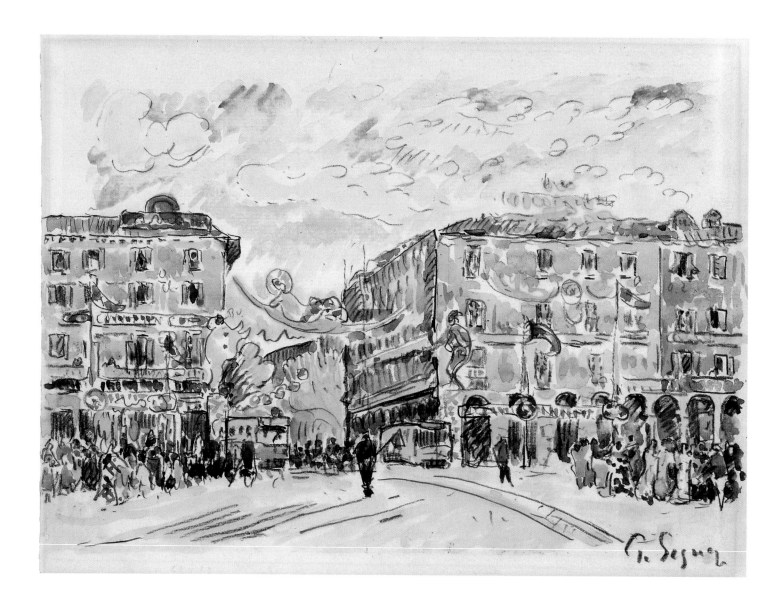

62.

Paul Signac. *City Square*. Pencil, watercolor, and gouache on laid paper, 9 x 11⅝" (22.8 x 29.7 cm). Signed lower right in lithographic crayon: *P. Signac*. Drawing surface marked with letters indicating colors. On verso in pencil: *K*. Watermark in center of lower margin: image of a crown(?). Inv. no. 155-83

PROVENANCE: Otto Krebs, Holzdorf.

Marina Ferretti dates this work c. 1925.

# PAUL SIGNAC

## HARBOR WITH SAILBOAT, TUGBOAT, AND BARGE

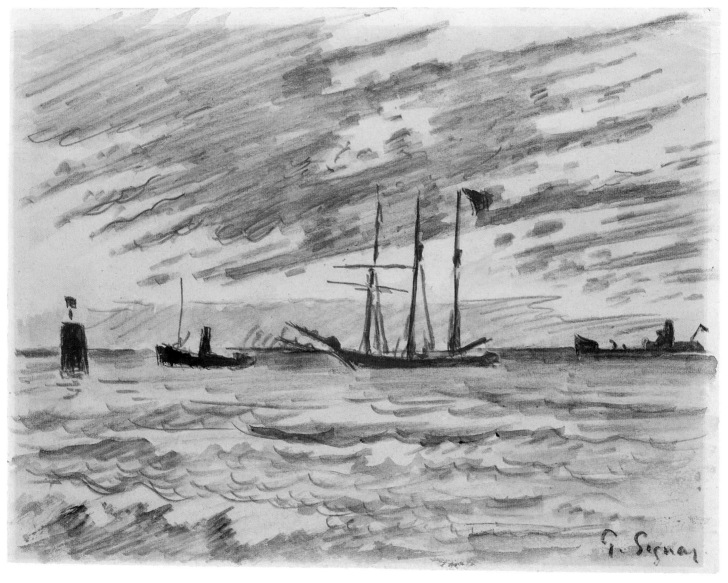

63.

Paul Signac. *Harbor with Sailboat, Tugboat, and Barge*. Pencil, water-
color, and gouache, 8¼ x 6⅝" (21 x 16.9 cm). Signed lower right in
lithographic crayon: *P. Signac*. Stamped on verso: *8514*. On verso
in pencil: *K.* Inv. no. 155-85

PROVENANCE: Otto Krebs, Holzdorf.

This work was executed c. 1920.

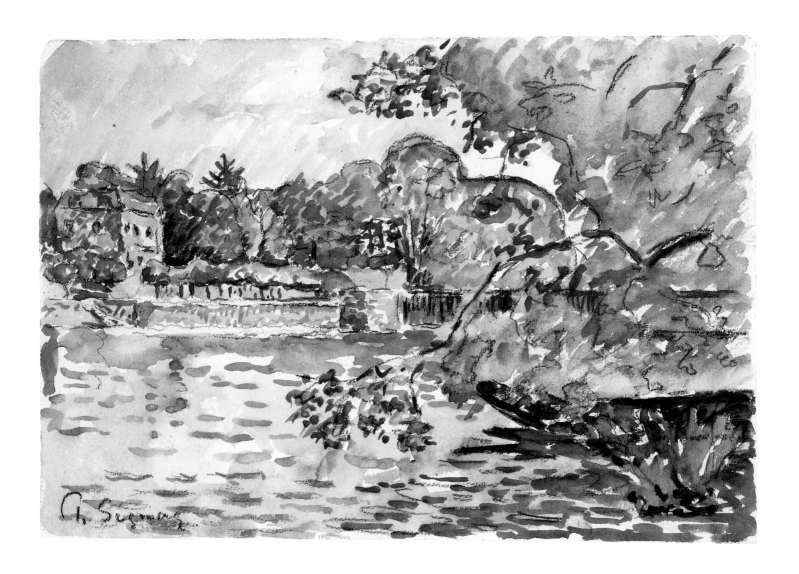

64.

Paul Signac. *Banks of the Seine*. Lithographic crayon, watercolor, and gouache, 6⅝ x 9½" (17.4 x 25 cm). Signed lower left in lithographic crayon: *P. Signac*. Stamped on verso: *8524*. On verso in pencil: *K*. Inv. no. 155-80

PROVENANCE: Otto Krebs, Holzdorf.

This work was executed c. 1900.

# PAUL SIGNAC

## FISHERMAN IN A BOAT NEAR A BANK OF THE SEINE

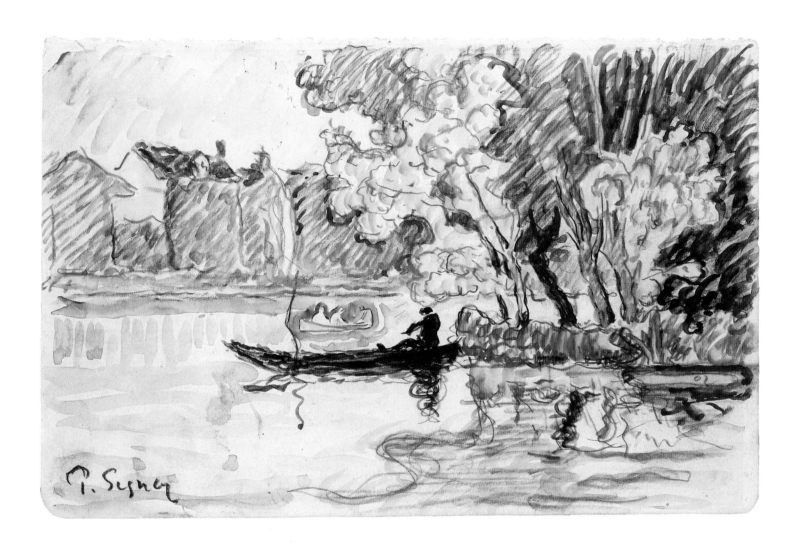

65.

Paul Signac. *Fisherman in a Boat Near a Bank of the Seine*. Pencil,
watercolor, and gouache on sketchbook page, 5⅞ x 8⅞" (14.8 x
22.1 cm). Signed lower left in lithographic crayon: *P. Signac*.
Stamped on verso: *8525*. On verso in pencil: *K*. Inv. no. 155-79
PROVENANCE: Otto Krebs, Holzdorf.

Like the previous work, this one was executed
c. 1900.

# PAUL SIGNAC

## SAILBOAT AT A PIER

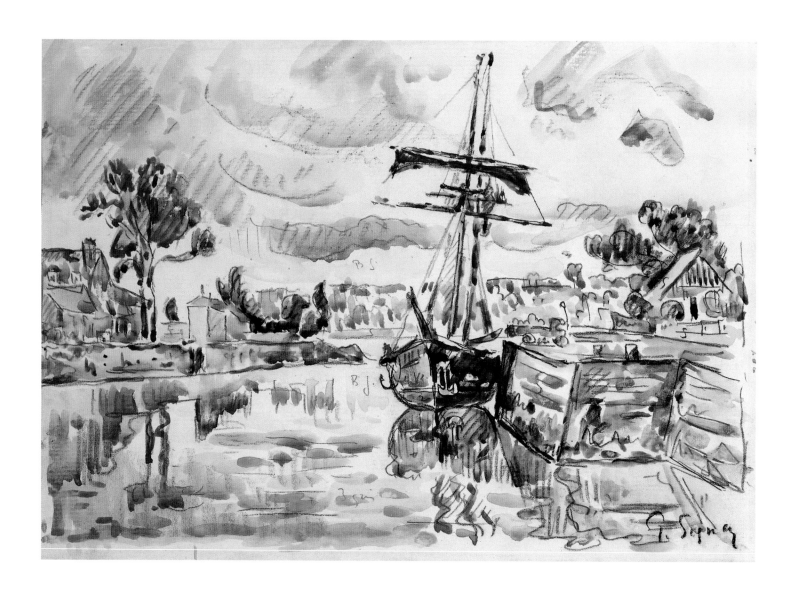

66.

Paul Signac. *Sailboat at a Pier*. Pencil, watercolor, and gouache on laid paper, 8⅝ x 11¾" (21.9 x 29.7 cm). Signed lower right in lithographic crayon: *P. Signac*. In center of sheet: letters indicating colors. Inv. no. 155-76

PROVENANCE: Otto Krebs, Holzdorf.

Marina Ferretti believes that this work was executed in the 1920s and that it may depict Concarneau.

# PAUL SIGNAC

## TUGBOAT AND BARGE IN SAMOIS

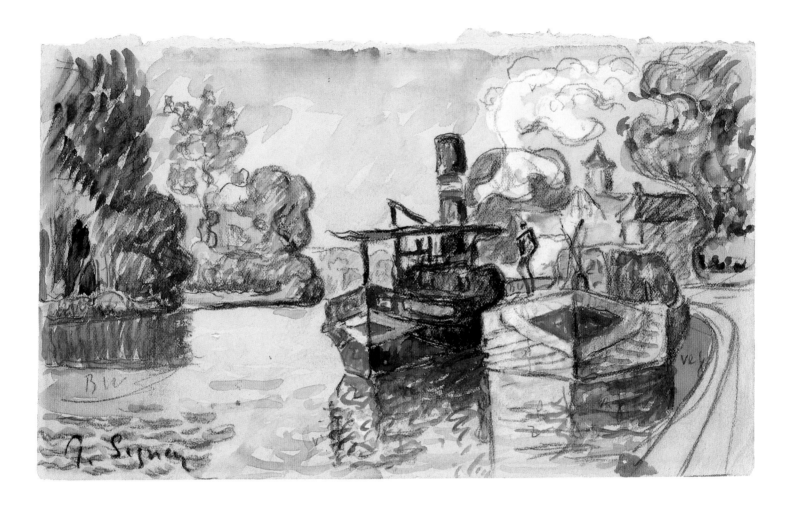

67.

Paul Signac. *Tugboat and Barge in Samois*. Pencil, watercolor,

gouache, and wash on sketchbook page, 4¾ x 7¾" (12 x 19.7 cm).

Signed lower left in lithographic crayon: *P. Signac*. On lower part

of sheet: letters indicating colors. Stamped on verso: 8527. On

verso in pencil: *K.* Inv. no. 155-78

PROVENANCE: Otto Krebs, Holzdorf.

This work was executed c. 1900.

# PAUL SIGNAC

## TWO BARGES, BOAT, AND TUGBOAT IN SAMOIS

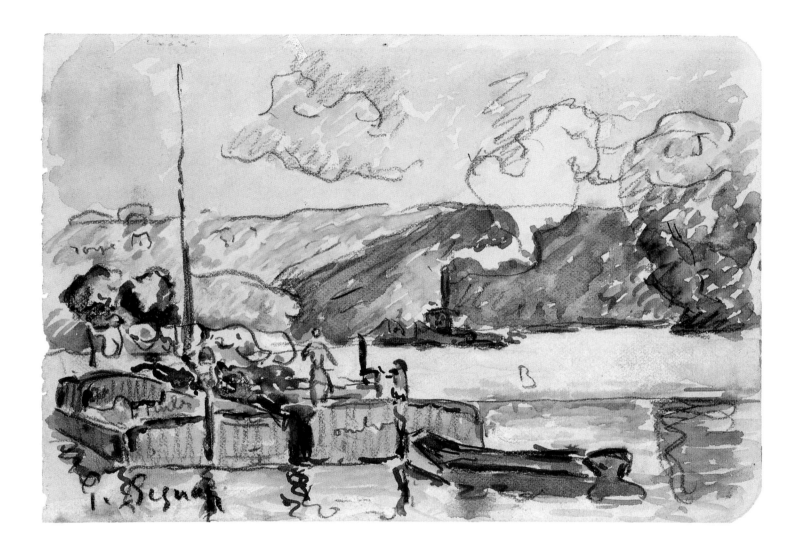

68.

Paul Signac. *Two Barges, Boat, and Tugboat in Samois*. Pencil, watercolor, gouache, and wash on sketchbook sheet, 4½ x 6⅝" (11.4 x 16.7 cm). Signed lower left in lithographic crayon: *P. Signac*. On right part of sheet: letters indicating colors. Inv. no. 155-77
PROVENANCE: Otto Krebs, Holzdorf.

This work was executed c. 1900.

# PAUL SIGNAC

## STREET WITH A FRAME HOUSE IN NORMANDY

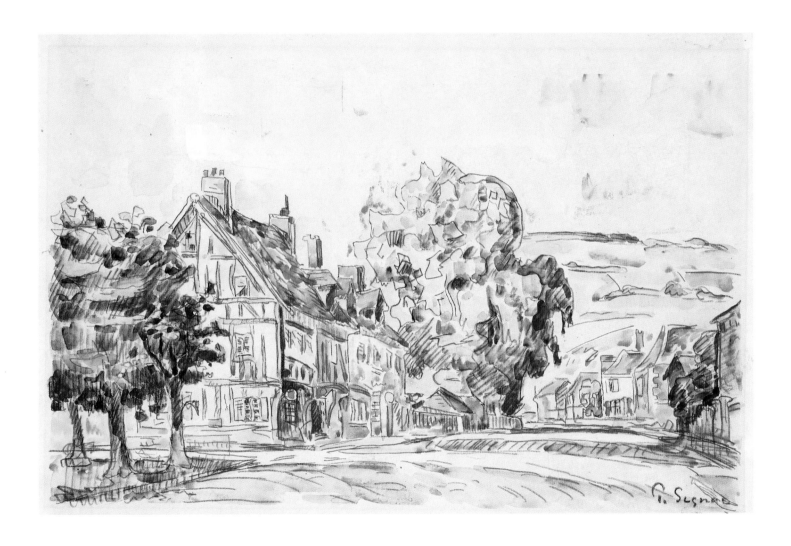

69.

Paul Signac. *Street with a Frame House in Normandy*. Pencil, water-
color, and gouache, 11⅜ x 16⅞" (28.8 x 42.8 cm). Signed lower
right in lithographic crayon: *P. Signac*. Watermark at upper left
and right (illegible). Inscribed on verso in pencil: *K*. Stamped on
verso: *8502*. Inv. no. 155-86

PROVENANCE: Otto Krebs, Holzdorf.

This work was executed c. 1925.

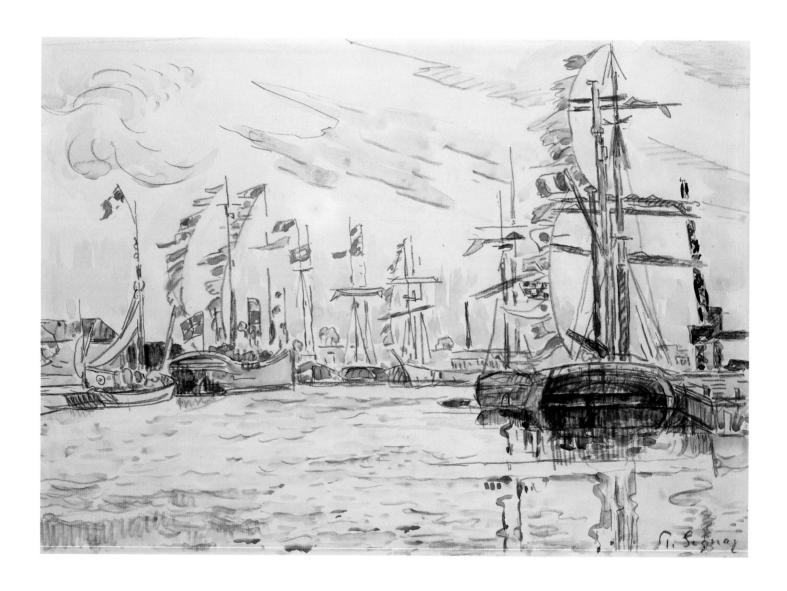

70.

Paul Signac. *Sailboats with Holiday Flags at a Pier in Saint-Malo*.
Pencil, watercolor, and gouache, 12¼ x 16¾" (31.1 x 42.5 cm).
Signed lower right in lithographic crayon: *P. Signac*. Stamped on
verso: *8503*. On verso in pencil: *K*. Inv. no. 155-81
PROVENANCE: Otto Krebs, Holzdorf.

This work was executed in the 1920s.

# PAUL SIGNAC

## SAILBOATS IN THE HARBOR OF LES SABLES–D'OLONNE

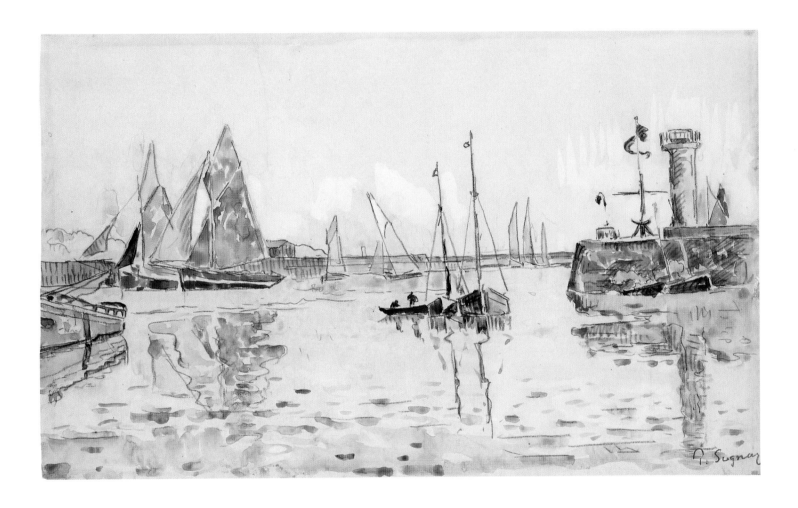

71.

Paul Signac. *Sailboats in the Harbor of Les Sables–d'Olonne*. Pencil, gouache, and watercolor on laid paper, 10¾ x 17⅛" (27.3 x 43.5 cm). Signed lower right in pencil: *P. Signac*. At center: letters indicating colors. Watermarks at lower right and left. Inv. no. 155-87

PROVENANCE: Otto Krebs, Holzdorf.

This work was executed c. 1920.

# PAUL SIGNAC

## SQUARE OF THE HÔTEL DE VILLE IN AIX-EN-PROVENCE

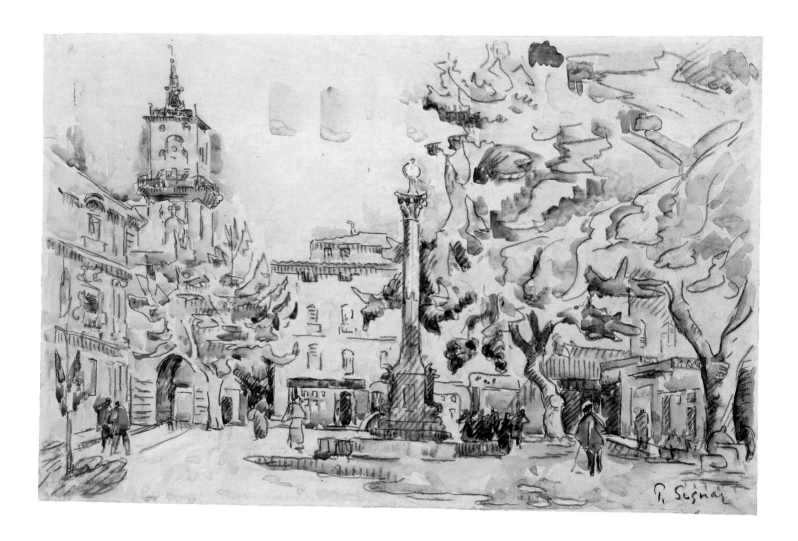

72.

Paul Signac. *Square of the Hôtel de Ville in Aix-en-Provence*. Water-
color, gouache, and wash on paper mounted on cardboard, 10¾ x
16½" (27.2 x 41.9 cm). Signed lower right in lithographic crayon:
*P. Signac*. Inscribed on verso in pencil: *K*. Stamped on verso: *8504*.
Inv. no. 155-89

PROVENANCE: Otto Krebs, Holzdorf.

1. Hôtel de Ville, Aix-en-Provence

There is another drawing by Signac that also depicts
the square before the Hôtel de Ville in Aix-en-
Provence. That sheet (Cousturier 1922, ill. 22) was
titled by the artist *Aix,* and was done from precisely
the same vantage point as the present drawing
from the Krebs collection, but in a different season –
spring – when the trees were just beginning to
bloom and their foliage did not yet fill that small but
charming square. Present-day photographs show
that the square has changed little since Signac drew
it (see figs. 1, 2). The Hôtel de Ville dates to the sev-
enteenth century and today houses the municipal
library. The clock tower was built in the sixteenth
century.

2. Clock tower, Aix-en-Provence

# PAUL SIGNAC

## SUSPENSION BRIDGE IN LES ANDELYS

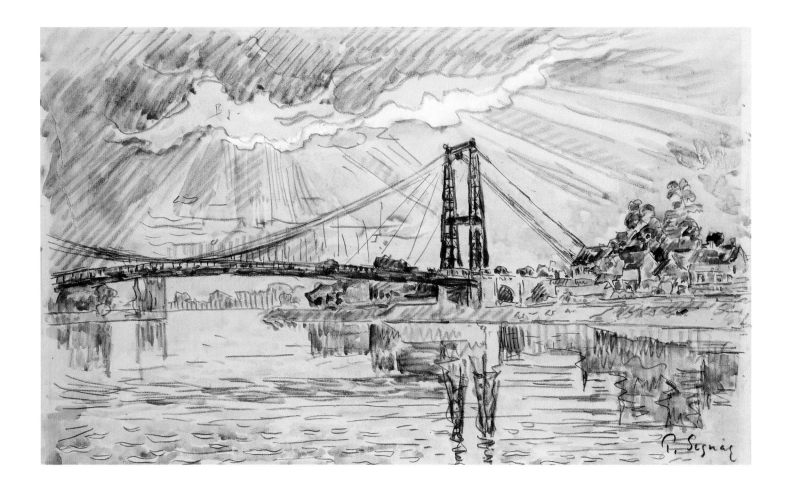

73.

Paul Signac. *Suspension Bridge in Les Andelys*. Pencil, black chalk, watercolor, and gouache, 10⅝ x 17⅜" (27.1 x 44.1 cm). Signed lower right in lithographic crayon: *P. Signac*. On upper part of sheet: letters indicating colors. Inv. no. 155-88

PROVENANCE: Otto Krebs, Holzdorf.

This work was executed c. 1920.

# PAUL SIGNAC

## SAILBOATS AT A PIER IN HONFLEUR

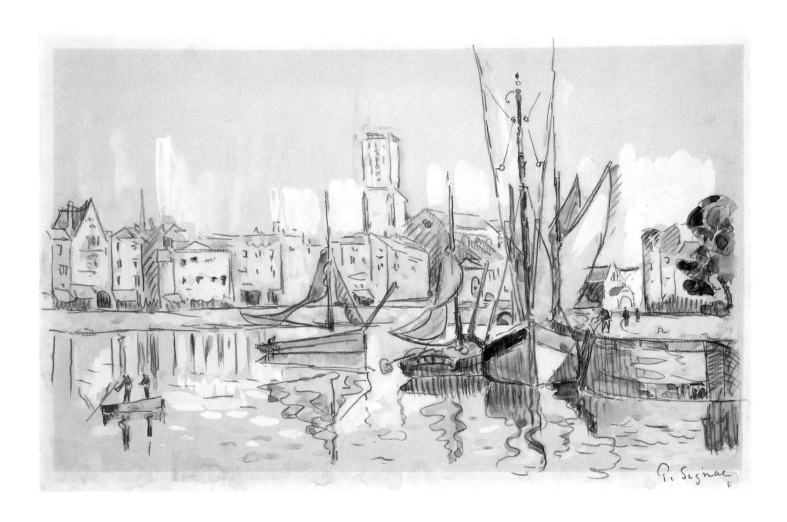

74.

Paul Signac. *Sailboats at a Pier in Honfleur*. Pencil, watercolor,
gouache, and wash on laid paper, 11⅛ x 17⅜" (28.2 x 44 cm).
Signed lower right in pencil: *P. Signac*. Inscribed on old mounting
in ink: *N. Pitzer*. Stamped on back of frame: *8942*. Watermark at
top (twice): RIVES. At bottom (twice): PEK. Inv. no. 130-21158
PROVENANCE: Friedrich-Karl Siemens, Berlin.

This work was executed c. 1920.

75.

Henri de Toulouse-Lautrec (1864, Albi, Tarn–1901, Malromé, near Bordeaux). *Riders*. Pencil, watercolor, and wash, 8¾ x 11⅞" (22.2 x 30.2 cm). Stamp at lower right: L.1338. Inv. no. 130-21159

PROVENANCE: Friedrich-Karl Siemens, Berlin.

LITERATURE: Jedlicka 1943, pp. 38–39.

This watercolor is not included in a single one of the Lautrec catalogues raisonnés (for example, Joyant 1927 and Dortu 1971). During the war years, the drawing was published in the monograph by G. Jedlicka without indication of its title or location.

Lautrec's acquaintance in 1872 with a close friend of his parents, the artist René Princeteau (1843–1914), became a catalyst for his interest in drawing. At the time, Princeteau was already well known and had exhibited in the Salons, making a name for himself in the "animalist" genre (see Schmidt 1994). Princeteau's preferred subjects were military and hunting scenes showing male and female riders (see fig. 1). The frequent depiction of horses in Princeteau's works also determined the arrangement of the imagery in his dynamic compositions.

Both at the family estate of Albi and later in Paris, Lautrec often saw Princeteau. It can be said that Princeteau was Lautrec's first mentor, for it was he who in 1881 advised Lautrec to study drawing and painting in Léon Bonnat's studio. Lautrec first came to Princeteau's studio in 1878, when he was only fourteen years old. Twenty-one years older than his

3. Henri de Toulouse-Lautrec. *Group of Riders on a Hunt*. 1878. Musée Toulouse-Lautrec, Albi

1. René Princeteau. *Le Bat l'Eau*. n.d. Musée des Beaux-Arts et d'Archéologie de Libourne, France. Bequest of Henri Brulle, 1932

2. Henri de Toulouse-Lautrec. *Horsewoman and Her Groom*. 1880. Musée Toulouse-Lautrec, Albi

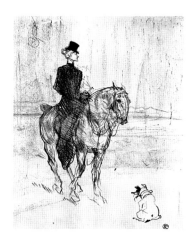

4. Henri de Toulouse-Lautrec.
*Horsewoman and Dog.* 1898.

Private collection

works, and also repeats his characteristic manner of painting. Like Princeteau, Lautrec seemed to be drawing with colored blots designed to create a light-filled atmosphere. There were quite a few such works imitative of Princeteau, and also of John Lewis Brown and other artists. This is obvious if we look at the sketches and finished works of Lautrec done before the beginning of the 1880s (figs. 2, 3). They clearly show the imitative nature of the earliest period of his life in art. Lautrec was in fact varying figures of a single type, arranging them like tin soldiers in one or another arbitrary order. For the beginning artist, these were études. By the mid-1880s, these training exercises had to a certain extent helped him move toward an independent, inimitable art. To the end of his days, the theme of riders remained in his art, though expressed through a different artistic language (figs. 4, 5). As in childhood, it remained the expression of the dream of free movement.

young friend, Princeteau did not in fact teach him very much. He merely allowed the boy to be there while he created his own works. But Princeteau depicted a set of subjects that was close to Lautrec's interests. Princeteau's studio in Paris was located on the rue Faubourg Saint-Honoré in a neighborhood where painters and sculptors had lived from time immemorial. It was here that Lautrec first encountered the artistic world of Paris. And Lautrec went with Princeteau to circus performances, usually at the Fernando circus. The motif of horses and riders now took on another meaning, associated with risk, daring, and play, with artificial light and an exaggerated manner of depicting these subjects.

During this early period, Lautrec often made use of the works of other artists as ideal – and sometimes real – models. A watercolor of 1878, *Group of Riders on a Hunt* (fig. 3; Musée Toulouse-Lautrec, Albi), bears a monogram and the author's inscription, *d'après Princeteau* ("after Princeteau"). The drawing virtually reproduces one of Princeteau's

5. Henri de Toulouse-Lautrec.
*Jockey.* 1899. Musée Toulouse-Lautrec, Albi (L.159)

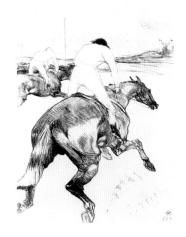

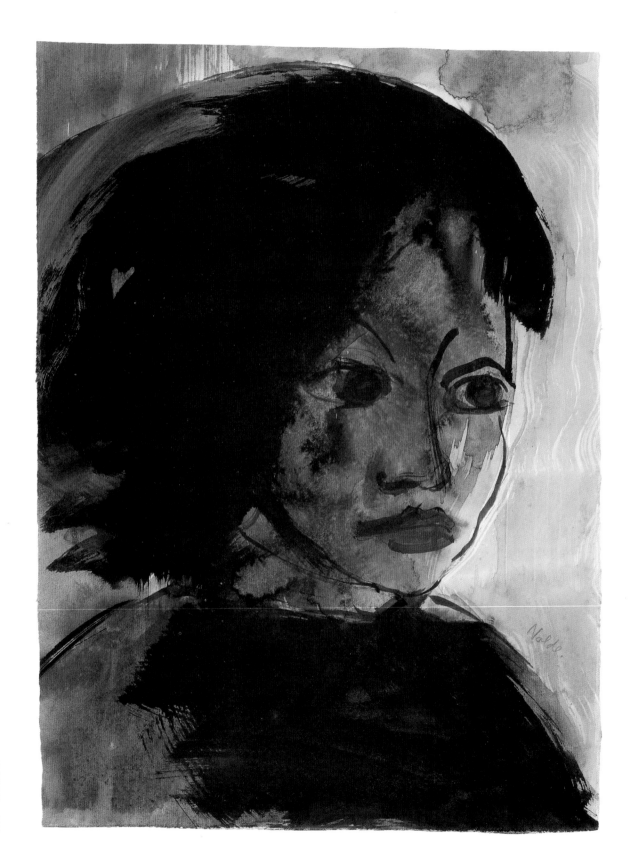

76.

Emil Nolde (1867, Nolde, Schleswig–1956, Seebüll, Schleswig).

*Portrait of a Young Girl*. Watercolor, ink, and gouache, 14¾ x 10⅜"

(37.5 x 26.5 cm). Signed lower right, above shoulder, in pencil:

*Nolde*. Watermark at upper right: monogram. Inv. no. 155-74

PROVENANCE: Probably Otto Krebs, Holzdorf.

Watercolors and gouaches played a significant role in Nolde's art. He was one of the finest colorists among the Expressionists, and his works on paper, too, reflect this particular strength. Even when creating black-and-white prints, he always remained a colorist for whom black and white were simply additional chromatic options on the palette.

Nolde's voyage to Oceania in 1913–14 marked an important stage in his attempt to broaden his artistic horizons. The images and colors that revealed themselves to him in the South Seas were naturally tinged with memories of the Tahitian canvases by Paul Gauguin. The present watercolor was most probably created during that trip. The northern European notion that the light of the south renders colors clearer and brighter turned out to be false, for the clarity of the color was scorched, so to speak, by the brilliant light, and darkened. Nolde's southern paint-ings and watercolors are more mysterious, more somber, than those created on the plains of his native Friesland. To achieve a full chromatic harmony, and capture something of the mysticism he felt was present, Nolde employed a multilayer system of applying paint to the surface of the paper. Without mixing colors on the palette, he partially covered one layer of paint with another. This is clearly visible in *Portrait of a Young Girl*. The hair is depicted by means of a triple layer of watercolor and gouache: The lower layer is light blue watercolor, on top of which there is a layer of dense India ink, topped off by spots of bright ochre. The same technique is used with the clothing. The lower layers show through the subsequent ones, each layer enriched by the one below it. Without blending with each other, they succeed in creating a balance of color, and also convey a feeling of dimension and form.

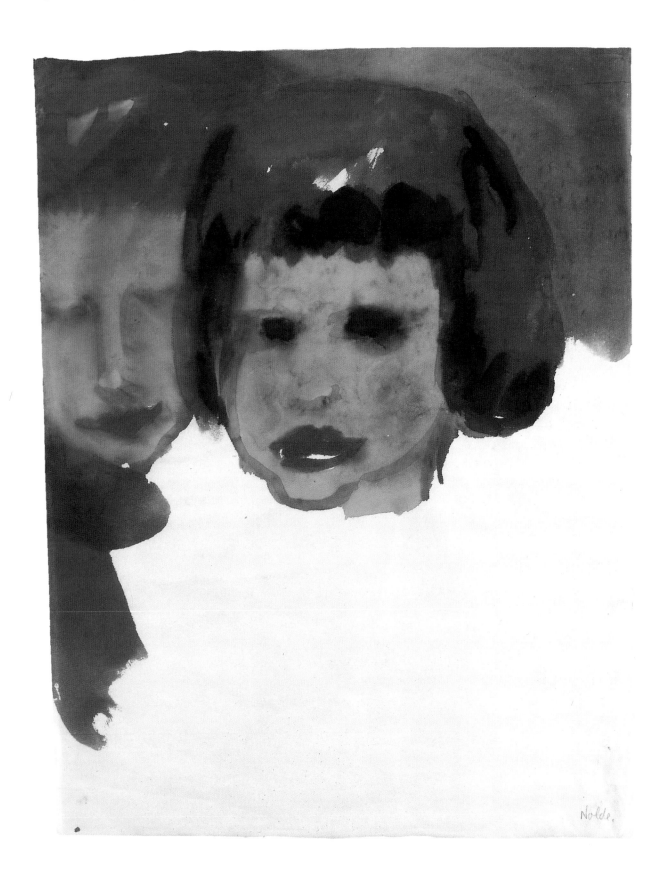

77.

Emil Nolde. *Portrait of a Young Woman and a Child*. Watercolor,
gouache, and ink on Japanese paper, 18 x 13¾" (45.8 x 35 cm).
Signed lower right in pencil: *Nolde*. Inv. no. 155-73
PROVENANCE: Probably Otto Krebs, Holzdorf.

1. Emil Nolde. *Mother and
Daughter*. 1947. Collection
Christian Carstensen, Flensburg

Like the two other sheets reproduced in this book,
this drawing is not referred to in the standard cata-
logue of Nolde's graphic works (Schiefler 1966–67) or
in any source with which I am acquainted.

Double portraits played a special role in Nolde's
work. In them, he expressed the special quality of the
relation between the paired subjects, whether they
are parent and child (see fig. 1), husband and wife,
sister and brother, or lovers or friends.

Nolde did not invent any particularly new com-
positional devices. He tended to present his charac-
ters in two ways, in profile or full face, and nearly
always from close up. The pattern of these double
images remained unchanged for many decades.
From about 1900 until the beginning of the 1950s, the
drama of the figures' interaction was determined
solely by two psychological situations – mutual
attraction or repulsion. The first, as a rule, was por-
trayed through an embrace or touch and a harmony
of color; the second, by a contrast of color and by
empty space between figures. During the periods of
the world wars, the theme of human relations
became crucial to Nolde's work, as the artist deliber-
ately contrasted themes of warmth and friendship
with those of death and chaos.

The present work may depict a mother and
daughter, or possibly two sisters. It is difficult to
assign a date to it, and it could have been created
anytime between 1910 and the 1930s. The head of the

young woman may possibly be linked to the image
of Margarete Turgel, whose portrait Nolde had done
several times in Berlin in September 1930 (fig. 2; see
Urban 1987, nos. 1097, 1098). In letters to his wife, the
artist described in detail the studies he had made of
this model. Of all the images of women he created
between the wars, those of Margarete, his neighbor
in Kampen, most closely resemble the young
woman seen here.

This work was executed on Japanese paper,
which Nolde often used for watercolors. It is known
that the artist engaged in unusual experiments with
this medium, leaving nearly completed works out
in the cold and the rain, allowing nature to "finish"
them. The colors blurred; forms were strangely
altered. He dampened the paper and let stains and
smudges randomly fill the surface of the sheet.
Nolde also sometimes worked on the reverse side of
a watercolor sheet: Like a blotter, the damp Japanese
paper let odd and interesting stains appear on the
back of the sheet, sometimes preserving the image
from the front. The verso of *Portrait of a Young
Woman and a Child* is an example of this reversed
imaging.

2. Emil Nolde. *Portrait of a
Woman (Margarete Turgel)*. 1930.
Nolde-Museum, Neukirchen

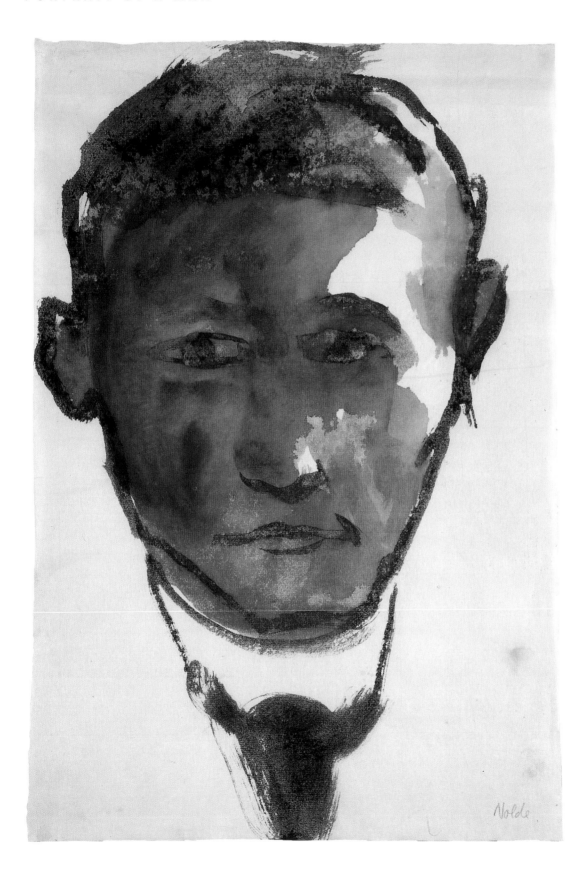

78.

Emil Nolde. *Portrait of a Man*. Watercolor, gouache, and ink with touches of pastel on Japanese paper, 16 x 10⅞" (40.9 x 27.5 cm). Signed lower right in pencil: *Nolde.* Inv. no. 155-72

PROVENANCE: Probably Otto Krebs, Holzdorf.

This watercolor is stylistically similar to the color lithographic portraits of 1926 (fig. 1; see Schiefler 1966–67, vol. 2, nos. 73, 74). They all employ the same compositional devices and virtually the same colors and method of application. Both in the lithographs and in the present work, there is the effect of a "scraped" pictorial surface. In the lithograph, it conveys the interplay of light, color, and shadow; in the watercolor, the artist deliberately dampened certain areas in order to create a more vibrant surface. Sometimes, as shown in plate 77, the artist allowed the colors to soak in deeply, while in other works, such as *Portrait of a Man,* he blotted them with absorbent paper. In such cases, Nolde then drew in the contours more clearly and modulated the play of light and shadow. The result was to expose the translucent parts of the paper even more strongly, creating a special effect of color and space. Throughout his creative work, Nolde made use of this technique to rework what were essentially already finished drawings.

1. Emil Nolde. *Boy*. 1926. Nolde-Museum, Neukirchen

Alexander Porfirievich Archipenko was born in Ukraine, and from 1902 to 1908 studied in Kiev and Moscow. As the artist said in a 1963 interview, while still in Moscow he produced two "symbolist" sculptures. In 1909, he went to Paris, where he was to spend the first years of his artistic career. (Archipenko himself gave a different date, 1908, for his arrival in Paris, but the documentation cited in K. J. Michaelson's dissertation confirms that the date was indeed 1909 [see Michaelson 1975, p. 4].) All of Archipenko's subsequent life and his mature work as an artist were linked with Europe and America, and he emigrated to the United States in 1923. It is in the West, and not in his native land, that his art is best known, and virtually all of the major Western museums exhibit his sculptures and graphic works. There is a notable body of work in the Tel Aviv Museum (Goeritz collection).

In Paris, where he first achieved fame, he came into contact with those who were creating the new art of the twentieth century. It is interesting that artists such as Pablo Picasso, Constantin Brancusi, Amedeo Modigliani, Marc Chagall, Jacques Lipchitz, and others, as they experimented with the new art, often blended in startling ways the traditions of their own native countries with the advanced styles emerging in the French capital, and at the same time often responded to the newly rediscovered cultures of ancient Greece, Oceania, and Africa. In Paris, the young Ukrainian artist was subjected to diverse influences, not only from the young innovators but also from the latest representatives of the European classical tradition, such as Auguste Rodin, Aristide Maillol, and Antoine Bourdelle. In this complex milieu, Archipenko saw Constructivism, Futurism, Expressionism, and other avant-garde modes as natural and even necessary forms of artistic expression. His inclination toward chromatic polyphony manifested itself in colorful works that combined ele-

ments of painting, sculpture, and architecture.

After showing five sculptures and one drawing in the 1910 Salon des Indépendants in Paris, Archipenko regularly participated in international exhibitions in Europe and had numerous solo shows. In the first two decades of the century, his art became known in France, Switzerland, Italy, Belgium, Holland, the United States – and, especially, Germany; he moved to Berlin in 1921, becoming popular with collectors during the two years he lived there, prior to leaving for America. Guillaume Apollinaire, Blaise Cendrars, Maurice Raynal, Theodor Däubler, Iwan Goll, and Hans Hildebrandt wrote about him. His work was exhibited in the Armory Show, in New York; in galleries such as Der Sturm, Richter, and Zborovski; at the Museum Folkwang (then in Hagen), in his first major solo show, organized with Karl-Ernst Osthaus; and at museums in Wiesbaden, Hannover, Mannheim, and Prague. He regularly participated in such major international exhibitions as the Paris and Brussels Indépendants salons; the well-known international exhibitions of Alexandre Merceraux in Prague; such Futurist venues as the Galleria Futurista G. Sprovieri; the Venice Biennale; and many others.

In the artist's Parisian period, the names of Archipenko and Picasso were sometimes linked. In the catalogue in which the poem dedicated to Archipenko by Blaise Cendrars was published (Potsdam 1921), Archipenko and Picasso were called the two leaders of the twentieth century, the former in sculpture and the latter in painting. In an article published in *Die bildende Künste* (11–12, 1921), Archipenko, along with two other émigrés from Russia – Chagall and Vasily Kandinsky – was called a leader of revolutionary art.

Today's assessments are quite different. It is understandable that the extent of Archipenko's "revolutionary" innovations was somewhat exaggerated

by his contemporaries. Indeed, the image of Archipenko as an innovator was in part created by the artist himself, with his perpetual need to expound theories of new "dimensions" in public statements and popular-science interpretations of his own work. Archipenko's art, including his efforts related to Cubism, Futurism, and Constructivism, rarely ventured beyond what the European avant-garde had established early in the century. After his polychrome construction *Medrano II* became notorious at the Salon des Indépendants of 1914, he went on to work in a variety of styles, combining classical forms with elements of Cubo-Futurism, and his early "distorted" constructions and sharp planes therefore sometimes came to be seen as reflections of the times.

The truly remarkable qualities in Archipenko's work, which was voluminous and possessed of a genuine creative spirit, reside in his mastery of materials, whether he was working in wood, stone, or metal. His sculptures have a distinctive, musical grace. They live in space and create space, interacting with it. The soft, ductile forms and contours of most of his sculptures are linked to the female form. He continually produced different versions of typical configurations and states, shifting between harmony and dissonance, between repose and dynamic movement.

The present drawings, from a German private collection, bear witness to the artist's skill at developing variations on a theme. At first glance, the drawings fall into three groups. The first group includes pencil studies done in a classical style, with some hints at salon art; the second, in charcoal, is reminiscent of the late Renaissance; and the third, in gouache, reveals the influence of Constructivist and Cubist form. The differences among the three groups are not great, however, and even in its avant-gardism the last group retains the smooth linear movement that was specific to Archipenko's talent.

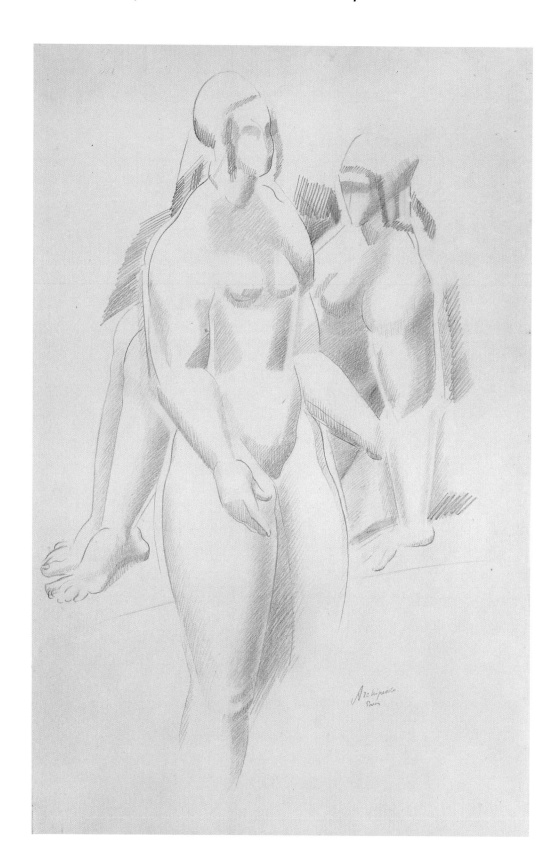

OPPOSITE:

79.

Alexander Archipenko (1887, Kiev–1964, New York). *Two Nude Female Figures (Standing and Seated)*. Pencil, 19⅝ x 12½" (49.8 x 31.8 cm). Signed lower right in pencil: *Archipenko/Paris*. Inv. no. 155-62
PROVENANCE: Probably Otto Krebs, Holzdorf.

OVERLEAF:

80.

Alexander Archipenko. *Two Nude Female Figures (Seated and Bending)*. Gouache on sanguine preparation; on cardboard, 22½ x 17" (57.3 x 43.1 cm). Signed lower left in wash: *Archipenko*. Label on verso of passe-partout: *Georg Ahl/Papierhandlung/Bilder und Rahmen/Charlottenburg Kaiserdamm.4*. Inscribed on label: *58/zwei frauen/Aquarell*. Inv. no. 155-68
PROVENANCE: Probably Otto Krebs, Holzdorf.

The composition is precisely that of the lithograph published in the Wasmuth edition (Berlin 1921; see also Karshan 1974, no. 13). The lithograph was shown in 1970 at the exhibition "Archipenko: The Parisian Years" at the Museum of Modern Art, New York (Lieberman/Kuh 1970), and in 1985 in Danville, Kentucky (Karshan 1985, no. 48). A variant of this theme appears in a lithograph of 1923 (Karshan 1985, no. 66).

PAGE 205:

81.

Alexander Archipenko. *Two Nude Female Figures with a Cloth*. Watercolor, gouache, and pencil on cream-colored cardboard, 22⅝ x 17¼" (57.5 x 43.7 cm). Signed lower left in watercolor: *Archipenko*. Label on verso of passe-partout inscribed: *57/zwei frauen/Aquarell*. Inv. no. 155-67
PROVENANCE: Probably Otto Krebs, Holzdorf.

This drawing is reminiscent of the lithographs *Two Women, One Seated* of 1921, published by E. Wasmut (Berlin 1921; see also Karshan 1974, no. 21), and *Figure Composition,* first published by Kurt Wolff (Leipzig 1921; see Karshan 1974, no. 23).

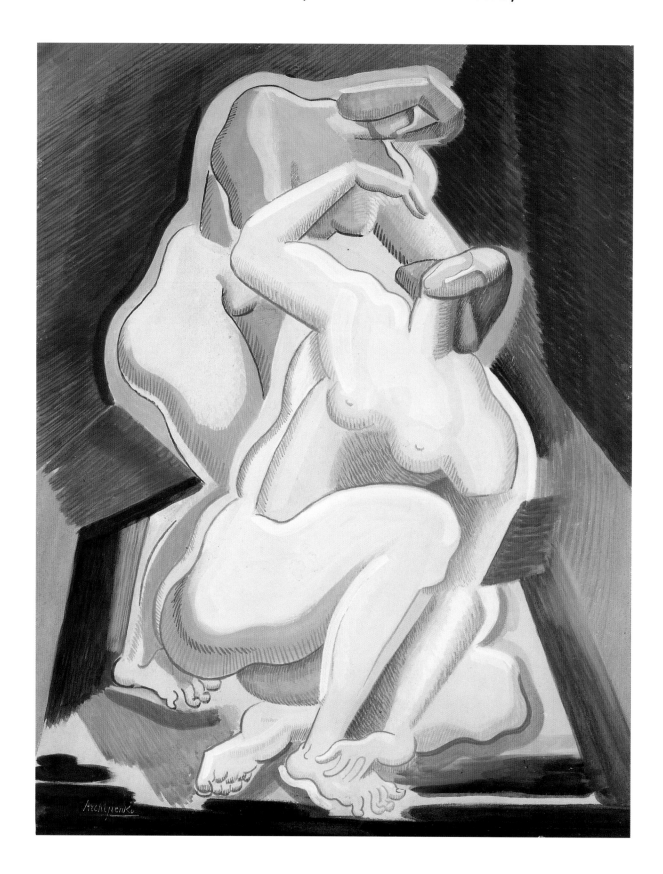

# ALEXANDER ARCHIPENKO

## TWO NUDE FEMALE FIGURES WITH A CLOTH

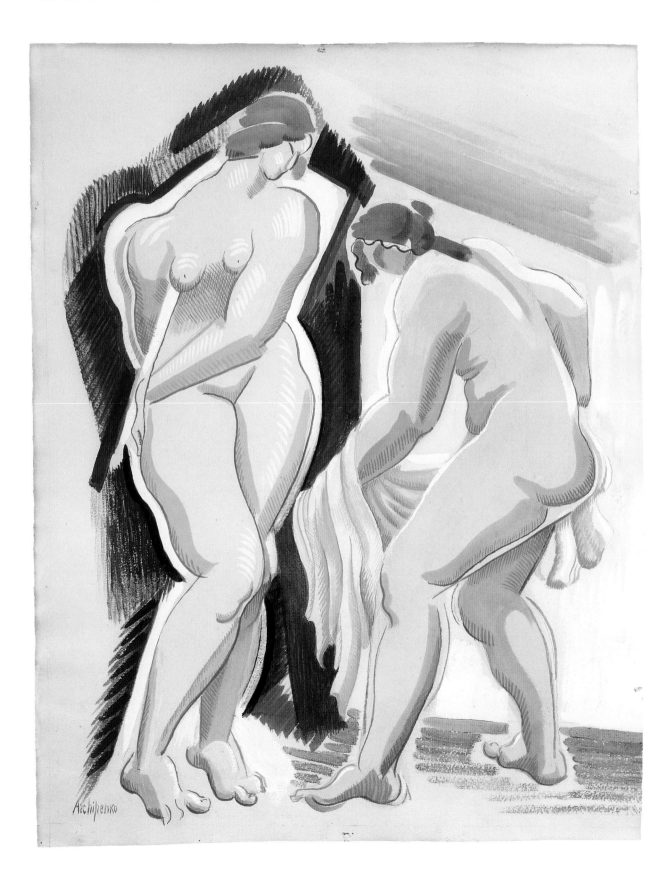

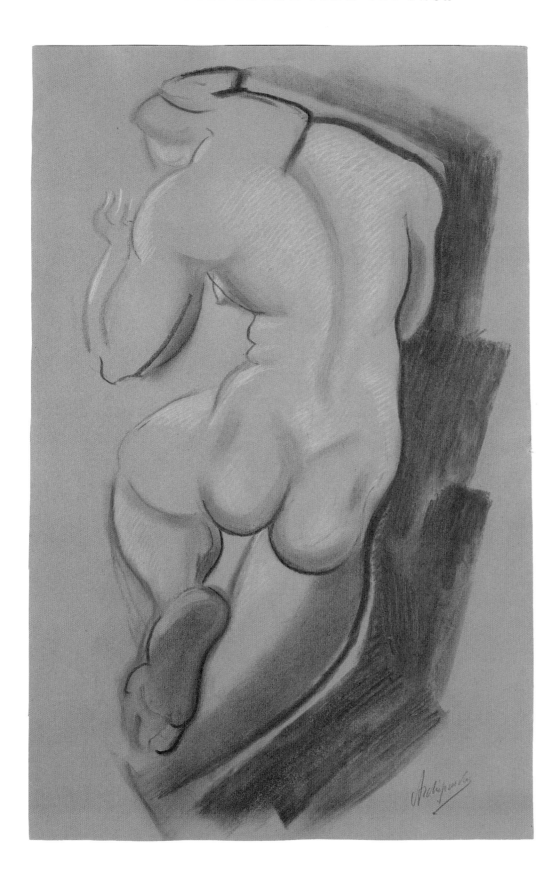

1. Alexander Archipenko. *Seated Nude Female Figure.* 1919. Städtische Kunsthalle, Mannheim

This sheet and the preceding one apparently were
done from the same model. The artist depicted the
same pose in the drawing *Seated Nude Female Figure*
of 1919 (fig. 1; Städtische Kunsthalle, Mannheim), a
composition executed entirely with Cubo-Futurist
forms. A comparison of these drawings clearly
shows the differing styles that the artist could bring
to bear on similar compositions. From the end of the
first decade of the century until he moved to the
United States in 1923, Archipenko is known to have
experimented with various styles simultaneously,
testing himself against the requirements of different
and often contradictory systems.

In composition, this work is similar to the lithograph
*Three Female Figures* of 1921 (Berlin 1921; Karshan 1974,
no. 15).

# ALEXANDER ARCHIPENKO

## THREE NUDE FEMALE FIGURES

# ALEXANDER ARCHIPENKO

## SEATED FEMALE NUDE WITH LEFT HAND AT BREAST

OPPOSITE:

85.

Alexander Archipenko. *Seated Female Nude with Left Hand at Breast*.
White chalk on brown cardboard, 19¾ x 12⅝" (50.1 x 32 cm).
Signed lower left in pencil: *Archipenko*. Label on verso inscribed:
*70./Kohlenzeichnung*. Inv. no. 155-56
PROVENANCE: Probably Otto Krebs, Holzdorf.

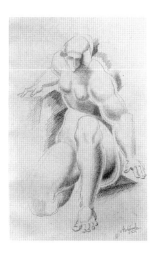

1. Alexander Archipenko. *Seated Female Nude*. 1920. Städtische Kunsthalle, Mannheim

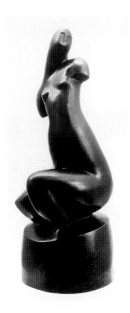

2. Alexander Archipenko. *Black Seated Torso*. 1909. Collection Frances Archipenko Gray

OVERLEAF:

86.

Alexander Archipenko. *Seated Female Nude with Left Leg Bent*. Pencil and black chalk, 19⅝ x 12½" (49.9 x 31.8 cm). Signed lower left in pencil: *Archipenko*. Label on verso of passe-partout inscribed: *69./Kohlenzeichnung*. Inv. no. 155-58
PROVENANCE: Probably Otto Krebs, Holzdorf.

The artist frequently depicted variations on this pose of a seated female nude with one knee raised. To cite only a few examples: a drawing and lithograph of 1916 (Hildebrandt 1923, ill. 33); the 1920 print *A genoux* (Karshan, 1985); and a drawing of 1920 (fig. 1; Städtische Kunsthalle, Mannheim; Potsdam 1921, ill. 18). The drawing reproduced here may possibly be one of the preliminary studies for the sculpture *Meditation* of 1924 (Saarbrücken 1986, no. 52). The earliest version of this dynamic figure is the sculpture *Black Seated Torso* of 1909 (fig. 2; Archipenko Gray collection).

PAGE 213:

87.

Alexander Archipenko. *Seated Female Nude with Left Hand on Right Leg*. Charcoal and black and white chalk on brown cardboard, 19¾ x 12⅝" (50.2 x 32.1 cm). Signed lower right in pencil: *Archipenko*. Label on verso of passe-partout inscribed: *76./Act/Bleistiftzeichnung*. Inv. no. 155-60
PROVENANCE: Probably Otto Krebs, Holzdorf.

There are some similarities between this drawing and the sculpture *Melancholy I* of 1929 (Saarbrücken 1986, no. 63).

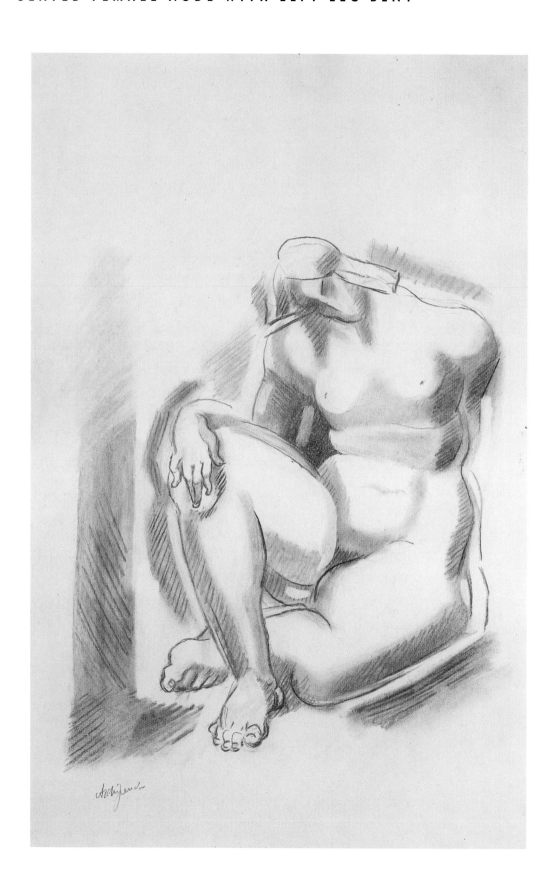

# ALEXANDER ARCHIPENKO

## SEATED FEMALE NUDE WITH LEFT HAND ON RIGHT LEG

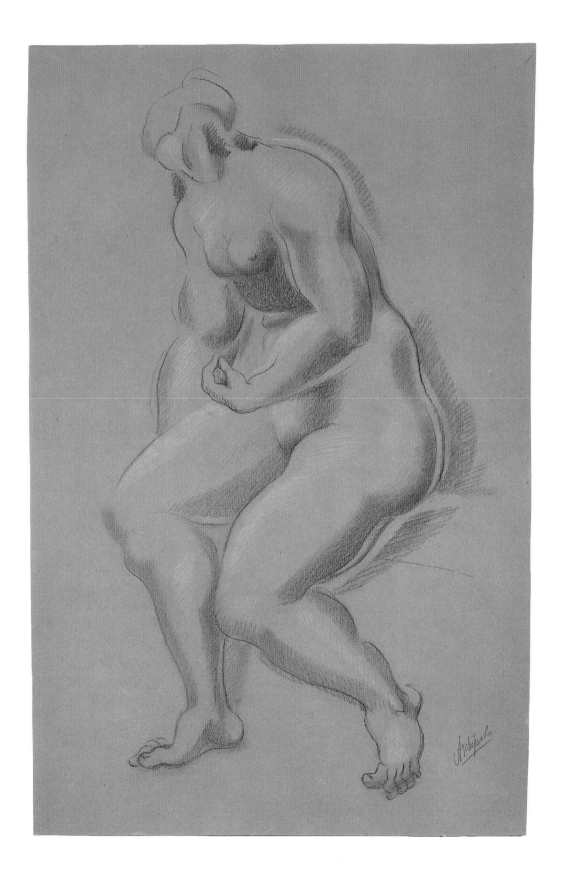

# ALEXANDER ARCHIPENKO

## STANDING FEMALE NUDE TOUCHING RIGHT FOOT WITH FINGERS

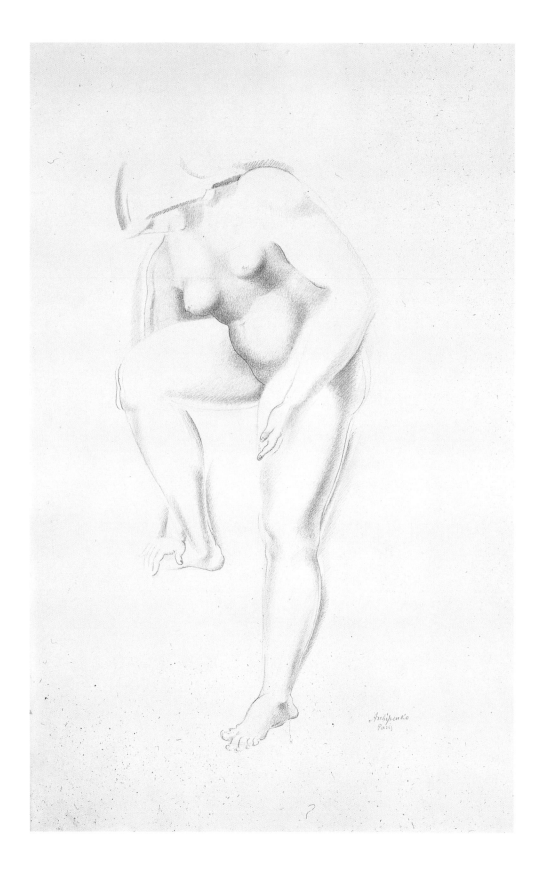

88.

Alexander Archipenko. *Standing Female Nude Touching Right Foot with Fingers*. Pencil, 19⅞ x 12½" (50.4 x 31.8 cm). Signed lower right in pencil: *Archipenko/Paris*. Watermark at bottom of right margin (cut off by edge of sheet): TORCHON LEPAGE & C^{ie} PARIS SPF. Inv. no. 1555-61

PROVENANCE: Probably Otto Krebs, Holzdorf.

The drawing is one of many related to the lithograph *Female Bather* (Karshan 1974, no. 14), which was shown in 1920 and 1921 in a number of American and European cities (see Reynal 1920–21 and Potsdam 1921, p. 19). The drawings closest to the lithograph are *Female Nude with a Towel* of 1919 (fig. 1), now in the Museum Folkwang, Essen; and *Woman Drying Her Legs* of 1920 (Michaelson 1975, no. D.34). All of these employ a relatively "realistic" style. In other works, however, such as *Bather* of 1921 (University of Michigan Museum of Art, Ann Arbor), Archipenko used explicitly Constructivist devices, and even earlier, in the drawing *The Circus* of 1915 (Karshan 1985, no. 29), he depicted essentially the same pose in a Cubo-Futurist style.

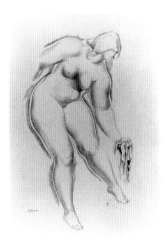

1. Alexander Archipenko. *Female Nude with a Towel*. 1915. Museum Folkwang, Essen

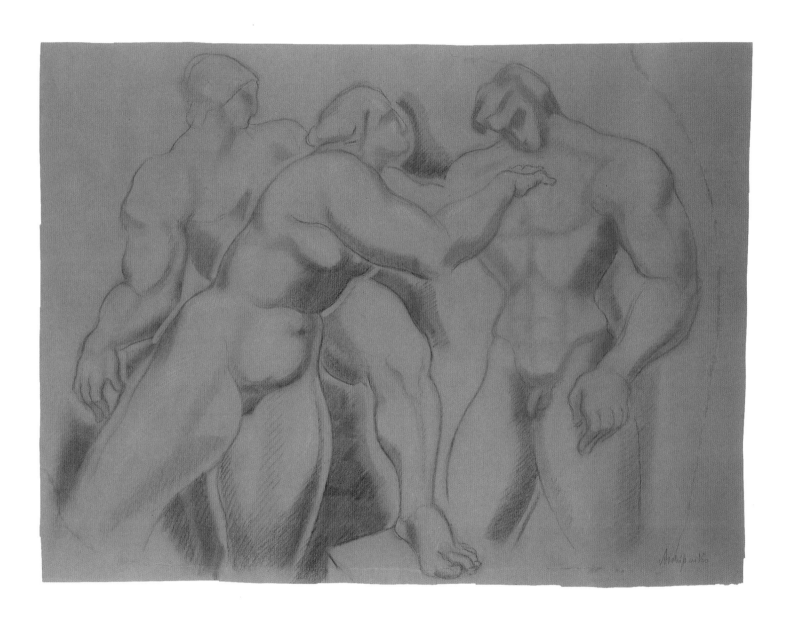

89.

Alexander Archipenko. *Group of Nude Figures*. Pencil and black and white chalk on brown paper, 17⅛ x 22¼" (43.6 x 56.6 cm). Signed lower right in pencil: *Archipenko*. On verso: sketch in black chalk of a nude female figure [see fig. 1]. Label on passe-partout inscribed: *91/eine Gruppe/Bleistiftzeichnung*. Stamped inside passe-partout: *Georg Ahl/Papierhandlung/Bilder und Rahmen/Charlottenburg/Kaiserdamm.4*. Inv. no. 155-69

PROVENANCE: Probably Otto Krebs, Holzdorf.

Group figure compositions are quite common both in Archipenko's works on paper and in his sculptures. The interaction between the figures and the surrounding space is complex, fusing dynamism with meditation, energy with serenity. The present drawing is one of many variations on this implicit theme, executed in the artist's monumental style.

1. Verso of plate 89, *Group of Nude Figures*

# BIBLIOGRAPHY

The abbreviations in **BOLD** are cited within the catalogue entries.

**ADHÉMAR 1954**
Adhémar, J. *Honoré Daumier: Drawings and Watercolors*. New York and Basel, 1954.

**ADRIANI 1986**
Adriani, G. *Toulouse-Lautrec: Das Gesamte graphische Werk, Sammlung Gerstenberg*. Cologne, 1986.

**ALAIN 1949**
Alain. *Ingres*. Paris, 1949.

**ALEXANDRE 1888**
Alexandre, A. *Honoré Daumier: L'Homme et l'oeuvre*. Paris, 1888.

**AMAURY-DUVAL 1878**
Amaury-Duval. *L'Atelier d'Ingres*. Paris, 1878.

**ARAMA 1987**
Arama, M. *Le Maroc de Delacroix*. Paris, 1987.

**ARS GRAPHICA 1924**
*Les Dessins de Daumier*. Ars Graphica series. Introduction by Charles Baudelaire. Paris, 1924.

**BERLIN 1921**
*Alexander Archipenko: Dreizehn Steinzeichnungen*. Berlin, 1921.

**BERTELS 1907**
Bertels, K. *Francisco Goya*. Leipzig, 1907.

**BERTHOLD 1958**
Berthold, G. *Cézanne und die alten Meister*. Stuttgart, 1958.

**BOZAL 1983**
Bozal, V. *Imagen de Goya*. Barcelona, 1983.

**BRIEGER-WASSERVOGEL [N.D.]**
Brieger-Wasservogel, L. *Francisco de Goya*. Berlin, n.d.

**BROGLIE 1973**
Broglie, A. de. "Les Monologues du sourd." *Connaissance des arts* 259 (September 1973).

**CALVERT 1908**
Calvert, A. F. *Goya*. London, 1908.

**CARDERERA 1860**
Carderera, V. "Francisco de Goya: Sa Vie, ses dessins et ses eaux-fortes." *Gazette des Beaux-Arts* 6 (1860), pp. 215–27.

**CASSOU 1949**
Cassou, J. *Daumier*. Lausanne, 1949.

**CHAPPUIS 1973**
Chappuis, A. *The Drawings of Paul Cézanne: A Catalogue Raisonné*. 2 vols. London, 1973.

**CHASTENET 1964**
*Goya: Collection génie et réalités par J. Chastenet*. Paris, 1964.

**COUSTURIER 1922**
Cousturier, L. *Paul Signac*. Paris, 1922.

**DAGUERRE DE HURLAUX 1993**
Daguerre de Hurlaux, A. *Delacroix*. Paris, 1993.

**DELABORDE 1877**
Delaborde, H. *Ingres*. Paris, 1870.

**DELACROIX 1932**
*Journal de Eugène Delacroix*. Edited and with an introduction by André Joubin. 3 vols. Paris, 1932.

**DE LA FAILLE 1970**
de la Faille, J.-B. *The Works of Vincent van Gogh: His Paintings and Drawings*. Amsterdam and New York, 1970.

**DORTU 1971**
Dortu, M. G. *Toulouse-Lautrec et son oeuvre*. 4 vols. New York, 1971.

**DUPLESSIS 1896**
Duplessis, G. *Les Portraits dessinés par J.-A.-D. Ingres*. Paris, 1896.

**ERPEL 1990**
Erpel, F. *Vincent van Gogh: Die Rohrfederzeichnungen*. Munich, 1990.

**ESCHOLIER 1923**
Escholier, R. *Daumier*. Paris, 1923. Subsequent eds., 1930, 1938.

**FEILCHENFELD 1988**
Feilchenfeld, W. *Vincent van Gogh and Paul Cassirer: The Reception of van Gogh in Germany from 1901 to 1914*. Zwolle, 1988.

**FLECHA 1988**
Flecha, R. A. *Literatura e idiologia en el arte de Goya*. Saragossa, 1988.

**FLEISCHMANN 1937**
Fleischmann, B. *Honoré Daumier: Gemälde und Graphik*. Vienna, 1937.

**FLEKEL 1974**
Flekel, M. *Velikie mastera risunka: Rembrandt, Goya, Daumier (Great Masters of Drawing: Rembrandt, Goya, Daumier)*. Moscow, 1974.

**FOSCA 1933**
Fosca, F. *Daumier*. Paris, 1933.

**FRANKFURT AM MAIN 1981**
*Goya: Zeichnungen und Druckgraphik*. Frankfurt am Main, 1981.

**FUCHS 1927**
Fuchs, E. *Der Maler Daumier*. Munich, 1927.

**GALICHON 1861**
Galichon, E. "Dessins de M. Ingres [exposés aux Salons des Arts-Unis]." *Gazette des Beaux-Arts*, July 1, 1861, p. 47.

**GANTNER 1974**
Gantner, J. *Goya: Der Künstler und seine Welt*. Berlin, 1974.

**GASSIER I**
Gassier, P. *Les Dessins de Goya: Les Albums*. Fribourg, 1973. English ed., *Francisco Goya, Drawings: The Complete Albums*. Translated by James Edmunds and Robert Allen. New York, 1973.

**GASSIER II**
Gassier, P. *Les Dessins de Goya: Tome II*. English ed., *The Drawings of Goya: The Sketches, Studies, and Individual Drawings*. New York, 1975.

**GASSIER 1983**
Gassier, P. *Témoin de son temps*. Fribourg, 1983.

**GASSIER/WILSON**
Gassier, P., and J. Wilson. *The Life and Complete Work of Francisco de Goya, with a Catalogue Raisonné of the Paintings, Drawings, and Engravings*. New York, 1971. Published in Great Britain as *Goya: His Life and Work*.

**GEFFROY 1901**
Geffroy, G. "Daumier." *Revue de l'art ancien et moderne* 9 (1901).

**GIARD 1934**
Giard, R. *Le Peintre Victor Mottez d'après sa correspondance*. Lille, 1934.

**VAN GOGH LETTERS**
*The Complete Letters of Vincent van Gogh*. London and New York, 1958.

**GÓMEZ-MORENO 1941**
Gómez-Moreno, M. E. "Un Cuaderno de dibujos inéditos de Goya." *Archivo español de arte* 14 (1941), pp. 155–63.

**GREGO 1880**
Grego, J. *Rowlandson the Caricaturist: A Selection from His Works*. 2 vols. London, 1880. Reprinted, New York, 1970.

**GUDIOL 1970**
Gudiol, J. *Goya* (biography and catalogue raisonné of the paintings). 4 vols. Barcelona, 1970. English ed., *Goya, 1746–1828: Biography, Analytical Study, and Catalogue of His Paintings*. Translated by Kenneth Lyons. 4 vols. New York, 1971.

**GUILLAUD 1987**
Guillaud, J. and M. *Goya: Les Visions magnifiques*. Paris, 1987.

**HAMBURG 1980**
*Goya: Das Zeitalter der Revolutionen, 1789–1830*. Hamburg, 1980.

**HARRIS 1964**
Harris, T. *Goya: Engravings and Lithographs*. Vol. 1, *Text and Illustrations*. Vol. 2, *Catalogue Raisonné*. Oxford, 1964.

**HAYES 1990**
Hayes, J. *The Art of Thomas Rowlandson*. New York, Pittsburgh, Baltimore, 1990.

**HELD 1980**
Held, J. *Francisco Goya in Selbstzeugnissen und Bilddokumenten*. Hamburg, 1980.

**HILDEBRANDT 1923**
Hildebrandt, H. *Alexander Archipenko*. Berlin, 1923.

HÖLSCHER 1988
Hölscher, T. *Bild und Exzess: Näherungen zu Goya*. Munich, 1988.

HULSKER 1973
Hulsker, J. *Van Gogh door van Gogh: De brieven als commentaar op zijn werk*. Amsterdam, 1973.

HULSKER 1977
Hulsker, J. *Van Gogh en zijn tekeningen en schilderijen*. Amsterdam, 1977.

IVES/STUFFMANN/SONNABEND 1993
Ives, C., M. Stuffmann, and M. Sonnabend. *Daumier Drawings*. New York, 1993.

JEDLICKA 1943
Jedlicka, G. *Henri de Toulouse-Lautrec*. Zurich, 1943.

JOHNSON 1986
Johnson, L. *The Painting of Eugene Delacroix: A Critical Catalogue (1832–1863)*. Oxford, 1986.

JOYANT 1927
Joyant, M. *Henri de Toulouse-Lautrec*. Vol. 2, *Dessins, estampes, affiches*. Paris, 1927.

KAISER 1975
Kaiser, K. *Menzel*. Munich, 1975.

KAPOSY 1968
Kaposy, V. "Remarques sur deux époques importantes de l'art de Daumier dessinateur." *Acta Historiae Artium* (Budapest), 14, nos. 3–4 (1968), pp. 255–73.

KARSHAN 1974
Karshan, D. *Archipenko: The Sculpture and Graphic Art, Including a Print Catalogue Raisonné*. Tübingen, 1974.

KARSHAN 1985
Karshan, D. *Archipenko: Sculpture, Drawings, and Prints, 1908–1963*. Danville, Ky., 1985.

KLINGENDER 1968
Klingender, F. D. *Goya in the Democratic Tradition*. 2nd ed., New York, 1968.

KLOSSOWSKI 1923
Klossowski, E. *Honoré Daumier*. Munich, 1923.

LAFOND 1907
Lafond, P. *Nouveaux Caprices de Goya: Suite de trente-huit dessins inédits*. Paris, 1907.

LAPAUZE 1901
Lapauze, H. *Les Dessins de J.-A.-D. Ingres du Musée de Montauban*. Paris, 1901.

LAPAUZE 1911
Lapauze, H. *Ingres: Sa Vie et son oeuvre*. Paris, 1911.

LASSAIGNE 1938
Lassaigne, J. *Daumier*. Paris, 1938.

LEIPZIG 1921
*Genius*. Leipzig, 1921.

LEROI 1894–1900
Leroi, P. "Vingt dessins de M. Ingres." *L'Art* 59 (1894–1900), p. 818.

LEVINA 1945
Levina, I. M. *Goya*. Leningrad, 1945.

LEVINA 1950
Levina, I. M. *Goya and the Spanish Revolution, 1820–23*. Leningrad, 1950.

LEVINA 1958
Levina, I. *Goya*. Leningrad and Moscow, 1958.

LIEBERMAN/KUH 1970
Lieberman, W. S., and K. Kuh. *Archipenko: The Parisian Years*. New York, 1970.

LOGA 1903
Loga, V. von. *Francisco de Goya*. Berlin, 1903.

LONDON 1976
*Jean-François Millet*. London, 1976.

LONDON 1984
*The Dent Collection*. Christie's, London, July 10, 1984.

LÓPEZ-REY 1953
López-Rey, J. *Goya's Caprichos: Beauty, Reason, and Caricature*. Princeton, 1953.

LÓPEZ-REY 1956
López-Rey, J. *A Cycle of Goya's Drawings: The Expression of Truth and Liberty*. London, 1956.

LUGHT 1921 (1956)
Lught, F. *Les Marques de collections de dessins et d'estampes*. Amsterdam, 1921. *Supplément*. La Haye, 1956.

MAISON 1960
Maison, K. E. *Daumier: Drawings*. New York and London, 1960.

MAISON 1968
Maison, K. E. *Honoré Daumier: Catalogue Raisonné of the Paintings, Watercolours, and Drawings*. Vol. 1, *The Paintings*. Vol. 2, *The Watercolours and Drawings*. London, 1968.

MALRAUX 1978
Malraux, A. *Saturne: Le Destin—L'Art et Goya*. Paris, 1978.

MARCEL 1907
Marcel, H. *Daumier*. Paris, 1907.

MARÉES GESELLSCHAFT 1918
*Drucke der Marées Gesellschaft, Portfolio VIII: Daumier*. Munich, 1918.

MAYER 1923
Mayer, A. L. *Francisco de Goya*. Munich, 1923.

MAYER 1932–33
Mayer, A. L. "Dibujos desconocidos de Goya." *Revista española de arte* 11 (1932–33), pp. 376–84.

MEIER-GRAEFE 1904
Meier-Graefe, J. *Entwicklungsgeschichte der modernen Kunst*, vol. 3. Stuttgart, 1904.

MESSERER 1983
Messerer. *Francisco Goya: Form und Gehalt seiner Kunst*. Freren, 1983.

MICHAELSON 1975
Michaelson, K. J. *Archipenko: A Study of the Early Works, 1908–1920*. New York, 1975.

NAEF 1977–80
Naef, H. *Die Bildniszeichnungen von J.-A.-D. Ingres*. 5 vols. Bern, 1977–80.

NEMITZ 1940
Nemitz, F. *Goya*. Berlin, 1940.

NEW YORK 1922
*Honoré Daumier: Appreciations of His Life and Works*. New York, 1922.

NÚÑEZ DE ARENAS 1950
Núñez de Arenas, M. "Manojo de noticias: La Suerte de Goya en Francia," *Bulletin hispanique* (Bordeaux) 3 (1950), p. 250.

OPPE 1923
Oppe, A. P. *Thomas Rowlandson: His Drawings and Watercolors*. London, 1923.

ORTEGA Y GASSET 1958
Ortega y Gasset, J. *Goya*. Madrid, 1958.

PARIS 1900A
*Catalogue de la vente A. Boulard*. Paris, 1900.

PARIS 1900B
*Catalogue de la vente A. Tavernier*. Paris, 1900.

PARIS 1907
*Catalogue de la vente A. Tavernier*. Hôtel Druot, Paris, March 25, 1907.

PARIS 1911
*Catalogue de la vente de Bériot*. Paris, 1911.

PARIS 1912
*Catalogue de la vente H. Rouart*. Paris, 1912.

PARIS 1927
*Catalogue de la vente P. Bureau*. Paris, 1927.

PARIS 1975
*Jean-François Millet*. Paris, 1975.

PASSERON 1979
Passeron, R. *Daumier, témoin de son temps*. Fribourg, 1979.

PAULSON 1972
Paulson, R. *Rowlandson: A New Interpretation*. London, 1972.

PÉREZ SÁNCHEZ/SAYRE 1989
Pérez Sánchez, A., E. A. Sayre et al. *Goya and the Spirit of Enlightenment*. Boston, 1989.

PICKVANCE 1984
Pickvance, R. *Van Gogh in Arles*. New York, 1984.

POTSDAM 1921
*Archipenko-Album: Einführung von Theodor Däubler und Iwan Goll*. Potsdam, 1921.

**PROKOFIEV 1986**
Prokofiev, V. N. *Goya in the Art of the Romantic Epoch*. Moscow, 1986.

**RAU 1953**
Rau, F. *Goya*. Lisbon, 1953.

**REYNAL 1920–21**
Reynal, M. *Alexandre Archipenko: Tournée de l'exposition de sculptures, sculpto-peintures, peintures, dessins*. 1920–21.

**ROBAUT/CHESNEAU 1885**
Robaut, A., with R. Chesneau. *L'Oeuvre complet d'Eugène Delacroix: Peintures, dessins, gravures, lithographies*. Paris, 1885. Republished, New York, 1969.

**ROSENTHAL [N.D.]**
Rosenthal, L. *Daumier*. (L'Art de notre temps.) Paris, n.d.

**ROTHE 1943**
Rothe, H. *Francisco Goya: Handzeichnungen*. Munich, 1943.

**SAARBRÜCKEN 1986**
*Alexander Archipenko: Werke von 1908 bis 1963 aus dem testamentarischen Vermächtnis*. Saarbrücken, 1986.

**SADLEIR 1924**
Sadleir, M. *Daumier: The Man and the Artist*. London, 1924.

**SAINT-PAULIEN 1965**
Saint-Paulien. *Goya: Son Temps, ses personnages*. Paris, 1965.

**SALAS 1979**
Salas, X. de. "Une Miniature et deux dessins inédits de Goya." *Gazette des Beaux-Arts*, April 1979, p. 167.

**SÁNCHEZ CANTÓN 1928**
Sánchez Cantón, F. J. *Cuaderno pequeño del viaje a Sanlúcar*. Madrid, 1928.

**SÁNCHEZ CANTÓN 1930**
Sánchez Cantón, F. J. *Goya*. Paris, 1930.

**SARAGOSSA 1981**
*Francisco de Goya, Diplomatario*. Saragossa, 1981.

**SCHIEFLER 1966–67**
Schiefler, G., and C. Mosel. *Emil Nolde: Das Graphische Werk*. 2 vols. Cologne, 1966–67.

**SCHMIDT 1988**
Schmidt, S. "Bernard Kohler: Ein Mäzen und Sammler August Mackes und der Künstler des *Blauen Reiter*." *Zeitschrift für Kunstgeschichte* 42, no. 3 (1988), p. 89.

**SCHMIDT 1994**
Schmidt, R., and M. *René Princeteau, 1843–1914: Chevaux et cavaliers—Catalogue raisonné*. Paris, 1994.

**SCHEIWILLER 1942**
Scheiwiller, G. *Daumier*. Milan, 1942.

**SEDOVA 1973**
Sedova, T. *Francisco Goya*. Moscow, 1973.

**SÉRULLAZ 1950**
Sérullaz, M. "Van Gogh et Millet." *Etudes d'art* 5 (1950), pp. 87–92.

**SIGNAC 1898**
Signac, P. *D'Eugène Delacroix au néo-impressionisme*. Paris, 1898.

**SIGNAC 1927**
Signac, P. *Jongkind*. Paris, 1927.

**SINGER [N.D.]**
Singer, H. W. *The Drawings of Adolph von Menzel*. London, n.d.

**STOLL 1954**
Stoll, R. *Zeichnungen des Francisco Goya*. Basel, 1954.

**UHDE 1936**
Uhde, W. *Leben und Werk des Vincent van Gogh*. Vienna, 1936.

**URBAN 1987**
Urban, M. *Emil Nolde: Werkverzeichnis der Gemälde*. Munich, 1987.

**VENTURI 1936**
Venturi, L. *Cézanne: Son Art, son oeuvre*. 2 vols. Paris, 1936.

**VIÑAZA 1887**
Viñaza, C., Muñoz y Manzano, Conde de la. *Goya: Su Tiempo, su vida, sus obras*. Madrid, 1887.

**VOLAND 1993**
Voland, G. *Männermach und Frauenopfer: Sexualität und Gewald bei Goya*. Berlin, 1993.

**WALDMANN 1923**
Waldmann, E. *Daumier*. Leipzig, 1923.

**WALTER/METZGER 1993**
Walter, J. F., and R. Metzger. *Vincent van Gogh*. 2 vols. Cologne, 1993.

**WARK 1975**
Wark, R. *Drawings by Thomas Rowlandson in the Huntington Collection*. San Marino, Calif., 1975.

**WOLFF 1920**
Wolff, H. *Zeichnungen von Adolf Menzel*. Dresden, 1920.

I should like to express my gratitude to all those who made possible this publication and the exhibition at the State Hermitage Museum, and to the many individuals who directly or indirectly supported my work on this complex project.

First of all, I should like to thank the staff of Harry N. Abrams, Inc., New York, for their dedicated work in preparing this catalogue for publication under difficult conditions. Most especially I want to express my gratitude to Paul Gottlieb, President and Publisher. I was indeed fortunate to work with such outstanding professionals in their fields as James Leggio, who edited this book, and Lynn Visson, who translated the Russian manuscript. I am also grateful to Catherine Ruello, who resourcefully tracked down the extensive reproductions of supplementary works. I owe debts of gratitude as well to Margaret Rennolds Chace, Managing Editor, and Ellen Rosefsky Cohen, Editor, who coordinated the simultaneous preparation of the Russian and English editions; and to Miko McGinty, who sensitively designed the book. And a special thank-you to Elena Smilevich, whose skill with languages facilitated my day-to-day work at Abrams.

Also in New York, I would like to express particular thanks to the Trust for Mutual Understanding and to its director, Richard S. Lanier; to the director of the Institute of Fine Arts, New York University, James McCredie; and to Professor Alexander M. Shedrinsky of the Institute. Their much-appreciated efforts made it possible for me to work freely in New York City's libraries and museums. At the Metropolitan Museum of Art, I was ably assisted by Dr. Marian Burleigh-Motley, Marcie Karp, and the staff of the Watson Library.

I am grateful to Frances Archipenko Gray, the widow of Alexander Archipenko, who kindly allowed me access to her archive in the late artist's home and studio in Bearsville, New York. Valuable information in determining the places depicted in Signac's drawings and their dates was provided to me by the compilers of the complete catalogue of his works: Françoise Cachin, Conservateur Général des Museés Nationaux de France; and Marina Ferretti di Castelferretto, to both of whom I am sincerely grateful.

In conducting research for this book, I received a great deal of assistance from colleagues and friends in Germany. During the initial stages, much valuable work was accomplished in the principal art history libraries in Munich and Berlin. Contact with my colleagues at the Lenbachhaus, Munich, proved particularly valuable. I also received valued assistance from Dr. Burhardt Göres and his wife, the art historian Wasilissa Pachomowa-Göres.

This book and the exhibition it accompanies would never have been possible without the initiatives undertaken by the administration of the State Hermitage Museum and especially by its director, Dr. Mikhail Piotrovsky. I would like to express particularly warm thanks to my colleagues at the Hermitage, who remained thoroughly understanding and supportive of my work throughout this effort: Irina Novoselskaya, Irina Grigoreva, Asya Kantor-Gukovskaya, Tatiana Kustodieva, Larissa Dukelskaya, Liudmila Kagane, Natalya Gritsai, Boris Asvarishch, and Mikhail Dedinkin. I am most sincerely grateful to Albert Kostenevich for his invaluable advice at all stages of the project. I received advice concerning the Signac drawings from Professor Nina Kalitina of the Department of Art History at the University of St. Petersburg. The editorial group headed by Olga Borodyanskaya, with editor Tatiana Uvarova and technical editor Natalia Slavianskaya, worked effectively in preparing the Russian edition for press. Larissa Nemchinova of the Editorial Department at the Hermitage actively participated in the early stages of work on the catalogue text. The superb color photographs reproduced here are the work of Leonid Kheifets. I was

assisted in analyzing the physical condition of the drawings by Alexander Kosolapov and Alexander Sizov in the technical laboratories of the Hermitage, where studies of the drawing papers were also conducted. Other aspects of my research were greatly aided by the staff of the library of the Hermitage. The computer facilities used in preparing the Russian text were provided by Vadim Gurulev and Sergei and Vladimir Chorny. The exhibition's installation was created in cooperation with the Hermitage's designers, headed by Viktor Pavlov. The conservators of works on paper made a particularly creative and enthusiastic contribution to the project; I should like to acknowledge their painstaking professional work in preparing the drawings for exhibition and to thank each of them individually: Valentina Kozyreva, Olga Mashneva, Marina Gambalevskaya, Elena Shishova, Tatiana Romanovskaya, Andrei Degtev, and Margarita Kovaleva.

I was also supported in my work by the efforts of my dear friends Anna Vilenskaya, Mira Myshalova, Elena Burmistrova, Tatiana Fridman, and Evgenii Abramov in Russia; and Margaret Sandler, Olga Landau-Ginzburg, and Leonid Ginzburg in the United States.

To all of these friends and colleagues I should like once again to express my deepest gratitude.

— T. I.

# LIST OF PLATES